Seeing her sex

MANCHESTER
UNIVERSITY PRESS

THE CRITICAL IMAGE

This series explores the historical and contemporary uses of photography. It aims to develop photographic history and criticism and investigates practice. The publications draw on methods and theories widely used in art history, literature, film and cultural studies.

SERIES EDITOR
John Taylor
Department of History of Art and Design, Manchester Metropolitan University

Seeing her sex

Medical archives and the female body

Roberta McGrath

MANCHESTER UNIVERSITY PRESS
Manchester and New York

distributed exclusively in the USA by Palgrave

Published by Manchester University Press
Oxford Road, Manchester M13 9NR, UK
and Room 400, 175 Fifth Avenue, New York, NY 10010, USA
www.manchesteruniversitypress.co.uk

Distributed exclusively in the USA by
Palgrave, 175 Fifth Avenue, New York, NY 10010, USA

Distributed exclusively in Canada by
UBC Press, University of British Columbia, 2029 West Mall,
Vancouver, BC, Canada V6T 1Z2

British Library Cataloguing-in-Publication Data
A catalogue record for this book is available from the British Library

Library of Congress Cataloging-in-Publication Data applied for

ISBN 0 7190 4167 8 *hardback*
 0 7190 4168 6 *paperback*

First published 2002

10 09 08 07 06 05 04 03 02 10 9 8 7 6 5 4 3 2 1

Typeset by D R Bungay Associates, Burghfield, Berks
Printed in Great Britain by the Alden Press, Oxford

Contents

List of figures

Acknowledgements

Without John Taylor this book would have neither been started nor completed and I am indebted to him. Alan Grossman, Áine O'Brien and Melinda Mash have been constant friends along the way, providing encouragement and support as well as reading and commenting on sections of the work. I especially want to thank them. Alan Grossman introduced me to Janet Davies, and I want to thank her for the careful editing of an unwieldy text.

Research for this project began at the University of Westminster and Sid Ray, Mitra Tabrizian, Christopher Williams and the Cutting Edge Research Group, particularly Helen Coxall and Erica Matlow, were vital in the early stages of its development. The completion of it was made possible by an award from the Arts and Humanities Research Board supported by Napier University, and I am grateful to them. I also want to thank David Archibald, Robin Thomson and Euan Winton at Napier, Iain Milne and Estella Dukan at the Royal College of Physicians, Edinburgh, David Weston and Nikki Pollock at Glasgow University Library Special Collections and the many staff at the National Library of Scotland. Thanks also to Matthew Kaufman, Professor of Anatomy at the University of Edinburgh for his comments on Chapter 4, and for permission to photograph the pelvic skeletons in the University's Collection and to Robin Gillanders for providing the image; to Isobel Garford for translating legal language into English, and to Jim Lawson for doing the same with Latin.

Majella Dunn, Liz Fidlon and Anthony Harris, Alison Herman, Matt Pearce, Heather Stewart and Janina Struk have, in different ways, kept me on the straight and narrow over a long stretch. My sisters, Irene Drummond and Maureen Hutchison, and my parents, Nancy and Robert, have done so for even longer and I want to thank them too, along with Edie, for whom the straight and narrow remains an alien concept.

I am grateful to the trustees of the National Library of Scotland, the Royal College of Physicians, Edinburgh, Glasgow University Library, the British Library, the Wellcome Library and the Science Museum for permission to reproduce illustrations.

Introduction

This book sets out to examine aspects of the close relationship between human reproduction and cultural representation. Its examples are drawn from visual inscriptions of the reproductive female body made between 1750 and 1910. In what follows I explore how the modern medical gaze was forged in relation to the woman's body as spectacle, as sexual object. Within a heterosexual visual economy it is the woman's body that excites the hand and eye. Whether alive or dead, she fascinates men by her capacity to give life and, by unconscious analogy, her power to take life away. Woman is therefore examined in the detail of her difference from men, rather than in her relation to men. Pre-mortem, she can be examined on the couch; post-mortem, she can be dissected on the anatomy slab. In either case, woman is *the* object of male speculation in both senses of the term.

Although repressed within narratives of modernity, sexual difference, nonetheless, lies at the heart of Enlightenment thought. Human knowledge in the eighteenth century quite literally begins to be envisaged differently. It is then that the female body was, for the first time, conceived as a new terrain, a final frontier to carnal knowledge. In the course of that and the following century, through her reproductive capacity, the female body came sharply into focus. She became, in a short space of time, an object of investigation and interrogation. However, in contemporary reproductive technologies, for better or for worse, the female body has disappeared.

The processes of mechanical production at the start of the nineteenth century are intimately tied to questions of human reproduction. Recovering this will necessitate a journey into the body and the 'terra incognita of the subcutaneous' (see Stafford 1991: 8). This is the realm of clinical anatomy; of the butcherly delights of meat, rather than flesh. 'To examine the causes of life' says Victor Frankenstein, 'we must first have recourse to death' (Shelley (1831) 1992: 35). In getting beneath the woman's skin, in stripping flesh from bone, the surgeon–anatomist enters the realm of death in the hope of unearthing the secrets of life. I am curious about this journey into the interior; about how and why a living, breathing subject became, in little more than a hundred years, a thing, an object first dismembered and taken apart; then macerated and finally dissolved.

Photography too is closely linked to death. Photographs are understood in a way that is characteristic of fetishism: we pretend that what is absent is really present, that in holding a photograph in our hands we hold the object to which it refers, while at the same time knowing that it is not that object. The photograph represents the death of the object, forever stilled and trapped. It is a memorial, but also, inevitably, a simplification, a diminution and a containment. Photographs and memorials trade on selective memory; they allow us to forget through an act of remembrance. This makes them, like woman, a special kind of commemorative object that simultaneously preserves and obliterates knowledge in a single stroke.

In studying the work of anatomists on women's reproductive bodies, I have followed the path they themselves laid down for their fellow surgeons. Over a period of some years I have examined many melancholy objects. I have set eyes on (yet not touched or held) many deformed pelvises, each of them resulting in the death of the woman, and often in that of her child too. I have pored over, touched and held the many books of engravings that surgeons presented, frequently at great expense, in large anatomical atlases. These books, heavy in weight, difficult to lift and awkward to turn, hold within their pages images of the female body flayed and opened up to scrutiny. They fascinate and it is not too much to say that they seem to have been made with passion. Most are finely executed; minutely observed. Under the direction of the anatomist, these measured images were carefully produced, first by the hand of the artist and later by that of the reproductive engraver. But they do not fully contain the excitation of nerves and blood, the contradictory pleasures and pains of such close observation.

By the mid-nineteenth century, surgeons and anatomists were employing photography in their exploration of the female body. I have scrutinised these different images too. In some ways, the claims of doctors and the facility of photography were a perfect conjunction; a smooth alignment of needs and aims. Both doctors and photographers claimed to produce objective truth, to represent exactly what had been. Both laid claim to a high level of credible, impartial, truthful knowledge. Of course, their claims to objectivity remained a matter of visual rhetoric within the discourse of realism. Though I have studied many of those books and atlases, I am not their preferred reader. Neither surgeon nor male, I am unlikely to follow the intended paths of interpretation. Instead, I read these images as a woman trying to understand the female body in its historical corporeality, rather than its biological specificity. Here, there can be no question of 'erecting an ontology based on what woman is, in and of herself' (Grosz 1994: 147).

Nevertheless, I too am drawn towards these powerful images. Confronted by a host of pictures in books or anatomical atlases, reproduced with care to persuade the viewers of their objective truth, I too find myself moving away from the lives of actual women and their desperate ends. I am seduced.

This book is not intended to be an 'exposé' of the work of anatomists and how they have historically employed visual media in their search for what they considered to be the truth of women's bodies. My aims are more diverse. I am seeking to unravel a paradox: how is it that, especially in the matter of generation or reproduction, women's bodies have disappeared? Although my inquiry commenced with a focus on the photographic, the array of images that surfaced became legible only within a wider disciplinary framework; the subject required an examination of a much broader visual economy. What I present here is neither disinterested nor impartial. It is motivated.

Chapter 1 begins with some questions of methodology and discusses photography and historiography in relation to feminist theory. I then place photography within a wider geographical context, with regard to the nature of vision and the status of the gendered body, and a longer historical context of print culture. In a narrative that is made by way of bodies, objects and images, I trace the relationship between popular, medical and scientific culture. This chapter aims to set the scene for issues that recur in subsequent chapters and in doing so, discusses the ways in which bodies and machines begin to merge in the period of industrialisation. Looser concepts of generation gave way to organised reproduction that was more easily aligned with industrial work. Since anatomical atlases form the backbone of my argument in the following chapters, in this opening section I discuss the processes of inscription through which female flesh was transformed into paper.

In Chapter 2, I go on to describe the overlap between obscenity, medicine and emerging definitions of pornography in the early nineteenth century, at a moment when the sexual and medical gaze had yet to be separated. The focus of my discussion is a popular medical treatise, John Roberton's *Diseases of the Generative System*. First published in 1811, it passed through numerous editions under the publisher John Stockdale. Stockdale's visual additions moved the book closer to pornography and the work enjoyed considerable success until it came to the attention of parliament in 1830s and became part of debates on the definitions of obscene libel.

Chapter 3 discusses the use of drawing and engraving in the large-scale, highly influential obstetric atlases printed in the mid eighteenth-century: William Smellie's *A Sett of Anatomical Tables* (1754), Charles Jenty's *The demonstrations of a pregnant uterus of a woman at her full term* (1757), and William Hunter's *The Anatomy of the Human Gravid Uterus* (1774). I also include a general work, John Lizar's *A System of Anatomical Plates of the Human Body*, published between 1822 and 1826, which included plates of the gravid uterus. These atlases mark a shift from William Smellie's 'close observation of nature *in action* to William Hunter's depiction of the *still-life* of the gravid uterus' (Stephenson 1909: 6). In this chapter I pay particular attention to the processes of anatomy and engraving.

In the subsequent chapters, I move across time, linking nineteenth-century technologies, radiography and photomicrography, to earlier anatomical techniques. The female body was a latecomer to the anatomical atlas and Chapter 4 examines engravings and radiographs of the female skeleton within the context of medical and popular discourse. Here I discuss the emergence of the female skeleton and pelvis as an object of medical scrutiny in the late eighteenth century in relation to pelvic and early foetal radiography at the end of the nineteenth century.

Chapter 5 looks at the use of stereophotography in producing an obstetric atlas in the early twentieth century. *The Edinburgh Stereoscopic Atlas of Obstetrics* was published between 1907 and 1908. By then stereography had largely fallen into disuse. However, at the very point its popular employment was in decline, it was taken up in medicine as a means of creating a virtual teaching environment. The *Stereoscopic Atlas* employed post-mortem specimens, skeletons and live bodies and exhibited some of the first photographs of live birth. This amalgamation linked it to both the older anatomy atlases and pointed towards the future, and I situate this work within a wider historical context in order to show how it functioned as a bridge between older spectacles, such as display rooms and anatomical museums, and the newer, more abstract visual technologies established in the late nineteenth century.

In the final chapter, I return to the paradox with which I began: how has visual representation been used to take women out of the picture, especially in the matter of generation and reproduction? Here microscopy played a significant role. By the mid-nineteenth century detailed, abstract visual imagery had conjured up a new understanding of what was meant by the concept of 'life'. That understanding, however, had a far longer history; ancient, residual theories of generation were incorporated into what, in the early nineteenth century, was an ascendant technology. The rise of cell theory, improved staining techniques and photography placed microscopy at the centre of a new, modern world. By the end of the century the nucleus was found to be the organising principle of life and this had a profound effect on how women's bodies were understood. Visualisation was absolutely central to the rise of the microbiological sciences and women's bodies were, in theory at least, redundant.

1
Geographies of the female body and the histories of photography: images, atlases and clinics

The politics of visual culture

> Structural qualities, cellular tissues, which form the business of technology and medicine are all much more closely related to the camera than to the atmospheric landscape or the expressive portrait. (Benjamin (1931) 1972: 7)

> The world thereby momentarily loses its depth and threatens to become a glossy skin, a stereoscopic illusion, a rush of filmic images without density. (Jameson 1984: 76–77)

In 1931 Walter Benjamin drew our attention to what an art-historical discourse on photography is unable to see. He emphasised the camera's capacity for dissection: for cutting and extracting; isolating and framing. Photography is forensic in its detail. However, its instrumental precision, its peculiar capacity for anatomisation and dissection is usually ignored in favour of its phantasmagoric qualities and its dream-like aesthetic.

We now have a much sharper sense of the heterogeneous, diverse bodies of material that have until recently remained invisible, buried deep within the archive. The repression of the social and political history of photography in favour of a history of photography as an art or as a dehistoricised celebration of continuing technological progress means that photography's very early and extensive use in microscopy, to take one example implicit in Benjamin's text, has largely been neglected. The internal 'unseen' within the individual body has a complex history which also embraces the unseen within the social body; those who remained beneath the threshold of vision who were, paradoxically, brought into view so that they could be made to disappear into the archive in what was an act of representational liquidation. Representation is no longer a privilege; in the nineteenth century it becomes, as John Tagg suggests, a burden (Tagg 1988). From the moment of photography's invention, such

images have been consigned to archives. There is something mortuary-like about these spaces with their drawers which slide out effortlessly to reveal a darker side to the history of photography. The title of Benjamin's essay, 'A small history of photography' also suggests the need for microhistory, marked by attention to detailed, focused historical study, rather than to sweeping narrative. For Benjamin, such detailed history matters.

Separated by fifty or so years, Jameson suggests that the vertical co-ordinates of time and history have given way to the horizontal plane of space and geography. What brings Benjamin and Jameson close together, what is at stake here, is the vexed question of history and politics in the ages of modernism and post-modernism. While Benjamin examines photography's attention to structural detail and the optical unconscious, Jameson examines the ways in which the material world is dissolved into a single scintillating surface.

I want to begin by tracing a relationship between modernist past and post-modernist present because these two epochs have shaped photographic history and discourse. The present demands a gaze that moves between the two: a view that is simultaneously microscopic and panoramic and a history that takes seriously both synchronic and diachronic registers. These two approaches may be incompatible; they are nevertheless necessary to any understanding of the power of photography. As Benjamin and Jameson make clear, the photograph is both literally a slice through time, a petrified moment, and simultaneously part of a narrative chain; the meanings and effects of a single image are simultaneously contingent and adjacent. Edward Soja puts it succinctly when he suggests that we have to be alert to 'a new animating polemic on the theoretical and political agenda, one which rings with significantly different ways of seeing time and space together, the interplay of history and geography, the "vertical" and the "horizontal" dimensions of being in the world freed from the imposition of inherent categorical privilege' (Soja 1993: 137).

Two questions present themselves. First, how we can begin to bring together recent *theories* of subjectivity, of language and discourse with the somewhat repressed question of *history?* Second, what is the relationship between technology, culture and the increasingly neglected questions of *politics?* For anyone currently working in the field of visual culture the question of the relationship between theory and history is politically urgent. We need much more detailed historical research, while at the same time responding to the anti-reductionist logic of post-modernism to reject 'the imposition of inherent categorical privilege'. This means asking questions about the various ways in which 'art history and visual culture have been narratavised to so as to privilege certain locations and geographies of art over others, often with a stagist and "progressive" history where realism, modernism and post-modernism are thought to supersede one another in a neat and orderly linear succession' (Shohat and Stam 1998: 27). They do not. This is a question of

politics. Any image, every image of the past that, in Benjamin's often quoted words, 'is not recognised by the present as one of its own concerns, threatens to disappear irretrievably' (Benjamin 1973a: 257).

For Benjamin, the technology of photography and film heralds a new age. The surgeon-cameraman rather than the magician-painter is Benjamin's analogy for the radical abolition of the distance between subject and object ushered in by photography. By the 1930s, an art-historical, expressive discourse on photography had already come to dominate a modern mechanical medium. The technology of the camera, thoroughgoing in its permeation of reality, created for the first time a picture that consisted of 'multiple fragments which are assembled under a new law' (Benjamin 1973a: 235–236). Other facets to photographic culture become apparent by simultaneously looking more widely and in greater detail; by accepting that every perspective is partial. In doing so we begin to confront a history of photography which was fractured from the start. There is 'no single panorama, but simply parts of bodies, torn-up or framed pieces, abyssal synecdoches, floating microscopic details, X-rays, sometimes focused, sometimes out of focus, hence blurred' (Plissart and Derrida 1989: 74; Jay 1993: 519). A modern industrial medium, photography is an assembly line that welds together bits and pieces; a system of representation that is made up of what cannot be seen as much as what is shown. It is only more recently that these other archives have come to be recognised as the greater part of photographic history. The images discussed here should be claimed as part of our visual culture. Such an approach stems from a desire to unsettle rather than reconfirm the seemingly fixed boundaries of photography as a discipline.

Indeed, photography has neither identity nor origin. There is no single moment when photography began; no beginnings, no clean breaks, or predetermined outcome. Photography is a fugitive discourse; an impure art of uncertain beginnings. There is no way back, no constants. Moreover, as Foucault puts it 'nothing in man – not even his body – is sufficiently stable to serve as a basis of self-recognition or for understanding other men' (Foucault 1977a: 153). 'The' body is not the new holy grail of visual cultural studies. Foucauldian epistemology explicitly acknowledges 'the corporeal roots of subjectivity and the non-coincidence of the subject with his/her consciousness' (Braidotti 1994: 59). The unconscious demonstrates that subjectivity is embodied and moreover that the roots of subjectivity lie beyond the subject itself, in the body of another, a body of which we were once a part.

The first body of knowledge is the mother's body and, as feminist writers have pointed out, we too readily forget that there is flesh before there are words; an imaginary, pre-symbolic world before the symbolic. Jane Gallop argues that 'the closed world of discourse – "nothing outside words" – is the structuralist version of the modernist doctrine of the autonomy of the work of art. Now it is not just Poetry, not just Art, but all language, discourse that is a

closed world' (Gallop 1988: 19). This closed world of discourse increasingly came under attack as 'the continuation of modernism by other means' (Ross 1988: ix). But the disruptive, troublesome body can never be totally subordinated to discourse; 'will never be totally dominated by man-made meaning' (Gallop: 1988: 19). As Elizabeth Grosz comments 'the most intense moments of pleasure, their force and materiality, while broadly evocable in discourse, are never captured discursively' (Grosz 1994: 147). 'Linguisticality', as Martin Jay puts it, 'does not exhaust being' (Jay 1982: 108).

Post-structuralist feminism in particular has drawn upon and developed the 'radical epistemology' of Foucault's analysis in order to consistently emphasise the relation between epistemology and ontology (Braidotti 1991: 126). This resists the essentialism at the heart of liberal feminist (or any other liberal) politics which attempts to separate what one is from what one does (Grosz 1994: 140–141). Feminism has re-theorised agency, re-thought the relationship between language and the body, discourse and experience, academic theory and political practice.

Within an anti-essentialist feminist politics, ontology can never be separated from epistemology. Feminism has had to think hard about the intricate and necessary relationship of life, thought and experience that cuts across comfortable intellectual categories, and has suggested very different ways of thinking about how knowledge is produced and organised and what knowledge does to the objects it produces; this necessarily includes ourselves. For writers such as Donna Haraway, feminist objectivity is about limited location, 'not about transcendence and the splitting of the subject and object'. It is in this way, she suggests, we might 'become answerable for what we learn how to see' (Haraway 1998: 192). Feminism as both a political practice and theoretical field places the female body at its decentred heart. However, this is not any body but a body that can only be understood in its historical materiality, rather than sexed specificity. The very lines, contours, shapes and substance of our bodies are moulded through, and dispersed across, discourse. Bodies, like meanings, are unwieldy, unstable, and shifting. From the moment you are born, as Braidotti puts it, 'you have lost your origin' (Braidotti 1994: 58). Far from being problematic or of being some irretrievable loss, this is, she suggests, a creative void which gives birth to desire (*ibid.*).

For anyone currently working in the field of visual culture the question of agency, of the relationship between theories, histories and politics is urgent. A political account is one that demands that we '[take] sides on what is a more adequate humanly acceptable knowledge' (Haraway 1989: 7). But the question of what counts as a political account, and what is a more adequate humanly-acceptable knowledge, is more vexed. Taking sides has more often than not meant privileging one side or other of what has become known as 'the semiotic divide'. This became a rigid division of theoretical sophistication versus

(supposedly simple) historical description; attention to the historical text versus social context; imaginative, subjective interpretation versus objective true description (Spiegel 1990: 202; 1992: 59–86). 'Sometimes', as Barbara Duden puts it, 'it seems that two different scholarly traditions restrict themselves to reading the same text on two different levels: history in search of facts; and literary studies in search of metaphors' (Duden 1991: 37).

When we are referred to the past however, it is always by way of an object, a text, an artefact. The past, as it really was, is not recuperable. History is always discursive, already interpreted and reproduced in mediated forms, and representations, no more and no less than 'sendings which never reach their final destination or reunite with the object or idea they represent' (Derrida in Jay 1993: 508). Post-structuralism is not an argument about 'whether or not a material world *really* exists, but only that knowledge of it, and indeed of the human subject, can only ever be constructed through specific discursive practices' (Shildrick 1997: 95). And while we are positioned by discourse, we also, wittingly or not, position ourselves in relation to discourse. Rather than simply taking sides, it is a question of how we situate ourselves in relation to discourse that matters.

In the study that follows I do not take the history of photography to be a history of retrievable photographic objects, any more than it is a history of bodily subjects. Rather I take photography to be a *medium* between subjects and objects, between painting and film, between past and present. Historicists, as Joan Copjec suggests, 'refuse to countenance the apparitions, spectres of the future and past, which necessarily haunt every present' (Copjec 1994: x). Photography, understood as the return of the departed, is a medium haunted by a pre-modern, spectral world that lives on in a post-modern electronic universe. All meanings are of necessity meanings created after the event, and historical events are themselves, like photographs, arrested moments in the flow of history (see Cadava 1997: xx–xxiii). There are simply no essences, no identities without differences, no origins, whether of photography, of history or of ourselves. However there are still discursive histories, and it is these that we might begin to trace through the image (see Batchen 1997).

Reading the image

> We have got the fruit of creation now and need not trouble ourselves with the core. Every conceivable object of Nature and Art will soon scale off its surface for us. Men will hunt all curious, beautiful, grand objects, as they hunt the cattle in South America, for their skins, and leave the carcasses as of little worth. (Holmes 1859: 748)

> The Lust of the eyes may turn into a panoramic-anatomic lust, leading our traveler-spectator into a curiosity for such things as mangled corpses. (Bruno 1992: 240)

Curious, beautiful, grand objects; carcasses, skins and mangled corpses. The lust of the eyes encompasses not only desire but also disgust. This gaze is one that is curious, as promiscuous as it is greedy; an avid gaze that scavenges, wants to see more. But what is abject, what is rejected and expelled, thrown out as alien, is of course part of ourselves; it belongs to us. It is the underbelly of culture, all that is concealed beneath the surface, but which can never be adequately contained; a seething mess out of which culture is momentarily formed and which constantly threatens to erupt or break through the glossy surface spectacle and destroy the cherished illusion of bodily integrity.

Death is what we most fear in ourselves. This is what lies beneath the skin, what threatens to break through and destroy life. It is our own bodies which in the end give up on us; in the end matter triumphs over mind. It is little wonder that we both love and hate the body, and that we project our desire and fear on to others. In the meantime, there are diversionary tactics: we try to contain or at least to limit the progress of death by making more humans; we try to thwart death by making objects. But there is a strict division of labour here between women and men: it is women who produce perishable bodies, while men make lasting cultural artefacts. This divide suggests that images of human reproduction occupy an ambiguous place within Western culture.

Turning flesh into paper, inscribing it, is in part a solution to this ambiguity and in part a sign of profound psychic need. Bruno Latour gives an anti-disciplinary definition of inscription. He describes it as 'all the types of transformations through which an entity becomes materialised into a sign, an archive, a document, a piece of paper, a trace' (Latour 1986, 1999: 306; Newman 1996). Turning flesh into something else is always part of a larger set of ideas than the technology of writing or picturing, and it is always part of a larger economy of signs. In other words, women's bodies, once they have been inscribed or turned into representation, are easier and safer to look at; they are easier and safer to order, move, preserve or destroy, to take out and put away. These 'surface skins' serve the lust of the eyes, even though their carcasses are of little worth.

For Holmes, anatomist and inventor of a stereoscopic viewer, 'every conceivable object' would be transformed into a skin, an image or thin surface film that existed only within an economy of *worth*. The linkage made here is not a matter of convenience but derives its authority from the system of exchange. Skins may be sloughed off from carcasses and therefore become easy to transport and trade, thus generating profit at every moment of exchange. Similarly, the image, the fruit, is preferable to the object, its core; it too is an object of exchange, and a whole industry squeezes profit at every exchange, from initiator to final consumer. In these few lines, Holmes brings together so much that presses directly on woman as image, the fruit rather than core, and the privileging of exchange-value over use-value. In the nineteenth-century the observer

becomes addicted to inspection, to looking closely and in detail, and the promise of pleasure lies at the heart of all kinds of representation that neither began nor ended with photography.

Woman is also one of these curious, beautiful, grand objects hunted as trophy and, as the allegorical representation of nature, already had a long history of 'unveiling' herself before science. In the course of the nineteenth century, as the Romantic imagination gave way to a (supposedly) rational and scientific paradigm, secrets were violently prised from both woman and nature. Nature, according to one Edinburgh professor of anatomy, was to be seized by the throat. Confessions would be wrung from her. The woman's body would become a graveyard, a denigrated, profane site of corporeal excavation.

One of the designated locations for that process was the clinic; not only an industrialised space but also a type of archaeological site scattered with fragments, it witnessed a new 'carving up' of bodies and the formation of new disciplines (Foucault 1976: xviii). Clinical material was described as 'overflowing' and the hospital was a 'technical school in which the medical student must learn his profession'. Patients were visual aids, 'the books out of which the medical student must read' subjugated to the interpretation of the doctor (Galton 1893: 10). Techniques were introduced to ensure that the object was mute and docile. The correlation between speech and spectacle was therefore mediated, not so much through bodies, but through their displacement into the scripto-visual text. Word and image came into a new hierarchical configuration. This marked not merely a fundamental shift but a reversal, a triumph of image over text. Text was subordinate, becoming mere caption and 'to the age of the hearer, in which men heard and heard only, had succeeded the age of the eye' (Osler (1906), cited in Stoeckle and Guillermo 1989: 72). Listening *to*, a reciprocal process of giving and taking meaning, was replaced by looking *at*, in which the object to be known is cut off from the knowing subject.

That reversal of word and image had been set in train in the eighteenth century but it was ruthlessly developed in the course of the following hundred years. A previously dynamic relationship between doctor and patient, where knowledge about the body had been on a more or less equal footing, was replaced by a system which privileged the vision and voice of the doctor; a new hierarchy of the senses emerged which increasingly relied less upon the older system of proximity and sentience. These older ways of listening or smelling were perceived as untrustworthy, as subjective and feminine. Now clinical observation was founded on a distanced, increasingly remote and technologically mediated gaze that became established as quickly as obstetrics and gynaecology. Although the dominant press suggested that the transformation 'from idle and arbitrary custom, to reasoning from real facts and accurate observation' had been 'gradual' (see Stephenson 1909: 6), other

writers such as James Ricci suggest that what had remained 'medical and stationary', became in less than half a century 'surgical and spectacular' (Ricci, cited in Dally 1991: 133).

This was part of a more general transformation. Writing in the early nineteenth century, Humphrey Davy conjured up a vision of the scientist who interrogated nature 'not simply as a scholar, passive and seeking only to understand her operations, but rather as a master, active with his own instruments'. Davy went further: 'not contented with what is found upon the surface of the earth, he has penetrated into her bosom and has even searched the bottom of the ocean, for the purpose of allaying the restlessness of his desires or of extending his powers' (Davy (1820), cited in Easlea 1981: 127). Nature is a mother, an object of sexual as much as intellectual desire: indeed the term nature is derived from *nascitura*, which means birthing (Duden 1993: 104).

In short, knowledge begins to be *envisaged* differently at the beginning of the nineteenth century. It is about power, transcendence and control. Welded together in Davy's remarks is a story that outlines a gendered relationship between science, technology, power and knowledge. Knowledge is commodified. For Davy, 'the man of science and the manufacturer are daily becoming more nearly assimilated to each other' (Davy (1820), cited in Easlea 1981: 127). It is the active verbs that matter here. Knowledge is masterful, powerful and punishing: it interrogates, penetrates, extends, creates. It is not a knowledge born of love, but a defensive knowledge born of fear. It is a means not to comprehend or understand the world but to control its meanings and master its material. It is, in short, a discourse of domination. Produced in the infancy of industrialisation, it is a language that betrays a child-like belief in man's omnipotence.

Latour's concept of inscription might be further developed within the context of gender. He discusses how meaning is formed through a process of constant textual cross-reference. 'Usually', he says, 'but not always, inscriptions are two-dimensional, superimposable and combinable. They are always mobile, that is they allow new translations and articulations while keeping some kinds of relations intact. Hence they are also called "immutable mobiles", a term that focuses on the movement of displacement and the contradictory requirements of the task. When immutable mobiles are cleverly aligned they produce the circulating reference' (Latour 1999: 306–307).

Inscriptions necessarily cut across disciplinary boundaries and time. Latour's definition makes sense of the way in which discourse mutates and simultaneously ensures, as he puts it, that 'some kinds of relations' remain 'intact'. Hence the 'immutable mobile' that accommodates continuity as well as discontinuity. Woman is one such figuration, both immutable and mobile; while the meanings ascribed to woman change over time, a 'clever alignment' of meaning ensures continuity across time and systems of representation.

For example, a comparison of two images made centuries apart might show an 'immutable mobility' over time. Vesalius' anatomical image from *De humani corporis fabrica* (1555) shows that death is never far behind femininity (see Figure 1). In Ivo Saliger's popular image from the 1930s, used as the cover for Jürgen Thorwald's *The Triumph of Surgery* (1960), woman exists in a kind of no man's land somewhere between life-preserving surgeon and death. This is an ambivalent image; it is unclear whether woman will, like the mother, pull man down with her into a nether world, or if he will be able to fend her off and avoid death. It is, in any case, certain that woman exists somewhere between masculinity and death and is more closely aligned with death, while man stands squarely on the side of life (see Figure 2).

Both woman and image are central and absolutely necessary to Western culture, and at the same time marginalised within it. Fetishised within the realm of art and pathologised within the discourses of medicine, the female body lives a double life. Fetishism is always based upon disavowal; socially marginal, woman is, however, symbolically central. Like the inscription, the woman's body is always a trace, a reminder of something else: the mother's body. The image of the castrated woman stands, in Mulvey's deservedly often cited words, as 'linchpin' to an entire social and economic system: patriarchal capitalism (Mulvey 1989: 14). Woman is the pivot, not the only one, but a

1 Vesalius, *De Humani Corporis*, 1555, Frontispiece

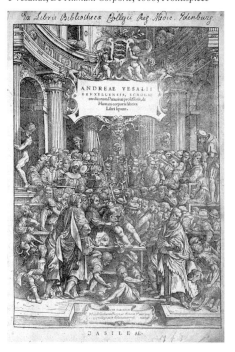

2 Ivo Saliger, *A surgeon holding a naked female patient whilst trying to push away death, represented as a skeleton*, 1930s

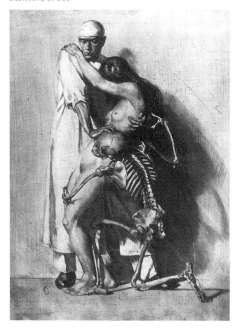

kind of superlative circulating reference, an immutable mobile, around which patriarchy's anxieties and ambitions endlessly revolve.

A culture of overt display, a literal exhibitionism of shimmering surface, is one way of controlling an excessive female body. Its underside is the female body as abject object of scientific scrutiny, a *corps morcelé*, subjected to a repeated, detailed medical examination; a body taken apart so that nothing dangerous inside remains hidden, unseen, unknown. This leads, as Giuliana Bruno suggests, to 'a curiosity for such things as mangled corpses' (Bruno 1992: 240). Indeed, maternal anatomy is so powerfully threatening and destabilising to patriarchal knowledge and culture that the body of the mother must be constantly kept in check, either exhibited or exiled; woman is removed from culture and knowledge and banished to the margins of nature and instinct. By means of this oscillation, she is neither so close as to be threatening, nor so far away as to be dangerously out of sight. Moreover, she can be called upon when needed. The female body has to be seen to be believed.

Within Freudian theories of fetishism, it is sight of the mother's genitals that invoke in the small boy the horror of castration. From the start knowledge is carnal, corporeal. The function of language, of words, is to 'get us back to bodies' (Phillips 1998: 23). But it is never very clear whose body is in question. As Goldenberg puts it, 'our first body of knowledge is a female body' (Goldenberg 1990: 186). For the male, the moment of recognition of anatomical difference, and its simultaneous disavowal, is commemorated in the reassuring fetish. Photographs are characteristic of fetishism and they too return us to bodies; they work metonymically; we know they are only scraps of paper, but all the same we pretend that what is absent is really present, that in having the photograph in our possession, in our very hands, we have the object to which it refers, while simultaneously knowing that we do not. Photographs paper over the cracks and, like all fetishes, our relationship with them verges on the infantile. We press the images close to our bodies in breast pockets, we kiss them, cut them up and rip them into shreds. The photograph represents the death of the object; the image is a memorial, forever stilled, frozen, sealed in a moment that is already past. In art, the horror invoked by the woman's body is covered over with the skin of surface spectacle; with so much to see, photographs which trade on selective memory do in a very real sense make us forget. This makes them, like woman, a special kind of commemorative object, preserving and obliterating knowledge at a single stroke.

Contemporary feminist theories have increasingly shifted their focus away from the fetishised female body to address those images which, for historical reasons as well as by cultural convention, have remained repressed and invisible. This is to encounter a different topography. Compare two images from different registers: one might, in Benjamin's terms, be described as an expressive and atmospheric portrait *Cassiopeia*, made in 1866 by Julia Margaret

Cameron, or, we could say, a severed head (see Figure 3). The other, a headless, anonymous torso, is from *The Edinburgh Stereoscopic Atlas of Obstetrics* (1908–9) (see Figure 4).

In bringing these images together, in disturbing the 'clever alignment', we see a different configuration of femininity. The woman's body appears as both fetish and abject object. Aestheticised beauty taken literally at 'face-value' in the first image and the horror invoked by the abject body in the second are, however, constructed upon the same territory: an unstable, excessive female body. In the first, the fetishised female face of the close-up cuts off any threatening knowledge of what lies below. In the second, the dangerous territory of woman's reproductive body is made frighteningly,

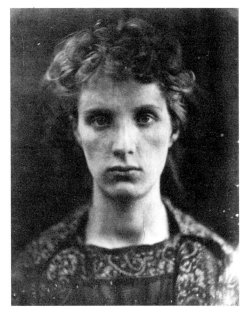

3 Julia Margaret Cameron, *Cassiopeia*, 1866

viscerally visible. The public spectacle of the fetishised body, the fantasy of wholeness, of something seamless, beautifully complete, and its obverse, the private circulation and display of a female body with its frightening fantasy of castration, dismemberment and death, are not separate, but one and the same. The second image is the unconscious price paid for the first. In creating a

4 Plate 62: 'Manual expression of Placenta in a case of delayed third stage (Crédé's method)', *Edinburgh Stereoscopic Atlas of Obstetrics*, 1908–9

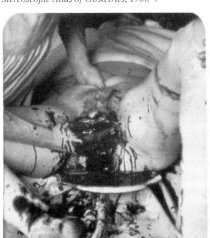

different alignment, in sliding these images horizontally from what are, after all, discursive parallel universes in photography, their meanings shift. It is only by unhinging them from the discourses in which they comfortably fit, and through which their meanings are regulated and contained, that the violence of portraiture with its stock of severed heads, and of bodies tossed aside like so much dead meat, becomes startlingly apparent.

It may be that the power and fascination of pornographic imagery lies in the powerful, extreme conjunction of the aesthetic and the medical. For some, hard-core pornography shows too much, is too gynaecological, too medical, too brutal; for others soft-core is too tame, too aesthetic and not revealing enough. Hard-core, as Linda Williams suggests, 'tries not to play peek-a-boo' with its bodies (Williams: 1990: 49). It shares this in common with anatomy. Here 'science and pornography meet and fuse' (Ballard 1992: 273).

One antecedent for pornography is to be found in the waxen medical 'venuses' of the seventeenth and eighteenth centuries with their tilted heads, parted lips, sensuously curved torsos and legs just slightly akimbo (see Figure 5). These life-size dolls, advertised as Florentine or Parisian Venuses, were exhibited in every major city European city in the late eighteenth and early nineteenth centuries (Anon. 1844). Unlike earlier ivory miniature models which were often dressed, and which adopt a religious pose with hands clasped in prayer and eyes and legs closed, these animated, almost life-like mannequins resemble closely what would become the standardised pose of the pornographic model. These early models suggest a sexualised female body that the observer, presumed male, might penetrate. The dolls, undressed and skinned, revealed at their core the 'truth' of femininity: a womb containing a tiny, removable foetus. But, to return to Holmes' words, once man 'has the fruit of creation he need no longer trouble with the core'. In a mercenary economy, exchange value is extracted at every point. Rosi Braidotti has argued that now 'pornography [is] the dominant structure of representation in scientific as well as in popular discourse'

5 Female anatomical wax figure, *c.* eighteenth century

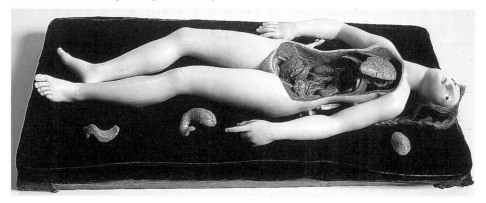

(Braidotti 1994: 73). Indeed, so pervasive is this structure, that feminist inter-
vention in the field of biomedical power will 'require that strong attention be
paid to the politics of visual culture' (*ibid.*). This suggests we need to resist the
widespread belief that 'popular images … can be understood with no spe-
cialised knowledge of production and interpretation, but understanding scien-
tific images requires highly expert training' (Treichler *et al.* 1988: 4).

During the period of industrialisation, the human body is subjected to a
battery of techniques. By the end of the nineteenth century it is flattened,
crushed, macerated, and finally dissolved. Cells, however, live on. By the late
nineteenth century, the nucleus was found to be the organising principle of
life. Photomicrography has had a profound effect on how women's bodies, in
particular, were, and indeed are, understood. Such abstract images now fill
our screens, presenting the viewer with a supposedly unbiased, objective 'pic-
ture' of life, produced at the touch of a button. This hides not only the visual
perversion of scientific imagery but also the vast amount of material labour
involved in creating a single scientific image. It also conceals the fact that sci-
ence is a form of cultural and capitalist knowledge that continues to package
its representations in terms of 'currently fashionable formats and colour
schemes in order to entice readers to appreciate (both scientists, and mem-
bers of other publics) their [scientists'] achievements' (Lynch and Edgerton
1988: 213). We are invited to gaze, allowed to see such things, only so that
we marvel at the wonders of medical technology.

Fyfe stops short of using the term 'commercial advertising', but this is
indeed what it is. In Davy's terms, 'the man of science and the manufacturer'
have now, finally and totally, 'become assimilated to each other' (Davy (1820),
cited in Easlea 1981: 127). We are not encouraged to think about the history
of such images, about how they are made, and even less about what these
images do to both the objects and the viewing subjects they produce. It also
suggests that the boundaries between the vocabularies of popular and scien-
tific visual culture are far from clear. Indeed, they never have been. Scientific
scopophilia, part and parcel of our everyday lives, presents us with a series of
postmodern miracles in which we should have faith. Increasingly, struggles
over meaning will be about how we see what we see. These more abstract
images are, nonetheless, prime sites for the construction of sexual and social
differences. Tracing the erasure of the woman's body, will show how that
process has been accomplished piece by piece.

Geographies and objects: a tale of two cities

> And what determines vision at any given historical moment is not some deep
> structure, economic base, or world view, but rather the functioning of a collec-
> tive assemblage of disparate parts on a single social surface. (Crary 1990: 6)

So narrow are the confines of photography as a discipline that it falls mainly into the dualism of a history of art (with its emphasis of upon connoisseurship, photographic authors and their issue) and a history of technology (with its emphasis upon hardware and the means of production). This double face of photography has been problematic, placing it either on one side or the other of a technological divide, or adopting an unsatisfactory compromise position by suggesting that, in common with earlier forms and painting and drawing, photography shares the still image, while, in common with the camera, it shares the technology of film. Such histories are defined by what they must repress in order to be. The history of photography as an art must repress the technical and industrial determinants of photographs, just as the history of photography as a technology must repress aesthetic and expressive considerations.

Histories, theories, institutions and practices are effectively founded upon this division. But there are other stories to be told. In what follows I want to place photography between two narratives and trace a different trajectory. This journey encompasses two spaces: the public showrooms, cabinets of curiosities and anatomical museums of the eighteenth and early nineteenth centuries where the modern body makes a spectacular appearance, and the hospital clinic into which the body disappears. If we are to understand the claim of photography to be both an art and a science, metaphor and fact, we have to go back to a period in which fact and fiction inhabited the same universe. This is the culture, at once popular and scientific, into which photography emerged and it is here that the boundaries between bodies, machines and images become blurred. I am interested in how, over a short period of time in the nineteenth century, lived experience passed into representation. In order to understand this we need to make a journey from popular to scientific culture by way of bodies, three-dimensional objects and two-dimensional images.

My study is, in effect, a tale of two cities that begins in London. It is shaped by my experience of working in the city centre and walking around the streets that cut between Regent Street and Leicester Square. This area is now a welter of theatres, hospitals, television companies, travel agents, hotels, wax museums, photography galleries, clothes and sex shops, pornographic and mainstream cinemas. Spectacles, images, objects and bodies jostle for space. I became curious about why, since its invention, photography had been exhibited and taught on this particular site, and I began to rummage in the archives.

Edinburgh, by contrast, is a much more discreet city. It is more carefully ordered, and more knowingly optical; one has to know where to look. The pleasures of wandering the streets are fewer and less carnal. History, a little like the old subterranean city buried beneath, lies in the basement presses of its many libraries. This was a different narrative, accessed only through call-slips. Strangely immobilised, I embarked on a different journey. From this dislocated geographical experience emerged an understanding of photography as a

discourse on the body that shares 'epistemological foundations with scientific investigation' (Bruno 1993: 67).

At the same time books such as Jonathan Crary's detailed study of vision, *Techniques of the Observer* (1990), began to displace more instrumental or aesthetic interpretations of technique or imagery into the observer's body. Crary's work is important because he makes clear that vision is corporealised, subjective; that photography is part of wider social, cultural and *bodily* shifts. It is this that disturbs and unsettles clear boundaries, narrow frameworks. The shifts that took place in the nineteenth century entailed not only the reorganisation of the public space but also a reorganisation of the interior space of the observer; they entailed a reorganisation of the spaces and the anatomies of the body and particularly of the female body. It is woman who bears the heavy burden of bodily representation, although, as we shall see, this was not always the case.

This shift of emphasis in writing history implicitly raised the question of the gender, though as Linda Williams notes, Crary's model of the observer is 'strangely neutered' (Williams 1994: 7). However, in Williams' own work and in other books that emerged in the following years, Anne Friedberg's *Window Shopping* (1993), and Lisa Cartwright's *Screening the Body* (1995), the gender of the observing body matters. While these books are very different in their scope, they emphasise that both gender and popular culture are absolutely central to modernity's vision.

As Friedberg makes clear, instead of writing the history of the mechanical image as divided between technology and art, there is much to be said in favour of placing photography within both a longer history, and a more panoramic discussion of the fantastic, spectacular and illusory, as well as the disciplinary. Certainly in the 1980s, in critical rather than art histories, photography's instrumental qualities were emphasised; where the body entered the scene it was as a target of power, not as agent. There was also a certain, understandable, reluctance to acknowledge photography's fantastical pre-history. Photography, it was argued, marked a fundamental break with older modes of experience and viewing. Panoramas, dioramas or magic lanterns, if they were acknowledged, remained 'background', and while these spectacles were understood as illusory, photography generally was not. However, the frequently contrasted elements of art and science, the optical and the chemical, the world of fiction and the world of fact, part of the same universe in the popular mixture of entertainment and education in the eighteenth and early nineteenth centuries, gradually came back into view, as did the gendered observing body.

Photography's emergence in the nineteenth century is located in the phantasmagoric spaces of the temple, gallery, showroom or museum, all words that were interchangeable in the businesses of the period. Those spaces facilitated a gradual disassembly of an older body; the process was one of modernisation

and morcelisation, which necessarily involved the displacement of an older and outmoded model of the subject and the production of a new observer-consumer (Crary 1990: 9). The transition is rapid.

Richard Altick, in his spectacular account *The Shows of London,* documents the area between Leicester Square and Regent Street where this transformation took place. In a chapter entitled 'The waxen and the fleshy' he describes this stretch as not only the prostitutes' beat, but also the location of numerous museums and exhibitions which sprang up in the metropolis between 1770 and 1850 (Altick 1978: 332–349). In these streets along which I wandered every day, the secrets of life and death, and more importantly sex, which brought both in its train, were explored in wax models, tableaux vivants and specimens preserved in spirits. 'Advice' was one of the museums' prime functions and most held 'lectures'. These operated on the edge of what was legal. As Altick suggests, the substance of such lectures was what we would now term sexology; many mixed inanimate exhibits with live shows.

Altick describes in detail models of Adonis and Venus that could be taken apart, displaying foetus, breast, pelvis and viscera. Some places, such as Reimer's Anatomical and Ethnological Museum (for men only) displayed 'the origin of Mankind from smallest particle of vitality to the perfectly formed foetus, Obstetric Operations and Branches of Midwifery alongside the terrible effects of debauchery in the form of Syphilis' (Altick 1978: 340). Madame Caplin's Anatomical and Physiological Museum (for ladies only) also held lectures. The shifting nomenclature is telling. For example, Dr Kahn's Anatomical Showroom, which first appeared in London in 1850, was advertised as coming 'from the continent', a byword for the exotic. By 1862 its name had changed to Dr Kahn's Museum and Gallery of Science and its emphasis on wax works gave way to instruments such as the oxyhydrogen microscope. As late as 1873, doctors whose professional pride was wounded, and no doubt their pecuniary advantage affected, wrote to the *British Medical Journal* complaining that quacks were distributing handbills outside the Museum (Anon. 1873: 718).

By the mid-nineteenth century those older anatomical spaces became the new galleries for photography and, later, filmhouses. Through tracking the history of one building, we can trace in detail the ways in which anatomy, photography and film are bound together. At the end of the eighteenth and the early nineteenth centuries the area directly around Leicester Square was already a well-known centre for indecent print shops. It was in Castle Street, just off Leicester Square, that Robert Barker had first shown his panorama in 1792. Opposite Barker, at 28 Leicester Square, lived the anatomist John Hunter. After Hunter's death, a number of temporary shows took place on the site of his museum and in 1852, the Royal Panopticon of Arts and Science was erected. The Panopticon housed a photographic studio on its roof and visitors

were transported to it by lift. By 1858 it had become the Alhambra Palace and in 1862 it was retitled the Alhambra Palace and Music Hall (see Altick 1978: 491). The building burned down in 1882 and it is on this site that the Odeon Cinema, Leicester Square, now stands (Gray undated: n.p.).

A glance at directories of the period shows that many photographic studios were simply added to these older cabinets and anatomical displays. In the early days of photography's development, these ran alongside the studio business, encouraging the development of an ideal of mechanised, objective seeing that sought to separate the eye from other senses and remove (or downplay) the body of the viewer by ostensibly establishing a viewing based upon mastery and control. In reality, photography betrayed the ways in which body and machine converged in the image.

Through such optical devices, objects that had previously been remote came within the grasp of the observer, reconfiguring the relationship between time and space. But by seeming to bring closer what was far away, photography disguised the ways in which it came between things, separating and pulverising knowledge and creating social distance. Photography encouraged observers to believe that what they viewed were portions of nature; what they were actually presented with were fragments of a culture that had been decimated. This may not have been apparent, particularly to early viewers, because photographs were neither quite physical objects, nor images in any conventional sense; they were, for a time, unstable objects.

Photography was a medium poised on the very threshold of artificial life, in which distinctions between real and fake, natural and manufactured began to break down. By the end of the nineteenth century, viewing had become a privatised activity of consumption. The diorama, the anatomical museum, and eventually photography, stereoscopy and film, enabled the viewer to 'witness' something potentially overwhelming, such as a frightening or erotic event without the accompanying danger, but with an excitement that could be repeated over and over again. Fear and wonder, which were previously accessible only to direct experience, were conjured up as if by magic. What had become intolerable and uncontrollable in the real world was rendered bearable in the spectacle. What was no longer bearable in the spectacle became immortalised in the photograph, until everything, so it seemed, had passed into the realm of representation.

There was, however, no transition from the older mysterious and magical world to a new rational and scientific age. These are, rather, overlapping and intersecting histories, which, as I aim to show, are made up of bits of bodies, dolls, bones, flesh, photographs and prints, drawings and paintings that were once closely interwoven. If these bonds have become loosened, then it is because historians have largely taken photography very much on its own late nineteenth-century positivist terms.

The nineteenth century was a much less ordered place; a world whose 'inhabitants can still remember what it was like to live, materially and spiritually, in worlds that were not modern at all' (Berman 1983: 17). It is this historical memory that modernity sweeps away. In *Natural Magic* (1834), David Brewster recalled Philipstal's Phantasmagoria in Edinburgh in 1802 with its 'thunder and lightening, ghosts and skeletons that changed places with the living' (Brewster 1834: 81–82). This archaic, disappearing world lived on in displays, shows, museums, exhibitions and in new visual technologies of photography and film. *Natural Magic* was one of a number of polemical treatises appearing in the early part of the nineteenth century – many written by medical practitioners – which aimed to demystify and lay bare optical and auditory tricks (Castle 1988: 54). The important point made in Brewster's book, however, is that the eye, far from being the organ of truth and knowledge is 'the most *fertile* source of mental illusion' (Brewster 1834: 157). Here illusions are not unveiled; they breed. The world Brewster describes is a fantastical world of magic lanterns, phantasmagoria, of spectacles, shows, cabinets, curiosities and public displays.

When the first edition of *The Photographic News* was published in 1858, that world was still alive. In its introductory address, the magazine attempts to displace magic with science, but its language and use of the metaphor of the magician's wand is, of course, as telling as the urgency of its drive for the Enlightenment's 'artificial life'. Gender is important here:

> The pagan nations of antiquity worshipped the sun, whose genial warmth impregnated nature, and clothed the hills with verdure, flowers, and fruit; but we have learned a wiser lesson; we have scientifically utilised the object of pagan worship and made his golden rays subservient to the purposes of an artificial life. ... Those wonderful agents steam and electricity, readily obey the wand of the modern magician and effect an immediate realisation of human desires; but no discovery can compare with this (photography), the last and greatest acquisition that the bold hand of science has snatched from the secrets of nature. And yet new mines of undiscovered wealth invite the enterprising disciples of this, as every other science. The exhaustless stores of nature are unfolded to us only as pressing wants urge on adventurous spirits to ransack her boundless resources. (Anon. 1858b: 1)

Here the artificial is placed above the natural, masculinity above femininity. From its conception, photography is a gendered technology. Indeed, photography's lowly status within art, and its prestigious place within science, is precisely attributable to its feminisation, as a mechanical doing without knowing at the service of man (Stafford 1994: 215). Through mechanisation, knowing and doing, intellectual and manual labour are separated. In a discourse that privileged class and gender, photography's place was that of a species of trusted upper-servant.

Brewster's desire may have been, in Crary's words, 'the democratisation and mass dissemination of techniques of illusion' but the result was to 'simply collapse the older model of power on to a single human subject, transforming each observer into simultaneously the magician and the deceived' (Crary 1990: 133). The strategy of rationalisation and demystification was to become a route that led not to the vanquishing of an illusionary image, but to its relocation and survival; now the image was not public and outside the subject, but private and within the subject's imagination. This is the realm of the optical unconscious and of fantasy, the spectre that was to haunt the scientific imagination of the nineteenth century. There was, and is, 'no great divide, only small, unexpected and practical sets of skills to produce images and to read and write about them' (Latour 1986: 4).

Histories and images

In this book I pay particular attention to the work involved in both the production and the consumption of pictures. More than any other media, photography, film and electronically generated images construct a smooth, seamless rhetoric of reality. However, this is the outcome of a lengthy process that is, in reality, achieved through material labour that is rendered invisible in the modern image. Photography is a detailing technique in its literal sense; it cuts up and cuts out, constantly re-framing its object. Both the matter of images – their materiality, their complex crafting and assembling – and their reading are important.

There remains, however, a certain theoretical disdain for the material aspects of prints and photographs, as if this is beneath the threshold of academic vision. In one sense Jonathan Crary is right in claiming that a history of vision depends on far more than an account of shifts in representational practice but, as Latour suggests, these are not immaterial (Crary 1990: 5; Latour 1986: 3). Attention to the craft of imaging reinstates the power of the object. It is not simply a question of the relation of the observing subject to her or his object (a position that reassuringly enables the observer to master or control the power of the object). It is also important to acknowledge the object makes demands upon, has considerable power over, the subject. This two-way traffic often remains unarticulated in otherwise political discussions.

In this sense any depiction is 'never just an illustration. It is the material representation, the apparently stabilised product of a process of work. And it is the site for the construction and depiction of social difference' (Fyfe and Law 1988: 1). It is also the site of construction of sexual difference. This is the product of work on both sides of the camera. It is we who do the constructing, take meaning from and give meaning to any depiction or inscription; we too are the apparently stabilised products of a process of work, the inherently unstable ground on which vision materialises.

Images are places of hard graft, of both material and emotional labour, where meanings, human identities and, more importantly, human differences are not merely illustrated or depicted but constructed. Any representation is always an intervention, an investment in meaning. It is the place where we both reinforce and contest what we make of ourselves, others and the world in which we live. As Ian Hacking puts it, 'we represent in order to intervene, and we intervene in the light of representation' (Hacking 1983: 31). In this sense we need to understand not just how we are positioned by discourse but how we might position ourselves *in order to intervene*. For Hacking, the final arbiter in philosophy is not how we think but what we do (*ibid.*). Representing cannot be separated from intervening; how we see the world affects what we do in it.

This means going into the image, rather than standing back from it. Hacking purposely chooses active verbs in order to suggest engagement with an object; whether one is conscious of it or not is irrelevant. The notion of agency invoked by intervening is useful in order to bridge the gap between the labour of production and consumption. Moreover, Hacking's concept of intervening might usefully be read alongside Latour's idea of inscribing. Inscription stresses the way in which the image-as-inscription cuts into the body marking it indelibly (Latour 1999: 306). To inscribe carries with it a certain material weight not dissimilar to engrave or carve. It is this materiality that is often lost in the shimmering surface of modern images.

A common techno-teleological argument is that during the nineteenth century printing processes became cheaper and that with the invention of lithography especially, greater print runs and increased reproduction could be achieved. Consequently, an increasing number of illustrated books were published. Inventions, however, are always social. It was the demand for a universal language, stimulated by the ideas of the Enlightenment, that simultaneously produced both new observers and new objects of study. Visualisation was absolutely central to the project of modernity, allowing commerce in knowledge across linguistic frontiers (Eisenstein 1979: 468–469). Prints were an essential part of this. By the eighteenth century, engraving was perceived as the universal language; it attained this status because it ensured permanent, good quality, consistent representations in larger numbers, thus making increased circulation possible. The quality of universality is most usually ascribed to photography. However, photography merely heralds a transformation in the scale of production. Moreover, the invention of photography was, in itself, an insufficient solution to the problem of circulation, since its transfer depended upon other modes of printing, such as engraving or lithography.

In any case, 'the circulation and reception of all visual imagery is so closely interrelated by the middle of the century that any single medium or form of visual representation no longer has a significant autonomous identity'

(Crary 1990: 23). By 1859 there were over one hundred and fifty different image reproduction techniques, of which photography was only one (Fyfe 1988: 91). Situated at the axis of chemistry and optics, photography's power had more to do with a new level of 'optical consistency' than with objective truth (see Latour 1986: 8). Photography also marked a new level of technological convergence; in conjunction with other instruments and techniques, it could be harnessed to a wide range of representational tasks, thus achieving both a new level of market saturation and far greater mobilisation.

The power of photography was, from the start, dependent on mass circulation. Indeed, even in 1886, when the *British Medical Journal* reviewed the considerable progress photography was making in relation to medicine, citing isochromatic film and better lenses, it ended by stating, 'these important technical refinements are doubtless very good, but when the specimens are taken, there yet remains the question of engraving. Some process of chemical engraving that will print with type without hand-touch, and will represent the specimen as truthfully as possible, has yet to be discovered. Hitherto, photographic engraving has not proved satisfactory' (Anon. 1886: 163). Realism and wider mobilisation through convergence of word and image were what was needed. However, this had nothing to do with truthfulness, and everything to do with 'optical consistency' (Latour 1986: 8).

Optical and chemical improvements in themselves are insufficient in explaining the rapid adoption of photography by various agencies. The critical issue is not photographic technology but the mobilisation of photography. As Latour puts it, the print is simply the *'fine-edge* and *final stage*, of a whole process of mobilisation that modifies the scale of the rhetoric' (Latour 1986: 17). This emphasises the way in which two-dimensional images form sedimentary layers, producing a kind of conceptual coherency. Photography did not simply supplant or supersede older forms of print; it was dependent upon and developed from techniques of printing. Neither photography nor photographers sprang forth fully formed in 1839.

It is not incidental that the first photographic processes failed to unite plate with paper. Daguerreotypy depended on the multiplication of small metal plates, little pieces of silver-coated copper, not much larger than nineteenth-century coinage or jewellery. Daguerreotypes resembled small books. They are an odd condensation of money, jewels and information, and as such represent powerful fetishes. Henry Fox Talbot's calotypy had advantages because it was closer to a mass reproducible system, and relied on paper for both its negatives and prints. It was lighter, faster, more productive and more easily moved around. However it lacked the sharp detail, the realism, that epitomised the daguerreotype.

These twin components, the plate and paper of older printing techniques were at first separate elements in the photographic process of production.

While photographs were pasted into periodicals and books with printed text, it is only with gravure that photography emerges as a system of mass visual communication and finds its proper place in books (see Armstrong 1998: 3; Ollerenshaw 1961: 7). Revealingly, Fox Talbot wrote in 1843 that photographs seemed 'to have the same fixity as a printed page' (Fox Talbot (1843), cited in Schaaf 1989). This was more projection than reality and suggested a faith in the photograph both as a permanent record and as a new way of combining image and type. Even in the 1880s, as the *British Medical Journal* makes clear, these had yet to be united on the same page. Until then, photographs were hybrids that combined a new level of optical realism with the older, and by then untrustworthy, hand-crafted techniques.

Between Niépce's unstable invention of the heliogravure in 1826 and Fox Talbot's 'photoglyphic' processes, patented in 1852 and 1858, lie a number of attempts to mass reproduce images photomechanically. Fox Talbot's technique was only revived and improved in 1879, and it took somewhat longer to transform the production process. This makes explicit photography's convergence with both engraving and lithography. Mechanically, photography is a surface process that appears to have depth and therefore might be described as lying between those two printing processes. Indeed, Fox Talbot's images in *The Pencil of Nature* (1844–46), the first photographic book, were mistaken for both, as the *Art Union* revealed by stating that, 'we know not what manner of engraving this could be mistaken for' (Anon. (1845), cited in Schaaf 1989: 28). Fox Talbot's mother blamed the confusion on his choice of term, namely 'plates'. She suggested that, had he used 'representations', the misunderstanding would not have arisen: 'many are possessed with the notion that though the original one was done by you & the sun, the others are copied by lithography' (Elisabeth Fox Talbot (1841), cited in Schaaf 1989: 28) Representation suggests a substitute that need not pass through the hands; an image that is not dependent on a middle-man between original image and final print. This is an economic model of production that multiplies goods while reducing labour costs.

Lithography, originally patented as polyautography in 1801, signaled a decline in the tangibility of the wood-block or engraved images printed up to the end of the eighteenth century. Until then, relief or intaglio, a depth model of image production, dominated printing processes. When Alois Senefelder published his history of the medium, *The Invention of Lithography* (1818), he foregrounded the industrial and commercial aspects of the invention: 'so I came to find I could print without a stone, from paper alone; and this process depending solely on chemical action, was totally, fundamentally different from other processes of printing' (Senefelder 1911: 25). With references to 'Lithographic stereotypes', and 'the chemical print', Senefelder emphasised the commercial advantages of lithography: 'two men can make two thousand

impressions of the size of a sheet of letter-paper daily even though the picture may contain a hundred or more colours' (Senefelder 1911: 89). The process required far less craftwork and the images produced 'by only average artists and printers, [are] usually more beautiful than if they had been done by the same men in copper or zinc' (Senefelder 1911: 100). Lithography was a process of de-skilling. It overvalued the sketch or outline, the bare bones of the fleeting image, which came to characterise the modern periodical press and circulating libraries.

Lithography was both a social response and a stimulus to the demand for cheap, mass-produced images that could be changed rapidly. It provided greater print runs, cheaper labour costs and faster turnover. As Benjamin notes, with lithography 'the technique of reproduction essentially reached a new stage. This much more direct process was distinguished by the tracing of the design on stone, rather than its incision on a block of wood or its etching on a copper plate and permitted graphic art for the first time to put its products on the market, not only in large numbers as hitherto, but also in daily changing forms' (Benjamin 1973a: 221).

Fox Talbot's original broadside for *The Pencil of Nature*, which was not dissimilar to the specimen copies produced by Senefelder at the start of the nineteenth century, declared that 'it used to be said that there is no Royal Road to learning of any kind. However true this may be in other matters, the present work unquestionably demonstrates the existence of a *royal road to drawing* presenting little or no difficulty. Ere long it will be in all probability frequented by numbers, who without ever having made a pencil-sketch in their lives, will find themselves enabled to enter the field of competition with Artists of reputation, and perhaps not unfrequently to excel them in the truth and fidelity of their delineations, and even in their pictorial effect; since the photographic process when well executed gives effects of light and shade which have been compared to Rembrandt himself' (Fox Talbot (1844), cited in Schaaf 1989: 22).

Photography took from engraving connotations of lasting incisive truth, rendered clearly in black and white, and combined it with the atmospheric quality of the lithographic image. In the early years of photographic development, techniques for combining photography and lithography were developed. For example, Lerebours, in the *Treatise on Photography* (1843) comments on 'the problem of multiplying the beautiful productions of M. Daguerre'. This, he suggests, might be solved by a lithographic artist [Mr Endicott] who has 'made copies of the surface of Daguerreotypes by means of gelatine' (Lerebours 1843: 199–201). Surface was all that mattered; copies would be made by peeling off thin layers, and this would require little knowledge, skill or time.

The trick of photography was simultaneously to inscribe and to fix an image on a surface effortlessly and without any contact with the referent

whatsoever, and eventually to multiply infinitely the number of copies. Here photography also superseded lithography. The 'number of copies which can be taken from a single original photographic picture appears to be almost unlimited' (Fox Talbot 1845). However, mimetic contact remains important in photography precisely because limitless industrial quantity and the auric quality of fine art could be cleverly combined.

Daguerreotypy and calotypy demanded, in their different ways, contact with the object and with older printing techniques of paper and plate. Daguerreotypy demanded polishing, cleaning and careful preparation of the copper plate in order to make an image appear on its silvered surface. It demanded that the object appeared before the camera, while calotypy only required the negative pressed on the paper to produce a positive. Both systems maintained contact, and retained the trace not only of an object but also of a subject who once stood where we now stand. It is that contact which connects the viewer as subject to the object of observation. The contact is rekindled in viewing the image. The thread of connection through mimetic contact, through a closeness to the object, is a particular type of fetishism. The method of printing from an original negative (even if not made by the photographer) is maintained in the photographic fine art print. The resulting print is a trace of the photographer, the author who once touched it. Thus the fine art print forms a direct connection between producer and consumer, especially if he or she can touch or hold the image, or be close to it.

Photography therefore heralds a decline in, but not the end of, auric power. It is in fact a means of ensuring its survival in a mass-manufactured, industrial world. As the distance between subject and object is gradually, but irrevocably, increased, paradoxically the photographic print ensures that contact is maintained among a rapidly expanding and increasingly isolated population. The transformation from manuscript to print, from hand to press, keeps mimetic contact alive, and this power, that of the facsimile, is then extended through photography. By the nineteenth century 'matter in large masses', as Holmes put it, 'must always be fixed and dear; form is cheap and transportable' (Holmes 1859: 748). With the invention of photography matter could be made to dissolve into smooth form. But it did so only gradually, unevenly and never entirely.

Politics and sex: visualisation, generation and reproduction

It was in the eighteenth and nineteenth centuries that, for the first time, surgeons published anatomical atlases that provided a fascinating topographical and panoramic guide to the emotive geographical anatomy of the pregnant body. These atlases produced increasingly detailed pictures, discovering new territories, redrawing boundaries and expanding frontiers.

From the eighteenth century onwards, going into the body meant going into the image first.

Early anatomical atlases were tentative attempts, literally stabs, at imagining what lay within the body. At first roughly hewn and then more carefully cut, the body is eventually minutely dissected; finely sliced. The anatomical atlas succeeded in dissolving human flesh and bone into a legible, two-dimensional, transportable field. The body was presented in lines, volumes and surfaces in accordance with the rules of perspective, and the female body was made visible in a series of plans, elevations and sections. Indeed, the craft of anatomist and artist lay in rendering the interior of the body legible, so that a chaotic mass of adherences and indistinct boundaries became comprehensible. The skills of drawing and dissecting were closely tied together. John Farre, for example, in his *Apology for British Anatomy* (1827), proposed an Academy of Minute Anatomy, claiming that 'an accurate sketch is a permanent Memorandum'. He further stated his intention 'that every student of the Academy, over whom he [Farre] may have some control or influence, shall both Dissect and Sketch' (Farre 1827: Advertisement). Cutting and looking, hand and eye were tightly bonded. Anatomy confirmed the primacy of sight as the location for the legitimisation of knowledge (Braidotti 1994: 71). The atlas prepared the anatomist, just as the anatomical specimen itself was prepared and, indeed, medical students still employ anatomy colouring books to enable them as it were, to go over the ground. 'The atlas renders the body transparent; it is a means of making the body *legible* to an observing eye' (Armstrong 1983: 1). It also enabled women's bodies to be objectified and safely distanced.

This approach had its origins in the thought and practice of the eighteenth-century Enlightenment, and it sought to make visible distinct organs and underlying causes of disease. As David Armstrong's Foucauldian approach suggests, it is less a question of how something 'so obvious today had remained hidden for so long, but how the body had become so evident in the first place' (Armstrong 1983: xi). The anatomical atlas created new objects of study and formed new realities; it was a radical reconfiguration of knowledge that disturbed any idea of first- and second-order discourse, of a real that precedes its representation. As Armstrong states, 'In effect what the student sees is not the atlas as a representation of the body but the body as a representation of the atlas' (Armstrong 1983: 2). In this radical reversal, the anatomical atlas actively *produced* a new body. In order to see anything at all, the anatomist needs to know what he is looking for and the atlas told the anatomist-traveller where to go and what to look for. It saved time by pointing out the principal sites in advance and describing the best vantage points from which they might be viewed. As Latour puts it in a more general context, 'Scientists start seeing something once they stop looking at nature and look exclusively and obsessively at prints and flat inscriptions. In the

debates around perception, what is always forgotten is this simple drift from watching confusing three-dimensional objects, to inspecting two-dimensional images which have been *made less confusing*' (Latour 1986: 16). The anatomist-explorer studies the map first.

The modern anatomical atlas was therefore conceived as a means of transition from ignorance to medical knowledge, teaching those who did not know and had not yet seen the clinical picture (see Foucault 1973: 115). Woman's bodies, especially, had lain beneath the threshold of vision. Mysterious, opaque and undefined, the origins of life lay hidden within them. In the eighteenth century, that mystery begins to became tangible. Eventually, by way of pathological anatomy, the gaze shifts from visible signs to hidden roots and by the end of the nineteenth century, 'the *unseen* became "the real", whereas the "*seen*" became merely the surface', a screen, or veil, to a deeper knowledge (Gilman 1989: 231, my emphasis).

Within this nexus woman becomes spectacular. In the realm of anatomical pathology, scientific curiosity could be satisfied through dissection, a procedure which enabled surgeons to take 'clinical pleasure in the precision with which the process of reducing the living, moving, vivid object to the dead status of thing is accomplished' (Carter 1979: 138). Thus atlases were crucial tools in understanding women's bodies, and furthering ideas about where the secret of life lay. The atlas stood between knowledge and ignorance just as the woman's body stood as a frontier between men and chaos, and between life and death. However, the threshold or frontier is always an uncertain place, and in representing it the medical atlas was no different from any other map: it was a rendition that had to be drawn and read in an imaginative fashion. Maps and women's bodies together both harboured and advanced fantasies and projections for future invasion.

The attempt to uncover women's bodies has a lengthy history, but it was a project undertaken with some urgency in the era of industrialisation. Anatomists only began to view woman in the course of the eighteenth century and, in the process, a distinct division between woman and her foetus was drawn. In the infancy of industrialisation the womb was figured as a machine that could be made more efficient. In order to discover how that might be achieved, the woman's body was set aside (and upstaged) by obstetric 'dolls' or 'phantoms'. While older waxen figures held at their centre the 'truth' of femininity, a womb containing a tiny, removable foetus, they remained complete bodies (see Figure 5). Life-size obstetric dolls employed in the seventeenth and eighteenth centuries to train growing numbers of midwives did not; made of wood, cloth and leather they are limbless, decapitated torsos (see Chapter 3, Figure 14).

Such truncated dolls made it easier to envisage the foetus as at the centre of a corporeal universe, and as separate and distinct from the mother, who

was already dismembered. Further refinements in the practice and ideas of anatomy were however necessary before eighteenth-century notions about separating woman from foetus were fully realised. In the eighteenth century there was neither a word for, nor a concept for what we call sexuality (see Duden 1991: 205 n. 100). There existed only 'the flesh' and 'generation'. By the mid-nineteenth century, there was a new division of labour that broke generation in two, divorcing sex from reproduction. The processes of generation and fertility, lay practices which had been controlled by women, were replaced by the processes of reproduction and sexuality, which could be regulated by the State. In the nineteenth century, as Barbara Duden points out, birth was reduced to a bodily mechanism. What had formerly been a 'passage', a threshold experience with analogies between birth and death, became a productive process (Duden 1991: 17). By the end of the nineteenth century, man-made machines powered by steam and electricity were spectacular generators poised to take on a life of their own. The discourses of sexuality and reproduction were fully formed, and the labour of birthing was now reconceived as an engineering problem, and therefore as a means of production that could, at least in part, be mechanised. The female body was no longer thought of in looser terms of generation but as *reproductive*; and there emerged class and racial narratives of over- and under-production.

This was the outcome of the accumulation of rational knowledge. In the eighteenth century, Jean-Louis Baudelocque measured thousands of pelvises in order to establish the optimum skeletal frame to contain the foetus: the 'well-formed pelvis' (Speert 1973: 213). The womb came to be evaluated in terms of its efficiency and labour was split into stages. Delivering a woman became the birth of a child, the final stage in a manufacturing process that marked the moment when a human product entered the marketplace. As Duden suggests, this created a new kind of corporeality (see Duden 1991: 17).

Recasting birth in terms of manufacture meant regarding it as a production process, and that process needed a specialised location. During the nineteenth century the new anatomical space of the clinic becomes a factory, and bodies became carnal commodities. What had once been waste – nothing more than corpses and carcasses – were transformed into valuable articles of trade that were sold whole or piecemeal (see Richardson 1987: 52). The woman's body, especially if she died *enceinte*, was a particularly valuable commodity.

If the woman's body comes into view, and her ability to reproduce comes under intense scrutiny, it is in part the outcome of social and economic shifts whereby the means of human reproduction became central to the nation's wealth. Prior to the mid-eighteenth century, the processes of generation were marginal to the nation's economy. But that changed rapidly over a short period of time. By the end of the nineteenth century, human 'generation' is finally

eclipsed by 'reproduction'. The processes of manufacture demanded the supply of 'hands', which could be turned to anything. Inanimate machines multiplied goods, much as fleshy machines multiplied human bodies. The drive was to produce machines that were more like bodies, and bodies that were more like machines. Machines become more animated and versatile; bodies become immobilised and reproductive labour becomes rigidly organised.

If we are to understand how the female body was taken apart, and how the pelvis and womb and eventually the foetus, emerged as discrete objects, then we must turn to the eighteenth century and the rise of obstetrics and gynaecology. The correlation of foetus and product was not made in the eighteenth century, but with the emergence of obstetrics the link was established. In Britain, Edinburgh had established the first professorship in *midwifery*, not obstetrics, in 1726 (Moscucci 1990: 51). There is, however, no evidence that any formal lectures were delivered on the subject until 1756 (*ibid*.). Those lectures were supplemented by illustrations from books, wax models and wet anatomical preparations. In the 1750s, the word 'obstetrix' meant a woman who received the child at birth, a midwife, but by 1817 it had come to define a branch of medicine and Obstetric Societies were established in the late 1830s.

The growth of industrialisation saw the advent of the man-midwife or accoucheur; since these men were usually surgeons, the term surgeon-accoucheur was also employed. Man-midwives were medical outcasts in the eighteenth and early nineteenth centuries. The Royal College of Physicians had excluded practitioners of midwifery from fellowship, and the Royal College of Surgeons prevented them from sitting on the council board. The man-midwife occupied a problematic sexual space. He might, for example, be regarded as effeminate or licentious. John Blunt (the pseudonym of W. S. Fores) imagined a complex sexual space in his cartoon of a cross-dressing man-mid-wife, *Man-Mid-Wifery Dissected* (see Figure 6). This broadside was made to advertise his book *Man-Midwifery Dissected or the Obstetric Family Instructor for the Use of Married Couples and Single Adults of both Sexes*. The actual cross-dressing in the scene may well have been an allusion to the accoucheur William Smellie's suggestion that men-midwives should at least take on the outward appearance of the female midwife (he suggested wearing a loose fitting wash-gown) when attending women. The image suggests a predatory wolf in sheep's clothing, combining effeminacy with licentiousness.

If *A Man-Mid-Wife* is folded vertically, the viewer sees only one of two opposed worlds. The half which is female appears in a domestic setting by a fire upon which water boils. S[he] merely holds a small cup. The male half appears in an apothecary's shop, armed with a lever in place of a riding crop. A mortar and pestle sits in the foreground, while on the shelves behind, labelled 'for my own use', sit perfumes, lavender water and cream of violets alongside cantharides, a popular sexual stimulant. The tools of the trade hang

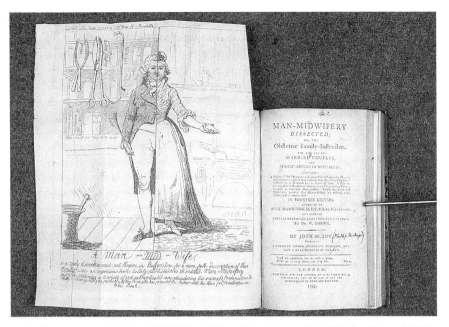

6 John Blunt (S. W. Fores), *A Man-Mid-Wife*, Broadside and Frontispiece to *Man-Midwifery Dissected*, 1793

menacingly above: scissors, hooks, forceps. A mortar and pestle stand in the foreground. The stark division in Blunt's cartoon made all too obvious the ways in which fertility and midwifery had passed out of the hands of women into the artificial hands of 'iron and steel' wielded by men (Nihell 1760: 36). Blunt's text is ironic: 'Sir, boys must be more expert and safe than women who have delivered hundreds, and perhaps thousands safely, because *they* are *only* women after all' (Blunt 1793: 87). For Blunt 'surgeons are very improper persons to attend labours, being too familiar with instruments and insensible to human pain' (Blunt 1793: 167). The cartoon describes the man-midwife as a monster.

But this is not the only reason why surgeons are 'improper persons'. In his text Blunt includes numerous examples of debauchery: 'You may have heard, that one of the London pupils was caught in bed with his patient the day before her delivery' (Blunt 1793: 87). There was considerable anxiety in the late eighteenth century that man-midwifery was merely an excuse for sexual licence. In *Against the Employment of Men in the Practices of Midwifery*, an undated treatise by Anthony Carlisle (1768–1840), the author fulminates against the evil which had ensued from men attending women: 'Although the privileges of these men are not very frequently (as I suppose) quite equal to those enjoyed by their husbands, they are fully compensated for the defect in quality of their gratifications, by the number of them. The husband, in some

instances, confines himself to his wife, while the doctors repeat their pleasures with hundreds or thousands of women in the course of a year' (Carlisle: undated, *c*. 1835). The man-midwife might well be a rake, but such licentious behaviour was not confined to men. One writer mentioned the problem of active female sexuality: it was reported that ladies of rank were writing 'billets to their surgeons requesting them to bring their speculum' (see Ricci 1949: 300). Since women of a certain class were property that had to be protected, unchecked female promiscuity had to be curbed.

Given that these prejudices affected new branches of practice, the founding of the Obstetric Societies in the 1830s was no easy matter. It was, however, also necessary for both professional and pecuniary advancement. One contemporary writer was quite clear that 'the object of the society was to place the practice of obstetrics on a more respectable footing than it had hitherto enjoyed' (Ramsbotham 1867: 1). The development of obstetrics as a reputable profession for men was not straightforward. The transformation from lay female practice to male medical profession depended not only upon prising the practice of midwifery from the hands of women, but also upon pathologising the female body. This connected obstetrics to gynaecology. The 'source' of woman's pathology was located in her capacity for creating life. Once that connection had been made and turned into practice, women and their diseases were no longer marginal but were perceived to threaten masculinity and men's health. The woman's body provided a common ground over which physicians and surgeons, divided professions in the eighteenth and early nineteenth centuries, could meet.

The term gynaecology comes into play sometime between 1820 and 1850; it signified the pathology of all women's bodies, not just the pregnant female body. Gynaecology quickly came to mean gynaecopathology, and this meaning has stayed with it to the present day. By 1847, gynaecology appears in dictionaries and is attributed to John Craig. However, as Cooter points out, Michael Ryan employed it a decade earlier, in 1837. In this earlier text it was accompanied by paedology and andrology as only 'one of the most important and positive in medicine' (Cooter 1991: 170). This suggests that by the late 1840s, as the profession became established, these earlier connections were lost. Subsequently obstetrics and gynaecology were, as indeed they remain, entwined and the twin, newly defined disciplines carved up the woman's body between them. The womb understood as the source of all women's diseases, was an inherently dangerous space. The conception of the womb as pathological and therefore diseased made it easier to separate the foetus from the mother.

The process of filleting foetus from mother intensifies during the course of the nineteenth century and in our own century the divorce between mother and foetus has become absolute. What has disappeared in that process of

separation is the body of the mother. The maternal space 'has, in effect, disappeared and what has emerged in its place is an environment that the fetus alone occupies' (Stabile 1992: 180). The foetus takes centre stage; the mother's body vanishes. This process, dependent upon visualisation, has taken effect in little more than two hundred years.

The modern, industrial environment within which the foetus now exists is a territory that can be controlled. The biological body of the mother is merely a side-effect. A previously hidden, undefined, privately experienced interior world becomes a space opened up to medical scrutiny, a womb that can be monitored and managed. As Anne Balsamo has noted, some obstetricians now go so far as to argue 'that the foetus is the *primary* obstetric patient' (Balsamo 1999: 236). The embryonic foetus is imagined as already complete, as separate from the mother's body, which can, if necessary, be bypassed. This current conception of the foetus is, however, merely a smarter, cleaned-up, postmodern form of medieval flaying. Women are encouraged to engage with this process and, by and large, seem to consent not only willingly but eagerly. Moreover, they do not just participate in the monitoring and management of the foetus, but start to assume responsibility for their own surveillance. Increasingly, the spectacle of 'life' is dominated by the image of the foetus as independent and self-sufficient; as disembodied and external, weightlessly floating in outer, rather than inner, space. In that ghastly, and ghostly, token of exchange, the foetal ultrasound image, the mother-to-be is presented with an image of her alienated labour; a simulacrum whose signified is preconceived. Boundaries of space and time collapse. Skin is rendered transparent; bone dissolves, and the maternal body vanishes into thin air. In these technologies the mother does not register. She is off-screen, out of frame; no longer part of the obstetric picture.[1]

The disappearance of the maternal body within obstetric medicine is the outcome of a much longer process of modernising. It also marks a symbolic disappearance of the female anatomy and voice, in favour of the rights of the foetus, which, conveniently having no voice of its own, has become a mouthpiece for the biotechnological ambitions of what remains a fundamentally patriarchal society. It is thus that the mother's body comes to be perceived as secondary and, ultimately, as redundant. Woman is a handmaiden whose services might soon be dispensed with altogether. Eggs can be 'harvested' from any female body and any uterus can be employed to 'grow' any embryo manufactured in a laboratory. While the part of the egg outside the nucleus is essential for development (and therefore women are still necessary as providers of eggs), the female egg can now be enucleated and replaced with a cell nucleus (the part of the cell that contains genetic information) from another person, male or female. Thus it becomes possible to eliminate women's distinctive contribution to life (Hanmer and Allen 1980: 219). Human parthenogenesis is in

sight. Stem cells, the holy grail of reproductive technology, can even be extracted and redeployed to repair any part of the body. The body is conceived of as a machine. If it runs into trouble it can be upgraded. Human beings, reconstituted as human products, can be produced on demand, to a desired specification, or for a specific purpose such as the supply of spare parts.

Through biotechnology, sex is now finally, and irreversibly, severed from reproduction. The current biotechnological revolution is not just scientific but ideological. Science also has to be understood as a form of cultural knowledge in which visuality has played a key role. The images we are presented with are not representations of a natural reality but the product of complex cultural construction. However, the ambition to bypass the female body in reproduction has a long history, which is marked as much by desire and the turbulent, shadowy unconscious as by the cool light of reason (see Keller: 1985). The ambition and desire has an early exponent, for example, in a poem attributed to John Wilmot (1647–80) entitled 'The Wish':

> Oh! that I could by some new Chymick Art
> Convert to Sperm my Vital and my Heart;
> And, at one Thrust, my very soul translate
> Into her – and be degenerate.
> There steep'd in Lust nine Monthes I would remain,
> Then boldly f… my Passage back again.
> (Wilmot cited in Bloch 1938: 515–516)

In Wilmot's poem the foetus is an identificatory figure for the adult male. The lines express a desire for degeneration, mixing desire with death, which is at the root of generation and life. The poem wishes for what is impossible: a way back to the future, a way in which man can come and go, can invent himself by means of the impossible fantasy of selecting his own mother and being his own father. The male subject obtains the object of desire and also becomes it. He dissolves the Oedipal relationship between father and son, and abolishes any dependency on the mother. Woman's function is to allow him to be. He can be both adult and child.

Sex and science are perhaps not so far apart. Wilmot's fantasy of independence might be read as a staging post on the road to parthenogenesis, a means of short-circuiting human relationships in order to realise an impossible fantasy of making the subject its own point of departure (Benjamin 1998: 84). Instead, Wilmot refuses to accept that he did not create himself, and his dream surpasses every one of biology's limitations. Man is sovereign, at the centre, self-made, creative. This relation of no relation is a specifically male fantasy. The wish is the infantile desire, to be neither dependent on the mother nor subject to the law of the father, as he once was. This is a narrative of mastery and control.

Wilmot's poetic fantasy has become a scientific reality. The historical images under review in this book matter today precisely because they might allow us to understand how human generation has been recast as reproductive biotechnology. In place of human bodies, what we now have is the mass 'comercialisation of living matter' (Braidotti 1994: 64). This is, in part, the outcome of specific modes of visualisation whose history can be traced as a current that runs through the body. As the commercial visualisation of 'life' becomes big business, we are all, wittingly or not, increasingly involved in a struggle over the meaning and value of life.

Feminist politics has consistently argued that patriarchal capitalism has worked not simply to constrain women within narrow definitions of what it means to be female, but more importantly to constrain us all, men and women alike, within too narrow definitions of what it means to be human. The present historical conjuncture both demands and makes necessary the re-evaluation of scientific visual culture and the role which sexuality and subjectivity have played in shaping that culture; it does not mean demonising that culture any more than deifying it. But it does mean looking beneath the smooth surface of the image and examining not just our ways of seeing, but the more material techniques of an observer who is gendered.

Historically it is, I argue, women's bodies that are at the sharp end of the scientific gaze. By the end of the nineteenth century, human flesh is transformed into layers of two-dimensional information. Palpable bodies became paper dolls. The process of turning three-dimensional flesh into two-dimensional paper begins, of course, much earlier than the period of photography, with engraving and lithography. But photography, optically consistent and mass-reproducible, was a medium particularly suited to a conceptual broadcasting of ideas that were already in play. Immutably mobile, these visual inscriptions maintained older understandings of the female body. In Latour's words, 'we have never been modern' (Latour 1993).

Notes

1 There is an image of Ian Donald, the inventor of this technology 'performing ultrasound on his daughter' and gazing at a screen (O'Dowd and Philipp 1994: 517). This does not seem dissimilar to William Harvey's anatomisation of his relatives in the seventeenth century (see Richardson 1987: 31).

2
Il-legal and non-medical:
John Roberton and John Joseph Stockdale

The eighteenth plate

In 1836 two government inspectors went into Newgate Gaol and were dis-
gusted by what they found. To their dismay, they noticed that the good supply of
prayer books and bibles 'bore little appearance of having been used'. On the
other hand, there was evidence of 'tobacco and newspapers, mince pies and cold
provisions' and 'a pack of cards, much used'. The authors wrote that among the
few harmless or improving books, such as '*Guthrie's Grammar*, a song-book
and the *Keepsake Annual* for 1836, they had found 'the——, by——, [with] 18
plates published by Stockdale, 1827'.[1] 'This last book', they continued, 'is of a
most disgusting nature, and the plates are obscene and indecent in the extreme'.
Worse, the book was claimed as his property by a prisoner, named——, and was
kept in a cupboard without any attempt at concealment' (Parliamentary
Reports From Commissioners (1836) 14: 4–5) (see Figures 7, 8 and 9).

What the inspectors had discovered was *The Generative System of John
Roberton*, edited by Thomas Little, a pseudonym of the publisher John Joseph
Stockdale. Roberton's original volume, *On Diseases of the Generative
System*, a medical work, had first been published in 1811. The book appeared
under both these titles. However, the version found by the Commissioners, the
fifth edition, contained not dry-as-dust illustrations of post-mortem speci-
mens, but what they considered to be eroticised pictures of engorged sexual
organs. They considered that the book was not so much medical as sexual, less
dead than alive, and concerned less with disease than with sexual desire (see
Figures 7, 8 and 9). They signalled their unease by using the typographic con-
vention for dubious or sensitive material, a series of dashes in place of the
author's name, the title of the book and the name of the owner. Thus no fur-
ther publicity was given to the text, although the offending publisher was
named.

However, the inspectors' report and the subsequent account in Hansard had
far-reaching consequences. Stockdale accused Hansard of libel, but the story did

not end there. Over the next four years there were further court cases about the nature of libel, with claim and counter-claim being made. It was an episode in the struggle between parliamentary privilege and publishing freedom and it landed Stockdale in gaol. Although Stockdale eventually lost his case, the *Stockdale versus Hansard* affair influenced new legislation on parliamentary reporting in 1840 and on the law of libel of 1843, as well as being cited in debates on obscenity in the mid-nineteenth century.

Why did 'a physiological and anatomical book, written by a learned physician and illustrated by anatomical plates, come to be described as 'a book of a disgusting

7 The eighteenth (unnumbered) plate from Thomas Little, *The Generative System of John Roberton*, London, J. J. Stockdale, 1824

8 Plate X from Thomas Bell, *Kalogynomia, or the Laws of Female Beauty*, London, J. J. Stockdale, 1821

9 Plate XXII from Thomas Bell, *Kalogynomia, or the Laws of Female Beauty*, London, J. J. Stockdale, 1821

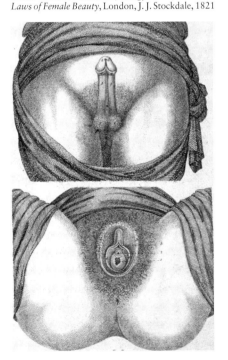

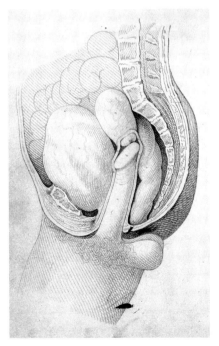

nature, with plates of an indecent and obscene description'? (Court of Common Sense 1840: 47). How did a minor work become central to State deliberations? Visual inscription plays a fundamental role here. It was the plates that attracted the attention of the inspectors.

The work of the Scottish surgeon John Roberton (1776–1840) and the publisher John Joseph Stockdale (1770–1840) is central to an understanding of what happened. Roberton's position was complicated; the medical profession in both Edinburgh and London always regarded him as an outsider. This was partly because the more influential members of the profession, including Matthew Baillie, nephew of John and William Hunter and physician to the Royal Court, knew that his work on the diseases of generative organs, particularly female generative organs, was *risqué*. Stockdale, meanwhile, was definitely engaged in supplying an expanding market for obscene material, and it was this that led him to purchase and to add to Roberton's already contentious book.

The story of these men, and the professions or institutions with which they engaged, is riven by emerging definitions, not only of what constituted doctoring and authorship, but also of what constituted an audience. The story is further complicated by the politics of gender and class that ferment around definitions of obscenity. This is a tale about subversion, social class and sexuality, which also opens new lines of enquiry about the ill-defined nature of pornography and the emergence of the medical profession; its focus is the representation of sexual organs in printed, mass-produced imagery.

John Roberton and the clash with Matthew Baillie

John Roberton MD was a surgeon, probably unqualified, who practised as a specialist in the treatment of venereal disease in Edinburgh between 1802 and 1810, and in London between 1810 and 1820 (White 1983: 407). Little is heard about Roberton after 1820.[2] He was known chiefly for his radical beliefs about medical police and his ideas about the nature of female sexuality. This mixture of radical social, political and sexual interests did little to help his career. Before emerging as a surgeon, Roberton had already made his mark in the welter of medical literature by writing a number of pamphlets. Shortly after he began practising in Edinburgh, he published his first book, *A Practical Treatise on the use of Cantharides* (1806) in which he advocated the use of cantharides (Spanish fly), a known aphrodisiac, as a cure for venereal disease.[3] His main contribution to medicine was his two-volume work, over 700 pages in length, *A Treatise on Medical Police* (1809). This book is described in John Comrie's *History of Scottish Medicine* as 'the first notable treatise in English upon the subject of public health' (Comrie 1932: 626). Although Comrie acknowledged that Roberton's work contributed to the emerging discourse on

the relationship between healthy bodies and a healthy democracy, he cites only the *Treatise*, and not Roberton's earlier or later works.

Even the *Treatise* did not receive unqualified praise. In her article 'Medical Police. Politics and Police: the Fate of John Roberton', Brenda White points out that its intended title was the far more parochial *Diseases of Edinburgh*, and suggests that this eclectic work 'added nothing to the known stock of scientific medical thought' (White 1983: 410). This is largely true, but what was radical about the book was Roberton's advocacy of sanitary legislation, to be enforced by medical inspectors provided by the State. He proposed the establishment of 'councils of health in cities and the appointment of medical inspectors' (Roberton 1809, vol 2: 358). In Roberton's opinion, 'a rational plan of medical police cannot ... be carried into execution without the aid of legislature' and hence the support of those in government. Roberton proposed that a tax be levied 'on individuals according to their income, or situation, for the purposes of suppressing the sources of such disease' (*ibid.*). This would produce a saving to all parties, but the most marked advantage would be 'in the preservation of health of those whose lives may be widely useful to society in general' (*ibid.*). Women, as the reproducers of labour, were about to enter into this category. But Roberton was also conscious that the political nature of such proposals would 'in many instances, meet with the most violent opposition; that the severest strictures from interested and angry parties, will from selfish motives or private malevolence towards the author, be secretly poured out against them' (Roberton 1809, vol 2: 360).

Roberton was well aware that politicians were reluctant to 'impose' such a tax and by 1809, moreover, he already had powerful adversaries. White suggests that Roberton emerges as a shadowy figure, a 'quick tempered, quarrelsome and notorious outsider, seeking patronage by whatever means available' (White 1983: 408). Despite his efforts to enter the Edinburgh establishment by joining the Freemasons, Roberton had indeed made enemies in the professions of medicine and law, the backbone of polite Edinburgh society. He also waged his many arguments in public, although this was not uncommon in the late eighteenth and early nineteenth century and should not, in itself, have been sufficient grounds for established doctors to gang up on him.[4] Fierce rows were openly conducted in the press or indeed in any public space. The university was an obvious place for grievances to be aired, sometimes in an unconventional manner; the surgeon James Syme, for instance, tore up the work of Sir James Young Simpson in front of students (Hamilton 1981: 168). Rival doctors attacked each other in the street and court cases were not uncommon. James Hamilton, Professor of Midwifery, was attacked in the street by the older established Professor of the Practice of Medicine, James Gregory, who was fined £100. Hamilton was also slandered by Andrew Duncan Senior and successfully won £50 in damages by pursuing

him in court. Those involved in the rising and still disreputable area of mid-wifery were particularly prone to accusations (see Hamilton 1981 and Comrie 1932). Roberton's rows have to be placed within this context of the cut and thrust of disagreements over trade.

Though Roberton's ideas were unwelcome, his attempts to gain respectability were also damaged by his long-running clash with the Edinburgh surgeons. From their point of view, he was disreputable in every respect: he was from the wrong social class, a dubious doctor of radical bent and had already advertised the forthcoming *Diseases of the Generative System*. The Edinburgh surgeons, on the other hand, were trying to gain recognition from their peers in England.

It is important to have a sense of the way in which medicine was practised in Scotland and England in the early nineteenth century. The hierarchy within the profession began at the border. The London Royal College of Physicians admitted only those who had read medicine at Oxford or Cambridge; it did not recognise Scottish degrees. Scottish universities had not helped themselves in this respect; it was possible in the eighteenth century to obtain a Scottish degree by post, with the universities requiring nothing more than a couple of letters of support from medical practitioners. This lax system was obviously open to abuse, one example of which was the case of an illiterate brush-maker called Samuel Leeds, who obtained an MD in this way from the University of Edinburgh (see Hamilton 1981: 144). The London College did admit a few foreign graduates each year but relegated these outsiders to the inferior status of 'licentiate'. Licentiates, however, were not allowed even to enter the college buildings. This state of affairs became so intolerable that in 1767 a group of them smashed college windows and broke down doors (see Hamilton 1981: 138–144). Despite exceptional cases, equal rights were not granted to Scottish graduates until 1858 (Hamilton 1981: 145).

Only the most successful found it possible to establish themselves in London. Among the fortunate few were William Hunter and his brother John. William had been one of the rebels in 1767, but it had done him little harm. The significance of the Hunters from John Roberton's point of view was that they were the uncles and patrons of one of his rivals, Matthew Baillie, who as an eighteen-year-old was sent to London to live with his uncle William. The Hunters, Baillie and Roberton also had their place of birth in common. At twenty, following William Hunter's death, Baillie had inherited the house and the lucrative Great Windmill Street anatomy theatre. His repu-tation was made by the publication in 1794 of an edition of Hunter's work, *An Anatomical Description of the Human Gravid Uterus and its Contents*. Hunter had intended this text as a supplement to his 1774 atlas, *The Anatomy of the Human Gravid Uterus* (see Chapter 3), but the manuscript was incomplete at his death in 1783. Baillie's clash with Roberton, though

based on class divisions and on his belief that medicine should properly be asexual, also reflected ongoing changes in the way in which the functioning of the female body was understood. Roberton, who rejected the older notion of the uterus as an independent organ, put forward in Hunter's original atlas and, supported by Baillie, had clear ideas of the active nature of female organs of generation and female sexuality, ideas that brought him closer to obscenity than to medicine.

Eager to publish, Roberton made a crucial error of judgement in 1809 in failing to acknowledge the work of Andrew Duncan Senior, whose lectures on medical police he had attended in Edinburgh. The Edinburgh establishment decided to get rid of him, and in 1810, after a fruitless attempt to get elected to the board of presidents of the Edinburgh Royal Medical Society, he was accused of 'writing obscene epithets on the voting papers and writing "highly indecent, disrespectful and disgraceful letters" to the Society' and expelled (White 1983: 416). His career in Edinburgh was finished and by June he was forced to leave the city.

In 1809, even as these troubles unfolded, Roberton was planning his work *On the Diseases of the Generative System,* and it seems that the intended publisher was Richard Phillips, a republican and sometime 'hosier, stationer, patent-medicine vendor, later bookseller and author, and publisher of the *Monthly Magazine*', who had been largely involved in producing cheap educational material for a wide readership (Lee 1909: 1096). As things turned out, there were problems 'about when and how [the book] may be published', and it was taken over by John Joseph Stockdale (Roberton 1817b: 16). Stockdale would have been interested in the subject matter because, under one of his assumed names, he was a well-known author-publisher of salacious works, a fact suggesting that, in his hands, the *Generative System* would not continue in the sober tradition of Hunter's *Gravid Uterus.*

In 1810 Roberton moved to Jermyn Street in London, no doubt hoping to follow in the footsteps of William Hunter, who had moved there in 1750. With an eye, as always, on patronage, the only sure route to promotion in the medical ranks, Roberton dedicated *Diseases of the Generative System* to Matthew Baillie, who was by then established as physician to King George III. Roberton knew well that advertisement and publication were both essential in promoting oneself as a member of the medical profession. It made doctors visible, enhanced their reputation and increased the profits to be made from practice. When Roberton's book appeared, doctors were still striving to establish medicine as a reputable profession, undiluted by charlatan practitioners or dubious books of a popular nature on sometimes controversial matters such as sexual organs. While Baillie did not complain about the dedication in the earlier editions, by 1816 he was rather less keen to be associated with Roberton. The two men started an acrimonious correspondence. Being in London does not

seem to have helped Roberton in his relations with Baillie or the profession. Indeed, Roberton complained to Baillie that 'your wishes, for my success in life, existed only while I lived in Edinburgh' (Roberton 1817b: 37). It became clear that Roberton's notoriety was not so easily shaken off. As White suggests, a close and powerful professional network operated between Edinburgh and London Scots (White 1983: 414).

In addition to the piqued tone that characterised all Roberton's letters, those addressed to Baillie were marked out by a deeply felt anxiety about his class background. Roberton resented Baillie's class advantage and social connections. Baillie and Roberton had grown up in Lanarkshire, and Roberton naively hoped to curry favour from what he perceived as both a local and a national connection. He came, however, from the opposite end of the social spectrum. Baillie's mother was the son of the Hunters' sister, Dorothea, and his father was Professor of Divinity at the University of Glasgow. Roberton carped about his own disadvantages and lowly beginnings and was unforgivably outspoken. He wrote, 'You probably may have some recollection of the retired situation in life, which my relations chose, and consequently the little I had to expect from their exertions in putting me forward in the line of my profession. My sole dependence therefore rested on my own industry' (Roberton 1817b: 9). Lacking useful family connections to advance his career, it is not surprising that he tried to ingratiate himself with one of the most powerful (Scottish) doctors in the land, patronised by (English) Royalty.

What distinguished Roberton's spat with Baillie was the question, or accusation, of obscenity. *The Diseases of the Generative System* was a successful publication, but it was undoubtedly on the very edge of the licit. It seems likely that, between the publication of the first edition in 1811 and the appearance of the fourth edition in 1817, perceptions of the book altered as a result of a change in the climate of opinion. Baillie felt compromised and sought to distance himself from Roberton. In 1816 Baillie complained, 'I shall not express what I think of Dr. Roberton's conduct in prefixing my name to an obscene book without my knowledge ... I did not know that there was either a second or third edition ... and I even thought Dr Roberton had been dead two years'. As White points out, in 1814 premature rumours of Roberton's death circulated in the press (White 1983: 417). Baillie continued, 'I hope I shall not be readily suspected of encouraging so gross a violation of morality and decorum' (Baillie in Roberton 1817b: 19). It is worth remembering that Baillie's patron, George III, had called for the suppression of the growth in licentious and obscene material, a move that led to the founding of the Proclamation Society in 1787 (see below, p. 55). Baillie made a point of addressing his letters to Roberton from Windsor Castle.

When the fourth edition of the *Generative System* was published in 1817, Roberton decided to prefix the ill-tempered correspondence and he also issued

it as a separate pamphlet, no doubt to the great enjoyment of the gossips. He asserted that 'preference is given to a medical attendant, solely because he dresses well, is a most agreeable and fascinating companion, plays a *clever* game of *whist*, is a bigot in certain religious tenets, espouses a particular side in political opinions, or in short, has studied any particular thing, or all things – except his profession' (Roberton 1817a: xxi). In Roberton's opinion, it was only 'after 200 copies circulated that they thought it safest to discredit me among my patients, the female ones especially' (Roberton 1817b: 17). Roberton was quick to remind Baillie, 'that the greater part of a physician's professional duties are really what you would term obscenities' (Roberton 1817b: 27).

Roberton's words acknowledged that there was no firm boundary between the medical and the sexual, an admission that doctors were struggling to avoid. Indeed, it is significant that the rise of the pornographic industry (although it was not yet known by that name) was contiguous with the professions of medicine and law. They all emerged cheek by jowl in the late-eighteenth century, and medicine and pornography depended on similar visual imagery for their understanding of sexual subjectivity.

Roberton's *On the Diseases of the Generative System*, 1811–17

The first edition of *On the Diseases of the Generative System* was announced in 1809 in a striking advertisement printed at the end of the author's *Treatise on Medical Police*. Attention was drawn to the main attractions of Roberton's forthcoming work. He declared that his book was 'in the press, and will be published in a few weeks'. It was to be 'A PRACTICAL TREATISE on the Anatomy, Physiology, Pathology and Practical Treatment of Diseases of the GENERATIVE ORGANS of both sexes' (Roberton 1809: unnumbered). Significantly, the work was intended to have a wide appeal: 'in this work no tedious, uninteresting investigations will be entered into; it will be purely practical, and suited to readers in general' (*ibid.*). It was, therefore, not written for specialists and would offer practical advice. This claim may seem contradictory, but in 1809 there was nothing unusual about the idea of a general readership, since the status of doctors, let alone those interested in the reproductive organs of both sexes, was by no means certain or privileged.

Roberton's book was eventually published in 1811 and in the course of its various editions became a best-seller. In the first edition, Roberton drew attention to what was already a rapidly growing industry devoted to medical publishing. He wrote that although there was a 'multitude of books, pamphlets &c on medical subjects … daily issuing from the press … the rational examination respecting the nature and treatment of many of the diseases of the Generative System have been too much neglected' (Roberton 1811: introduction). In claiming to examine the subject rationally, Roberton's intervention

both marked the increasing importance of such questions and added to the expansion of sexual medical literature, both popular and professional, in the early nineteenth century. Public health and private pleasure had, however, begun to be reconfigured.

Four editions of the *Generative System* were published by 1817. These editions included eleven medical plates (an additional portrait of the author was included by the second edition); significantly, all but the final plate were of male organs. In the text, Roberton emphasised similarities 'common to both sexes' rather than differences (see Figure 8). As was then usual, he visualised the female organs of reproduction as mirror images of the male. The clitoris was therefore clearly shown and explicitly discussed within the text. None of this exercised the lawyers, and Roberton's book was not regarded as a text to be suppressed or prosecuted in the years between 1811 and 1817. It appeared, however, in the middle of a lively debate regarding print culture, obscenity and authorship.

The late eighteenth and early nineteenth centuries witnessed a peak of anti-vice legislation in the wake of the French Revolution; after 1789 'it was as dangerous to publish, display or recite an immoral work as a seditious one' (Bristow 1977: 40). When Roberton advertised his book, the obscene and the seditious were still closely linked. If his book had fallen into one of these categories, it would have been likely to fall into the other also. Sexual freedom and political liberty were closely entwined and any publication that seemed to feed the former could be accused of fermenting the latter. Roberton was discussing and, crucially, picturing troublesome matters at exactly the time when government was trying to control an expanding and unwieldy press and publication and performance industries which had begun to transform the relationship between public and private life.

In the late eighteenth century, as Ornella Moscucci puts it, 'new political and economic significance [was] attached to questions of life and death, health and disease' (Moscucci 1990: 7). Generation, previously marginal to the economy, became central to it. Regular mechanical production depended upon sound human generation. The regulation, or what became known as the policing, of relations between the sexes was perceived to be at the heart of social democracy. Within this context, the increased production and distribution of printed materials containing written descriptions and, increasingly, visual depictions of bodies took on a particular force. It was through illustrated books that public necessity and private wishes came into a new configuration: books were increasingly read, looked at and passed around, placing observers in the centre of the body politic.

Roberton's *Generative System* was part of a resurgence of interest in the procedures and mechanisms by which life was generated. Through being passed around it created its own set of observers. If it was too sexual in itself,

or if it made medicine appear to be sexual at its core, then it would be considered disruptive and destabilising. Nonetheless, illustrated books of this kind encouraged the type of observer who was already flourishing in a hothouse of sexualised literature.

On *Kalogynomia*

Roberton was taking part in a fiercely contested row about the nature of medicine and his work was part of the debate on obscenity (albeit on the margins), but *Diseases of the Generative System* was not his only claim to a place in medical history. The work must be placed not only in a sequence that includes the subsequent editions, but also alongside many other books, some of them written and published under his and Stockdale's pseudonyms. This makes authorship confusing; Roberton reappears as T. Bell MD in a work entitled *Kalogynomia, or the Laws of Female Beauty* (1821).[5] But Stockdale went further. He revamped and altered versions of Roberton's earlier texts, often varying the titles. He began publishing a whole series based on, or relating to, Bell's (or Roberton's) *Kalogynomia*. Using his own pseudonym, Thomas Little, Stockdale then published, in 1824, *The Beauty, Marriage Ceremonies and Intercourse of the Sexes in all nations; to which is added the New Art of Love (Grounded on Kalogynomia)*.[6]

In the same year, Stockdale also published Little's edition of *The Generative System of John Roberton*, and in 1825 he produced two books by Little: *An introduction to a natural system of anatomy, physiology, pathology and medicine; to which is added a general view of natural history* and *Systems of Physiology of Camper*. Each book recorded the existence of previous ones. The cross-referencing of title and author alerted readers to related books. Roberton/Bell had no authorial interest in their continuing life, but Stockdale/Little managed to create a complex web of references for the keen observer; he knew he was on fertile ground. In the Advertisement to *A practical essay on the more important complaints peculiar to the female* (1813), Stockdale suggests that he had 'become the sole proprietor of Dr. John Roberton's valuable publications' (Roberton 1813: Advertisement). It seems likely that Roberton had sold his work, possibly because of debt, to Stockdale, who knew that the books were valuable not only for the explicit nature of the writing, but because they included plates. Stockdale thus became the owner of a number of medical works of a sexual nature which he could then extract from, or supplement, in order to reach a target audience. Most profitably, he could capture a growing popular market for the publications which operated in the grey area between the medical and the sexual.

Kalogynomia, a prime example of this type of text, was a sex manual divided into four sections: 'of Beauty', 'of Love', of 'Sexual intercourse', and

'of the Laws regulating that intercourse'. The book offered instruction to a reader (presumed male). It opens coyly by mixing erotic pleasure with intellectual interest: 'to acquire a mastery of the art of distinguishing beauty, a little knowledge of anatomy is absolutely essential' (Bell 1821: 2). It ends by suggesting that 'the Kalogynomist who happens to follow a female in the street or promenade, may be aided in determining whether it is worth while to glance at her face in passing' (Bell 1821: 312). This knowledge of anatomy was provided in the text and in the twenty-four plates. However, the nine plates containing details of the genital organs were by the mid-nineteenth century 'often wanting' (Lowndes 1858–65: 2102). This may be the result of theft or of the fact that the plates were bound separately, making for more publishing opportunities and greater safety from possible prosecution. All the plates can be seen in the edition held in the British Library, but Stockdale as publisher (in a self-serving note included at the very beginning of the book) gave readers a revealing piece of advice. He advised that certain plates, which he thoughtfully listed (10, 17, 18, 19, 20, 21, 22, 23 and 24) 'should not be carelessly exposed to Ladies' or 'Young Persons' (Bell 1821: i).

The work was presented 'as a scientific one, calculated by both its mode of construction and its price for the higher and more reflecting class of readers' (*ibid*.) and this suggests that price was a check on the 'quality', or social class of the readership. Similarly, looking at such images was made to seem acceptable by half-pretending they were quite legitimate; great efforts were made to print them on fine paper and to add elaborate frames. Stockdale was well aware of the illicit nature of these prints; he knew also that their inclusion would boost sales, so he described them as 'entirely scientific and anatomical' (*ibid*.). The warning was intended to flatter the reader by suggesting that he was a discriminating viewer, and it also permitted him, as a member of the educated classes, to engage in scientific observation rather than sexual voyeurism. Such an observer was not to be confused with those who might pore over explicitly sexual images without any intellectual intent. Stockdale ended by that claiming that 'the Publisher might have dispensed with this precaution; but he is anxious that these readers should have it in their power to obviate the possibility of the careless exposure of such anatomical Plates; they are therefore detached from the work, and may be locked up separately' (*ibid*.).

By 1821 the publisher was aware that to mention the desirability of private use might make a useful appeal to his readers; he was declaring his expectation that readers would exercise judgement and restrict the consumption of those plates listed as explicitly sexual. The note pointed in the direction of future developments, when publishers would act as mediators between the state, public legislation and private consumption. In his appeal to paternal responsibility, Stockdale's note unintentionally anticipated the changes that led up to

the passing of the Obscene Publications Act of 1857. Thereafter, the earlier emphasis on the regulation of public display shifted to take in the realm of private consumption, an area that proved difficult to police. For a time, responsibility for censorship rested with the owner of the book, and the home was a microcosm of the public realm. Individual liberty depended upon patriarchal responsibility and was therefore closely linked to questions of class and gender differences.

There was nothing inevitable about the ways in which the discourse of sexuality was worked out from the mid-nineteenth century onwards. About a century earlier, between 1694 and 1725, a popular sex manual, *Aristotle's Masterpieces or the Secrets of Generation*, had emphasised the similarities between the sexes rather than their differences. It stated baldly that 'there is no vast difference between the Members of the two sexes' and that 'the use and action of the clitoris in women is like that of the penis or yard in man, that is, erection' (cited in Porter 1987: 15). Roberton's work still had traces of a period when generation was a byword for sexual information. He gives a fulsome account of the active nature of both penis and clitoris. The language used is poetic and suggests an active female sexuality. He wrote, 'From the delicate structure of the clitoris, and its extreme sensibility, it is the principal seat of pleasure during coition. When titillated it becomes erect and the portion of it which runs round the margin of the vagina swelling, it grasps the penis with rapturous ardour' (Roberton 1811: 16). This description of the 'action' of the clitoris suggests both a correspondence with the erect penis, and a difference. Male and female parts could be simultaneously similar and different; at the very least, they were not absolutely unlike one another (see Figure 8). This awareness of similarity was eventually erased in the course of the nineteenth century.

Kalogynomia therefore lies somewhere between those earlier tracts on sex on the one hand and the repression of an active female sexuality in the second half of the century on the other. By the time it was published Roberton had disappeared from view and although it was based on his original text, *Diseases of the Generative System*, it bore many of the hallmarks of changing attitudes to women's sexuality. It is a contradictory work, straddling democratic sexual aspirations and the emerging political and economic demands that women be subjugated. For example, unlike the *Generative System*, which contained notions of equality, in *Kalogynomia* women were subjugated by the demands placed on their bodies: 'the real destiny is characterised by these circumstances' (attachment to infants, or dolls when an infant is not to be had) and thus, 'those fools are answered who want to confer on woman the intellect and occupation of man' (Bell 1821: 55).

There was a clear tension between the need to describe women's 'real destiny' as motherhood and the need to acknowledge women's active pleasure in

sex. Conception was still believed to be possible only if women achieved orgasm. 'Some have asserted that this pleasure has more extensive relations in women than in men. This is probable because the generative system is more extensive in women. Certain it is that without such pleasure, no conception is possible. Whenever, therefore, a woman becomes a mother it is her spontaneous act' (Bell 1821: 192). Here female sexual pleasure is still central rather than marginal to the possibility of conception. Although the illustration is more anatomical (see Figure 9), *Kalogynomia* contained a graphic written description of orgasm (although this term was not used) under the heading of 'United Functions of the Male and Female Generative Organs'. 'features seem to contract ... eyelids drop over the eyeballs, which are convulsively drawn upward and inward, while the lips are half open ... motions of the body are vivid and violent ... an ovum is immediately burst, and an albuminous drop, thus disengaged, consequently descends along the fallopian tube into the uterus, where meeting with the male semen, the future embryo is formed. The female generally experiences a shivering – a voluptuous horripilation at the moment of conception' (Bell 1821: 191–192).

The early nineteenth century still perceived female sexuality as active and had long-standing notions about female ejaculation and shared roles in the processes of conception. Roberton in 1811 stated, 'It seems ridiculous, amidst the uniformity, beauty and simplicity, of the operations of nature, to suppose that the fallopian tubes are doomed to the double and clumsy office, of first transmitting the semen to the ovaria and afterwards returning it to the uterus. It is more probable, that when the semen excites the womb, the ovaria sympathetically contract and burst an ovum, the fluid of which escaping, descends through the fallopian tube to the uterus (Roberton 1811: 15). Indeed it was not until 1845 that it was discovered that ova were ejected spontaneously. Until the latter part of the nineteenth century, female pleasure was closely bound up with generation.

It was observation or speculation about orgasm and conception that allowed the author to ponder the possibility of sexual liberty and, just as importantly, of sexual equality. Bell argues that 'considering then sexual pleasure, without any reference to moral and political consequences, it is ridiculous to assert, that there is any more crime in two persons of opposite sex mixing together two drops of albumen in the sexual embrace than there could be in their mixing two drops of saliva by spitting on the same spot on the ground ... the love of variety must be quite as natural to woman as to man' (Bell 1821: 277). None of this excitement was without danger. The author added some scientifically observed examples of the life-threatening possibilities of passion: 'There have been many examples of persons who have died during the union of the sexes from excess of passion, and the same has been observed among insects. Frogs during this act, do not quit each other, nay do not cease, though their

limbs be cut' (Bell 1821: 192). Such assertions underline *Kalogynomia*'s position as a contradictory work caught between older, ancient ideas about generation and emerging politics of reproduction.

Once warned, the 'Kalogynomist' was left to make his own observations, and was wished 'as much theoretical and practical pleasure, as we ourselves have had, in the cultivation of so charming a science' (Bell 1821: 331). The dangers of excessive pleasure, so well described, could not go unchecked. Certainly, if excessive passion was found among women, or women enflamed men so much that they died, this was a state of nature that required the tempering of society. Roberton, though he was writing in the first two decades of the nineteenth century, hinted that sexual pleasure should be harnessed to the demands of tighter political and economic conditions and curtailed. The solution was to separate passion-for-pleasure from passion-for-procreation by dividing women into two classes, or two kinds of vessel. By the 1830s there was a clear division of labour between sexualised working girls and sexually-anaesthetised middle-class women.

However, this division of labour, which was also a division of knowledge (and ignorance), was not passively accepted. For instance, it is clear that middle-class women who employed doctors took the opportunity to ask them 'to institute an examination of the sexual organs' and as Marshall Hall, writing in 1853, noted with concern, were likely to speak of '"the womb" and of "the uterine organs" with a familiarity formerly unknown' (Hall (1853), cited in Moscucci 1990: 116). There is also much to suggest that women were consumers of obscene prints, and of the medical-erotic work of Roberton/Bell and Stockdale/Little. The linkage between pornography and medicine, with their shared interest in the body, is part and parcel of modern experience.

Little's *The Generative System of John Roberton*: the infamous edition of 1824

Despite the number of reprints and reworkings, Roberton's work would probably have disappeared from view, like so many other books, if it had not been altered in the fifth edition of 1824, the edition which came to the attention of the prison inspectors. Stockdale enlarged the work to a substantial 561 pages and published it under the title *The Generative System of John Roberton*, edited by T. Little (one of his own pseudonyms). He added seven medical plates to Roberton's original set of eleven; some of them, borrowed from *Kalogynomia*, were more explicit in what they showed of sexual organs (see Figure 9). The most important, however, was an unnumbered eighteenth plate that was not even listed in the table of contents (see Figure 7).

This image is almost certainly what upset the prison inspectors in 1836 and tipped the balance from the medical into the definitively sexual. It is an image

that is less a medical view of the vulva than a pornographic view of a cunt. The plate has the advantage of a carefully engraved representation of an ornate frame, the presence of which alters the status of the image from simple to special object; the realm of art is held within the frame. In line with the conventions of art, the image is seen from outside, with permission, but as if through a window into another world. The elaborate frame shifts the image from the unadorned medical and directs the gaze towards the centre, focusing tightly on the slit. It is not at a safe distance, but close up, at eye level, literally in the observer's face. This is a privileged view, offering a marked depth of field that is lacking in the other images, which are flatter and lifeless. Last but not least, the image is printed on thick paper. It has a certain stiffness, a tangibility which makes the whole thing easier to hold, or even to finger. It is an image that deliberately draws the viewer in. It is at the level of form, not simply of content, that the image stands out.

This eighteenth plate in *The Generative System of John Roberton* (1824) was not, however, taken from *Kalogynomia*. It was from a different register (pornography) bound into a (supposedly) dry anatomical book. The image drew on an older iconographic system, in which the open book lying on a woman's lap signified the parted female genitals. Furthermore, the image was both a representation of a cunt and its metaphor, an opening concealed within the covers of a slim volume. The British Library copy, unsurprisingly, bears the traces of much use: the book conveniently falls open at this image and at an explicit engraving of an erect penis and parted thighs, taken from *Kalogynomia* (see Figure 8). Sections of text (including a description of large clitori) have been clearly marked by readers (although thoughtfully in pencil) for their affective powers. The reader's attention is immediately drawn to the parts of the work worth perusing.

However, Little's edition of *The Generative System of John Roberton* can hardly be said to be the same work as the editions published between 1811 and 1817. After Stockdale had entered the scene in 1813, the book no longer had a single author. The various changes it underwent and the use Stockdale made of it in *Kalogynomia* suggest the instability of authorship and works in the early nineteenth century. These texts did not emerge from a single original point but from cutting and pasting and putting together the results. Clearly, this is nothing new. Roberton's 'original' work benefited from the addition of new prints, shrewd marketing, assembling and extracting, compiling and, most importantly, from repetition. Stockdale knew how to put these texts and images to powerful effect and a knowing reader would have been adept at cross-referencing Roberton and Stockdale, Bell and Little. Even if he or she was not, Stockdale offered clues in plenty.

Stockdale's acquisition of *Diseases of the Generative System* raises questions, at a key moment of social, political and sexual transformation, about

the status of authorship, or of any stable authorial identity. Roberton the author ceases to have individuality as an 'originary, inaugurative source' and becomes a 'function of discourse'. The book is merely a 'verbal cluster' around definitions of pornography and sexuality that had emerged out of obscenity and generation (see Foucault 1977b: 113–138). The author here is neither solid, nor fundamental. Roberton's relationship with Stockdale, as far as it can be determined, suggests extremely unclear boundaries and the impossibility of ascertaining authorship. Much was repeated, superimposed or combined. At best, Roberton's work was a template that could be supplemented with various plates or additional text. Identity and even gender could be adopted and cast off at will by authors and publishers. While Roberton became Bell, Stockdale was variously Harriette Wilson or Thomas Little. Fact and fiction were not always distinguishable. Works had no singularity or integrity, any more than authors: Bell covered up Roberton; Stockdale hid under Little and Bell and Roberton. The proliferation of authors made for more books, which in turn created more readers and viewers, intensifying or at least spreading the hothouse effect. Sometimes, Roberton's *Diseases of the Generative System* had simply *Generation* stamped on the spine, alerting the reader to its explicit nature.

Two further books were published in 1825. The first, *An Introduction to a natural system of anatomy, physiology, pathology and medicine; to which is added a general view of natural history*, was advertised as being by the author of *Kalogynomia* (T. Bell edited by T. Little) and was published only six months after the fifth edition of *The Generative System of John Roberton*. The fictitious Little (Stockdale) prefixed the *Introduction* with an advertisement referring to his acquisition of the papers of the 'late author' some twelve years previously, which suggests that Roberton was possibly dead by then. Little/Stockdale wrote that the author's plans were 'curtailed' and consequently he, as editor, 'thought it advisable at least for the present to dispense with the plates, which may, or may not, appear hereafter' (Little 1825a: Advertisement, unnumbered).

Stockdale (Little) did not explain why he 'curtailed' his plans for illustrations, but it suggests that his activities had already been noticed by the censorship authorities. The visual material was the problem, and *Lowndes Bibliographer's Manual* states that when the fifth edition of The *Generative System* was published in 1824, 'some of these plates were afterwards suppressed and the book sold without them' (Lowndes 1858–65: 2102). The *Generative System* was not one book; it was not coherent or integrated, but was altered in accordance with the pressures on publishers, who added titillating material to it when they could, and extracted dubious illustrations when necessary.

The alteration of text to gain advantage could take unexpected forms. For example, in the final page of Little's edition of Bell's *Introduction to a natural*

system of anatomy, the author drew attention to the precocious sexual development, coyly termed the 'gift of Venus', of the large numbers of pre-pubescent girls who, from the nearby villages, 'flow to London ... and making traffic of their persons, wander over the streets in great numbers during the night'. Bell took these comments on prostitution and, in a neat class reversal, translated them from everyday English in the body of the text to a Latin footnote, then still the language of the male professions (Little 1825a: 223).

Little's final work, *Systems of Physiognomy of Camper, Blumenbach, Virey, Gall and Spurzheim, Lavater, Schimmelpennick and A. Walker etc.,* was also published in 1825.[7] It managed to direct the viewer to Roberton's plates in the *Generative System.* In a final note, Little wrote that 'instead of inserting the plates referred to ... in the present work, the editor has thought it preferable, on account of the delicate nature of the subjects, to mention that they are appended to the fifth edition of Dr. Roberton's celebrated book on the *Generative System.* The Editor also avails himself to add, that his readers ... will probably be equally gratified and informed by pursuing the new, and popular work on *Beauty, Marriage Ceremonies and Intercourse of all the sexes in all nations'* (Little, 1825b: 142). By using the term 'popular' to describe his latest book, Little (Stockdale) signalled the illicit nature of the prints. He had provided a network of references for the motivated reader and the new observer.

The prison inspectors' report of 1836

In 1836, when the prison inspectors discovered the engraving that offended them so much, it was not at all clear who had broken what law, or if indeed any law had been broken at all. In naming Stockdale in the Parliamentary Report of 1836, the inspectors were, however, advocating the suppression of obscenities. Stockdale's work was grist to the mill of censorship that continued to grind down the press and publishing trade, and he must have appeared an obvious target. He had a thriving business in salacious literature and the demand for his work, particularly *The Memoirs of Harriette Wilson* and *Paris Lions and London Tigers*, both published in 1825, was so great that a barricade had to be erected outside his shop in Colonnade. Thomas Little was also the editor of the latter work.[8]

The report in Hansard related to Stockdale's wider publishing activities and it is likely that he was targeted as much for his other works as for those based on Roberton's text. In any case, it set in train a series of unexpected consequences, not least debates which dealt specifically with the right of government to extend parliamentary privileges to its own official publication, while exerting control over the press and publishing industries. Stockdale's case turned out to have a bearing on the question of what it was permissible to print in an age that resounded with calls for new political freedoms.

The story was simple enough. On leaving Newgate, the inspectors wrote an official report. They found that what was usually concealed, what indeed they felt should be concealed, fell open to view and was laid bare as the leaves of the book were parted. They promptly declared Stockdale culpable of publishing obscenities by interpolating them into Roberton's text.

The crucial term here is 'obscene'. The Royal Proclamation of 1787 urging subjects to 'suppress all loose and licentious Prints, Books and Publications' had led to the formation of the Proclamation Society, which in 1802 was superseded by the Society for the Suppression of Vice, popularly known as the Vice Society (Kendrick 1996: 99). Erotic and obscene pictures, commonly found among eighteenth-century prints, remained uncontrollable, but this did not prevent the Vice Society from trying. In the next fifty years, the society initiated 159 prosecutions, all but five of which ended in conviction (*ibid.*). In the years between 1834 and 1880 it seized '385,000 obscene prints and photographs; 80,000 books and pamphlets; five tons of other printed matter; 28,000 sheets of obscene songs and circulars; stereotypes, copper plates and the like' (Bristow 1977: 49). This was probably only a fraction of the material produced but gives some idea of the scale involved. Despite stiff sentences, the threat of prosecution had little effect on the trade in obscene or, as they were still called, 'wanton' prints, which was too widespread to police. The society even called upon eminent figures to support its attempts to stamp out obscenity, only to discover that, not infrequently, those very individuals turned out to be some of the most avid consumers and, in some cases, producers (Thomas 1969: 196).

Government moved against obscenity indirectly, tacking clauses on to unlikely Bills as they passed into law. Clauses in the Vagrancy Acts of 1824 and 1834 made it an offence to *display* obscene prints or pictures in public places, although the police had no power to destroy such material (Kendrick 1996: 99–100). A successful prosecution demanded that the law establish a publisher or author intended to disturb the peace or corrupt the morals of the public. These particular motives and intentions were hard to prove. No one sued Stockdale for intending to disturb the peace or corrupt the public. He, however, claimed that the inspectors' report, as printed in Hansard, amounted to a libel, and so he sued the government's publisher, claiming that it was a false and scandalous libel to accuse him of being a publisher of obscene books, an accusation which injured his trade and reputation. This, of course, also drew the public's attention to his, and their, interests. It was good publicity.

In 1774 Luke Hansard had won the right to publish the official record of parliamentary proceedings; Stockdale's action threatened to overturn a situation of longstanding. Although Hansard was Parliament's official record, it was not certain that the publication enjoyed the same protection against libel

as Members of Parliament speaking in the House of Commons. This uncertainty led Stockdale to pursue his claim and a series of court cases followed. The court found Stockdale guilty of publishing obscene books and upheld Hansard's plea of justification that it had simply repeated the Parliamentary Report's statement that the book was obscene. But the judge did not stop there. He tried to rule that the parliamentary privilege which protected the House of Commons did not extend to Hansard. Seeing an opening, Stockdale sued Hansard on this one point.

Stockdale's determination was perhaps shaped by his father's earlier success in challenging the law of libel. In 1788 the older bookseller (who dealt mainly in cheap, remaindered books, and was thus a thorn in the side of fellow publishers) had been prosecuted for seditious libel by the House of Commons and acquitted. His case established that a man was not to be judged for a few unguarded expressions, and placed importance upon examining libellous passages in context rather than as extracts. Moreover, the decision as to an alleged libeller's general purpose or animus in writing was left to the judgement of the *jury*, not the judge. This was enshrined in the Libel Act of 1792, which marked a triumph for the freedom of the press in the wider campaign to destroy political censorship (Thomas 1969: 104).

It appeared that Stockdale's right to print the book rested on the definition of libel established in 1792, which had rejected the extraction of passages out of context. But the obscenity of the book, according to the inspectors, was in its parts, and not in its totality. In many versions of the book, there were no obscene elements at all, merely, as Roberton had claimed earlier, medical information about reproductive organs. Of course, as Roberton had also made clear in his correspondence with Baillie, any information about such organs would be open to various interpretations, as 'the greater part of a physician's professional duties' involved what Baillie would term 'obscenities' (Roberton 1817b: 27). The problem was twofold: medicine and obscenity were linked and definitions of the latter depended on emotion rather than reason (see Scott 1945: 26).

Stockdale turned the tables by suing Hansard and, consequently, charging Parliament with issuing libellous reports. The case of *Stockdale versus Hansard* dragged on for several years until, eventually, the younger Stockdale, like his father before him, was vindicated. This endangered Hansard, and the House of Commons therefore intervened and resolved the argument about the status of its official record in 1840 by passing an 'Act to give summary Protection to Persons employed in the Publication of Parliamentary Papers' (3 & 4 Vict. c. 9–10). Hansard, protected against prosecution for reporting parliamentary proceedings, now had the same privilege as Parliament itself (May 1893: 99–138). Section III of the Act also gave qualified privilege to newspapers that published accounts of such proceedings.

Stockdale versus Hansard raised more general questions about parliamentary privilege and press freedom. In its *Judgement in Error in the Case of Stockdale v. Hansard* of 1840, the Court of Common Sense commented that parliamentary privilege, by setting itself outside the ordinary operation of the law, consisted 'not so much in the right of publishing, as in that of suppressing and preventing publishing' which it considered 'adverse to the interests of society' (Court of Common Sense 1840: 10). The accusation and the defence occurred at a time when 'the people were growing more intelligent, and more inquiring. They were dissatisfied with the veil of obscurity, which concealed the Parliament from the nation' (Court of Common Sense 1840: 11). In other words, the case fuelled both Republican hopes for political transparency and Conservative anxieties about the possibility of such transparency.

The *Judgement* did not mention Roberton's book – indeed, the authors said that, as they had not looked at it, they were not in a position to comment – but offered a more general discussion of a political nature about press freedom and parliamentary control. The Court of Common Sense suggested that it was not so much Stockdale as the prison inspectors who appeared in a dubious light by declaring 'a physiological and anatomical book, written by a learned physician, and illustrated by anatomical plates to be a book of a disgusting nature, with plates of an indecent and obscene description' (Court of Common Sense 1840: 47). Obscenity was in the eye of the beholder and, in a neat reversal, the Court named the inspectors: Crawford and Russell. The *Judgement* stated that 'Mr Stockdale could never have known that the book would find its way into the cells of Newgate, there to be discovered by some lynx-eyed inspector who would make a report thereupon to the Secretary of State, which would be laid before the House of Commons, who would mix up his name with the business of the nation, and render him an historical personage' (Court of Common Sense 1840: 56–57).

The *Judgement* continued that 'had the book been found in the juvenile apartments of Eton or Harrow, the affair might have ended in the whipping of a schoolboy, or the dismissal of an usher' (*ibid.*). It was common knowledge that at the beginning of the century the investigations of the Vice Society had discovered a thriving business; a major network existed for the distribution of obscene materials and schools, particularly girls' boarding schools, did brisk business. There had also been one prosecution of a master at Eton (see Bristow 1977: 45). The *Judgement* ended with the observation that had more sensible measures been taken, 'Mr Stockdale's Friends would have lost the opportunity to win the laurels of Wilkes and Murray' (Court of Common Sense 1840: 57).[9]

The judges were referring to the notorious introduction to John Wilkes' *An Essay on Woman* (1763), in which the author drew attention to the overlapping and diverging boundaries between medicine and pornography. Wilkes

crossed the boundary between obscene and seditious libel. In his introduction he stated: 'I do not mean to enter into the anatomy of a cunt, to give a learned disquisition on the Hymen, to examine the droll animalcules in semine mas-culino … to conclude, I only mean to examine the *open* and *perceptible* parts; their finer *Nerves* and *Vessels* I leave to the Faculty' (Wilkes (1763) 1871: 10). Thus Wilkes established a kind of division of labour between what was deemed academic and what was considered popular: medical matters involved the hidden 'nerves and vessels', whereas popular (and obscene) matters were about what was 'open and perceptible'. The point was, however, that such a division between the academic and the popular, or the medical and the obscene, could not be sustained; Stockdale's publications contained both. To borrow from one of Stockdale's later titles, the plate of which the inspectors disapproved was 'il-legal and non-medical' showing none of the 'finer vessels' referred to by John Wilkes, but only the open and perceptible parts (Little 1832).

The significance of the case of *Stockdale versus Hansard* lies in the fact that it gave rise to a debate about state legislation and the relationship between the freedom to publish and parliamentary privilege. It did not matter that the trigger that led to a clarification of the law was not a political work and could hardly be considered subversive. Once the relevant legislation was in place, the press would have the same rights as Hansard and reporters the same protection as the parliamentary printers. The Court of Common Sense shrewdly commented that 'the press, though it may aggravate the mischief caused by the slanderer when successful, incalculably diminishes his chance of success, and affords the very best security against him. We must be content to take the good with the evil … the press which has overthrown bastiles, inquisi-tions, star-chambers, monasteries, priestcraft, tyranny and iniquity of every kind, is itself not unattended with evil. Nevertheless, blessings be upon it' (Court of Common Sense 1840: 58–59).

The government's intervention in the case of *Stockdale versus Hansard* drew attention to the question of privilege in publication, but it was only one piece of legislation among many that attempted, piecemeal, to use censorship to limit the freedom of publication. The Metropolitan Police Act of 1839 and the Drama and Performance Act of 1843 extended the powers current earlier in the century, but stopped short of giving the courts the power to destroy obscene material (see Scott 1945: 53–54). It was not until the passing of the Obscene Publications Act in 1857 that material could be 'forfeited' and destroyed if it was judged to be obscene (see Robertson 1989: 180). The Obscene Publications Act initiated two new ideas: first, it declared that obscenity was self-evident and established that 'obscenity as a ground for sup-pression could stand alone' (Scott 1945: 84); second, it held that obscenity could be separated from authors or motives. A prosecution could now succeed

when there was no author's or publisher's name on the offending article, a development which indicated a shift away from the crime of authorship to the crime of ownership and acknowledged the fact that, from the early nineteenth century onwards, the author, especially when mass-produced material was in question, had become a mere functionary. The Act modernised the law and brought it into line with the wider organisation of a society in which consumption was outstripping production. The new legislation did not, however, put an end to obscenity or pornography, although it pushed the increasing number of cheap publications underground, encouraging the development of an expanding mail-order business (Roberts 1985: 627). Censorship failed. As Robertson points out, from mid-century onwards, pornography thrived as never before (Robertson 1989: 181).

In the early nineteenth century, as Stockdale's activities make clear, images were routinely extracted from one book and used in another. Later in the century, however, it became cheaper to publish images combined with text, and it is at this time that the beginnings of a reconfiguration, a reorganisation of the body and gender begins to take place; there is a remodelling of the older discourse on generation and a gradual emergence of male and female sexuality. The woman's body that had come into view in the early nineteenth century disappeared by the end of it. By the end of the nineteenth century, sexuality hinged on what was visible, what the image could *show*.

Medical illustrations were becoming increasingly problematic for a society obsessed with sex. By the latter half of the nineteenth century, medical treatises became 'vague in anatomical and functional detail' (Bristow 1977: 126). For example, Trall's *Sexual Physiology and Hygiene* (1866), an illustrated work that was popular in mid-century, had its images removed by 1891. Trall's introduction lamented the ways in which 'the medical profession has wrapped its knowledge, vague and unsatisfactory as it is, in so many folds of technicalities, that the non-professional readers find little for them in the standard works' (Trall 1891: 6). His own work had little more to offer. Most of the book's discussion is concerned with animal reproduction and diet, 'tea, coffee, flesh meats … the abominations of the baker and confectioner' cited as the cause 'of the precocious development and morbid intensity of amativeness in primary school children' (Trall 1891: 224).

What had changed was *how* the female body came into view. The term pornography, as a distinct category of written or visual representation, appears at the same time as the Obscene Publications Act. Kendrick cites the 1909 definition from *The Oxford English Dictionary* as revealing 'a complexity often missing from later definitions'. The first definition is from a medical dictionary of 1857: 'a description of prostitutes or of prostitution, as a matter of public hygiene'; it was only secondly defined as 'a description of life, manners etc., of prostitutes or prostitution and their patrons' (see Kendrick

1996: 1). The term was not used widely before 1864 (Weeks 1981: 20–24). As a category, it was defined less by any content than by the strenuous efforts undertaken to regulate it (see Hunt 1993: 10–11). Pornography thus 'name[d] an *argument*, not a thing' (Kendrick 1996: 31, my emphasis). It is a 'category invented in response to the perceived menace of the democratisation of culture', and it was the form which the regulation took that mattered (Hunt 1993: 12–13).

One strategy for guarding against too much close observation by do-gooders (who seemed most concerned about the lower social classes) was to hide pornography from everyone except those already in the know, or those whose class (and purchasing power) allowed them to join those already in the know. The purveyors or keepers of both pornography and medicine created 'secret' museums of uncatalogued holdings. This was a means of regulating 'the consumption of the obscene so as to exclude the lower classes and women' (Hunt 1993: 12; Kendrick 1996). Price was also seen as a check on the availability of materials; penny papers were supposedly more likely to demoralise the public than those sold at a pound. One author described the Society for the Suppression of Vice as 'a society for suppressing the vices of persons whose income did not exceed £500 a year' (Craig 1963: 38). Form and quality, rather than content and quantity, are important here.

In the same period, two complementary movements had taken place, but at different levels of society. On the one hand, there was a radical severing of authors from texts: by virtue of sheer numbers, texts took on a life of their own and generated other texts, a characteristic shared with other mass-produced forms. On the other hand, a closer watch was kept over the intellectual rights and ownership of other types of texts, those unique or limited editions produced by and for high culture. Attribution and provenance, the question of tracing sources, became important in high culture just as the idea of originality lost its significance for mass-produced culture. The mass forms of pornography and medicine, where they overlapped, derived their strength not from attribution but from a kind of textual generation, from re-arrangement and repetition. Consequently, publishing became less innovative and more managerial. Stockdale was essentially an entrepreneur. The various editions of texts offering a mixture of these materials, one thinly disguised as another, are a testament to the reordering of objects rather than to the emergence of anything specifically new. The texts of Roberton/Stockdale and Bell/Little generated other texts by referring to each other.

One area of overlap that the Act of 1857 did not clear up was the ground shared by pornography and medicine and, most critically, the body of the woman, either by itself or imagined in drawings or photographs of generative organs. Roberton's text emerged in an era when the categories of medical and sexual were bound together (and, of course, the relationship between the two

still remains): English became Latin to screen titillation with higher culture; one author became two or more, as did books; medical descriptions were hot-blooded; vagina and vulva became cunt; drawings of reproductive organs swelled and had life even in the abstraction of a cross section (see Figure 9).

Roberton's work remained in circulation until the end of the nineteenth century when it was withdrawn from public sale; *Kalogynomia*, first published in 1821, was reprinted as a limited edition of 1,000 copies 'for subscribers only' in 1899.[10] The long-continued popularity of his work and its chequered publishing history offer an insight into how the politics of publishing and sexuality were intertwined and transformed in nineteenth-century Britain, and it was a small focal point in debates that helped to define modern representation. His *Generative System* marked the ways in which older, popular sexual beliefs were widely disseminated through print culture (see Porter 1987: 14). It was this same print culture which was responsible for the development and dissemination of 'professional' medical knowledge, before 'hegemonic medical policing', which was the dominant definition of professional practice by the mid-century, emerged (*ibid.*).

The illustrations in Roberton's books demonstrate the way in which the medical and the sexual gaze, which had yet to be separated, converged in the term obscene. Such plates were disquieting and unprofessional. Roberton's work is very much of its time, with its mixture of authors, images, publishers, popular medicine and sexual information, a melange absolutely characteristic of the early nineteenth century, before looser ways of writing, producing and consuming books were transformed into more ordered procedures, directed at two distinct markets.

Notes

1 The date of publication is erroneous in the report. There is a different date, 1831, given in the Parliamentary proceedings of 1840 (see vol. 52, page 1262). The actual date is 1824.

2 The catalogue in the University of Edinburgh gives this as his date of death. White suggests that he died in 1840.

3 The copy in the Royal College of Surgeons, Edinburgh, is inscribed to the eminent surgeon Geo. Bell, 'with best respects from the author'.

4 A 'bullet-in' by Benjamin Hardtman, MD, dated April 1 1808, complains of a messenger-at-arms preventing him from 'laying a hand on Roberton' … 'lest I should be put to any trouble by being suspected of having any concern in tweaking the said Mr. ROBERTON'S nose, pulling his Ears, caneing his Shoulders or kicking his seat of *Honour*'. Roberton suggests that Hardtman is 'well known for his shameless and beastly annoyance of every young lady however respectable either in the street or elsewhere' (National Library of Scotland, RY.1.4.215 (13)).

5 See Lowndes, *Bibliographer's Manual*, Part 8, 1858–65, p. 2102: 'Bell is said to be a fictitious name and the real author is John Roberton'.

6 This has been missing from the British Library since 1972. I have been unable to trace any existing copies.

7 This work is listed as edited by E. Little in The British Library Catalogue.

8 See facsimile edition of *Paris Lions and London Tigers*, 1936, p. 8. This book ran into 30 editions within the first year of publication.

9 In 1763 Wilkes, publisher of the *North Britain*, a publication critical of monarchy and government, had published *An Essay on Woman*. This was only the second work to be prosecuted as an obscene libel under the terms of the 1727 Act. Described as an 'obscene burlesque' of Pope's *Essay on Man*, Robertson called it a work on the theme that 'life can little more supply / Than just a few good fucks, and then we die' (Robertson 1989: 181). Clearly, both class interests and the need for careful regulation are involved here. Wilkes, an MP, had published only a dozen copies for private circulation and it was argued that, as in Stockdale's case, the government, which drew widespread attention to the case, was the real publisher. After fleeing to France, Wilkes returned to serve a year in prison. Thomas Potter is believed to have been the author.

10 The copy held in the British Library repeats that the Plates should not be carelessly exposed to Ladies or Young People: 'these Plates are therefore stitched up separately, and placed in a secret pocket cunningly hidden in one of the covers of the binding'. They are, not surprisingly, missing from this copy.

3
Political anatomies and the rise of the obstetric atlas

Prior to the mid-eighteenth century, the only bodies that came to the anatomy schools were those of murderers, whose corpses were normally gibbeted in chains, a post-mortem punishment reserved for relatively few crimes. This system produced about six corpses a year for dissection. However, in 1752 Parliament passed an 'Act for better Preventing the horrid Crime of Murder', which allowed judges, when delivering death sentences, to substitute dissection for gibbeting (Richardson 1987: 35). This increased the supply of bodies available to anatomists. Ending up on the anatomy slab, like gibbeting, was a post-mortem punishment worse that death itself, since it denied the wrong-doer a grave and an eventual resurrection. Birds no longer tore at gibbeted human flesh, slowly destroying the body piece-meal; instead, the rational anatomist carefully dismembered. The spectacle became less public, but the dissected bodies had a significantly lengthier afterlife in books.

The surgeon-anatomist, as Richardson suggests, became 'an executioner of the law' (Richardson 1987: 34). Legal and medical practice together transformed the market for bodies in the mid-eighteenth century, although the increased supply did not, in fact, meet the increasing demand for corpses, and certainly not the demand for female cadavers. Most murderers were male, and consequently female bodies were prized as rare commodities; pregnant female cadavers were doubly rare. It is therefore unsurprising that anatomists had few diagrams or other pictures of female anatomy; anatomical images of the generative or reproductive organs, including wombs and foetuses, were particularly scarce. It was not until much later, with the passing of the Anatomy Act in 1832, that dead bodies, particularly those of the poor, became ordinary articles of medical trade (see Richardson 1987: 220–238). Until then, exhumation made up the shortfall and cadavers were sold like meat in bits and pieces: half or whole, limbs or trunks, a head or a foot.

During the period when the supply of bodies for dissection was especially meagre, four anatomical atlases were produced. Three of the atlases were published in London in the twenty years between 1754 and 1774; however, they

were all conceived in the mid-eighteenth century and belong conceptually to the 1750s, lying somewhere between the older works on midwifery and the emergence of the new discipline of obstetrics. They are William Smellie's *A Sett of Anatomical Tables, with Explanations, and an Abridgement of the Practice of Midwifery, With a View to Illustrate a Treatise on that Subject, and Collection of Cases* (1754), Charles Jenty's *The demonstrations of a pregnant uterus of a woman at her full term. In six tables, as large as nature. Done from pictures painted after dissections, by Mr. Riemsdyk* (1757), and William Hunter's *The Anatomy of the Human Gravid Uterus exhibited in figures* (1774). These atlases have been studied both by art historians and feminist scholars. William Hunter's atlas, which is, arguably, the finest and largest of these works, is the most widely discussed.[1] A fourth atlas, John Lizars' *A System of Anatomical Plates of the Human Body,* was published in Edinburgh between 1822 and 1826. This was a general anatomical atlas but the gravid uterus was included because by then midwifery had been included in the medical curriculum. Lizars, unusually, produced his work himself and his original images are not cleaned up, do not survive so well, nor travel easily. However, they offer a different point of view on the ways in which images and bodies merged.

Since real bodies were in short supply and medical practitioners on the increase, the demand for illustrations in anatomy books increased. However, the expansion of the market in medical textbooks was not simply a matter of spreading knowledge more widely. The anatomical atlases had a profound effect on the way in which bodies were visualised and understood. From the eighteenth century onwards, there was no question of distinguishing between bodies and their representation; bodies were seen in the terms set out by the atlases. Anatomists were not only encouraged to 'dissect and draw' but increasingly learned the craft of anatomy from atlases rather than from bodies (see Chapter 1).

The atlases are multi-authored works. They use illustrations of moments in pregnancy so impossibly dramatised as to be untrue to life. They are made up from a number of bodies, by a number of men, employing a range of techniques. In order to visualise bodies, the anatomists first dissected them and then employed artists to make drawings in chalk or ink from 'life', or rather, from the dead woman and her foetus as they lay on the anatomist's slab. All three eighteenth-century anatomists, Smellie, Jenty and Hunter, employed one particular artist: Jan Van Rymsdyk.[2] Additional artists were also employed by both Smellie and Hunter. Lizars, on the other hand, was both dissector and artist, and his work marks the end of an older system of engagement with the object rather than solely with the image.[3] The atlases are very different, not only at the level of content, but in their formal expression.

Neither the original art works nor the style of the artists lent visual unity to the eighteenth-century atlases; this was produced in the process of translating

the drawings into plates for engraving. The anatomists required a high degree of authenticity, objectivity and exactitude, and a consistent method of reproducing illustrations was also necessary. Visual representation was (and is) complicated; reality must be transferred from one medium or more into a final stage, a process that requires a labour of transcription to take place. At the same time, any visual representation that claims authenticity or veracity always tries to conceal, or at least to play down, the act of transfer and to hide the elements of translation. Here 'optical consistency that cuts a regular avenue through space' is the key requirement (Latour 1986: 8).

The first two atlases used one of two methods: line and mezzotint engraving. The third employed finer engraving techniques in order to create a heightened sense of three-dimensionality. Each atlas was finally made coherent within itself, but that consistency was produced by the engravers, not the artists. Engravers were skilled in crafts that translated unique, original art work into systems that printers could use in book production. They all used drawing and painting at some stage, but moved on to processes more suited to the mechanical methods necessary for mass reproduction. Indeed, as John Thornton notes, engravers were paid considerably more than artists (see Thornton and Reeves 1983: 102). Not only did they unify disparate drawings but their plates enabled cheap copies to be made. Prints were more valuable than single, original drawings because they could appear in what it was hoped would be large print runs and in subsequent editions of atlases.

Atlases never were, or are, straightforward, unmediated representations of the body. Visualisation was central in defining how people understood themselves or, in these cases, how men understood women. Each atlas had a specific view of women's bodies that was supported by the anatomist's choice of printing method. Nothing was accidental or contingent in choosing from among the printing systems and the illustrations in each atlas represented part of an argument about the way in which women's bodies should be seen at the particular historical moment when generation was beginning to decline and reproduction had yet to emerge.

Significantly, however, none of the atlases specialising in women's organs included the words 'generation' or 'reproduction' in their titles. The absence of these words marked a transitional moment; the older, vaguer term, generation, which depended on the knowledge of the subject, was disappearing and the new, objectively verifiable word, reproduction, did not yet exist. Surgeon-accoucheurs were in competition with physicians, and they used the atlases to demonstrate and spread their professional practice, promoting rational, organised *reproduction* in opposition to those who still believed in the older ideas of disorganised *generation*. These atlases were part of the professional struggles taking place both among male professionals and against women as midwives. By the mid-eighteenth century, especially among the middle-classes,

men-midwives had begun to prise pregnancy and birthing away from the supervision and domain of women.

The atlases might not mention 'reproduction' in their titles, but the most influential ones pictured the female body as merely a germinator providing warmth and nourishment. The anatomist needed to know only about the processes of gestation, not about the body of the mother as an independent being with life, thoughts and projects of her own. The fact that life, until birth, is entirely dependent upon the mother's body was ignored. It was as if anatomy sought to dispel fantasies about the power that mothers have over life. Instead, in the minds of the anatomists, and in their books of instruction, mothers were already in pieces, already symbolically dead; pregnant women who died near to term were particularly valuable objects.

One outcome of the struggle between the older idea of 'generation' and the newer emphasis on 'reproduction', or, more properly, part of the developing argument, was that men distanced themselves from women. They imagined women as lying between themselves and nature, as conceptually some distance away. Men placed machinery in a similar bracket. They expected to gain ascendancy over nature partly by using machinery and partly by controlling women's bodies (especially in matters of reproduction). Again, as part of the argument that eventually defeated the idea of 'generation', women's bodies were actually conflated with machines, and were figured and described as such. Smellie, for example, viewed women's bodies as birth-machines. The mother's body was already regarded not as a living being but as a dead object, an inanimate machine for reproduction. Machines were made from parts and so anatomical images began to mirror the processes of industrialisation itself; they divided the body into what were perceived as productive parts which could be isolated or extracted. Anatomists, both in their everyday practice and when instructing their engravers to make prints, cut off and discarded those parts of the mother's body – head, arms, legs – which they perceived as unnecessary components.

Such perspectives were carved, inscribed on the body by the surgeon's knife, and by the engraver's needle. A certain violent activity joined engraving to anatomy. Anyone who has ever engraved is aware that it is a material act, not a surface process. The pleasures of gouging into a steel or copper plate are entirely carnal. Both dissection and engraving require a decisive cutting and carving. The eternal life of the image is always secured at the expense of the death of the object of study. Thus engraving, which involved incising, mirrored the work of anatomical dissection. Both processes demanded a degree of precision, a certain exactness and both are, essentially, a question of where to draw the line.

Anatomists began to imagine that the foetus was not formed within a body at all and to portray it that way in their illustrations. It made its antenatal

appearance at the centre of a universe of its own creation, as if it had formed itself, built a structure that it would later discard. Some of this reflected changing views which held that the foetus was alive before birth and acted as a trigger to labour, but the idea was significant chiefly because it made possible a complete separation of mother and foetus. Indeed, Hunter proved that the systems of foetal and maternal blood circulation were distinct (Needham 1959: 226). The anatomist and the foetus had one thing in common: they were active while woman was inactive. The anatomist could see, which is to say understand, that the mother was a merely passive object carrying an active subject, and was justified, so he thought, in rendering the maternal body inert. But he kept returning to the body, as if the mother was never safely dead, or sufficiently life-less. A large number of bodies was required to produce the most elaborate atlases.

William Smellie and *A Sett of Anatomical Tables*

William Smellie (1697–1763), who taught midwifery in Wardour Street in London's West End, did not at first sight appear well suited to 'the art'. A contemporary, William Douglas, described him as 'a raw-boned, large-handed man, no more fit for the business than a ploughman is for a dancing master. Such monstrous hands, are, like wooden Forceps, fit only to hold horses by the nose, whilst they are shod by the Farrier or to stretch Boots in Cranbourne Alley' (Douglas 1748: 17–18). He made his reputation, with some difficulty, by advocating and formulating rules for the use of forceps. Designs for forceps were introduced by the Chamberlen family in the late seventeenth and eighteenth centuries and their details were first published in Britain around 1733. These artificial hands were introduced into the woman's body that was, in complementary fashion, imagined and treated as mechanical or machine-like. The concept was clear for all to see in *A Sett of Anatomical Tables, with Explanations, and an Abridgement of the Practice of Midwifery, With a View to Illustrate a Treatise on that Subject, and Collection of Cases,* first published in 1754.

A Sett of Anatomical Tables contained thirty-nine plates, drawn largely by two artists, Pierre Camper (1722–89) and Jan Van Rymsdyk (*fl.* 1740–88); three illustrations were probably by other artists.[4] Critically, the different styles of the artists' initial drawings were eliminated in the printing process. The engraver Charles Grignion (1717–1810) introduced a degree of consistency to match the written text, with its concentration on the mechanical elements of 'parts' and 'dimensions'. Eleven of the illustrations were made by Camper in 1752 and used different drawing systems: line drawings in ink, line drawings with wash and a number which included cross-hatching, as if ready for translation into print. Another twenty-five illustrations were made by Van Rymsdyk in 1751; these drawings in red crayon were radically different in

style to Camper's and included much more detail. Such differences are accommodated in the tables (see Figures 10 and 11). The moment before the body is entered into, or exited from, is given depth, a certain life-like quality (see Figure 12). In Van Rymsdyk's original drawing a braided cushion remains in place. This is removed in the engraving. When the use of forceps is displayed, the body appears as 'diagrammatic', rendered in technical drawings that lack any sense of depth. Grignion produced a clear, coherent style that emphasised the mechanical nature of 'operative' midwifery and, necessarily, of women's bodies. This was a technical manual; Smellie set out to avoid what he called 'extreme Minutæ, and what else deemed foreign to the present design; the situation of the parts, and their respective dimensions being more particularly attended to, than a minute anatomical investigation of their structure' (Smellie 1754: Preface). He described Grignion's interpretation of the drawings as 'faithfully engraved' (*ibid*.). Smellie was not so much interested in 'delicacy and elegance' as in 'a strong and distinct manner'. He thought this type of rendition would make the atlas cheaper and therefore 'of more general use' (*ibid*.). But it had another desired effect: Grignion produced clear-cut, clean images in which the pelvis and uterus appeared machine-like. The female body was without organs, other than the foetus. The book opens with an image of the well-formed pelvis. It is then rendered as a series of parts and dimensions that had to be extended to include the instruments of midwifery; the forceps are given as much prominence as the body of the foetus, which appears at the centre of the image. While the foetus, as always, is complete, the mother's body is visualised in half-section (see Figure 13).

Indeed, in his Preface, Smellie states 'I hope I may without vanity say, that I have done something towards reducing that Art, into a more simple and mechanical method than has hitherto been done' (Smellie 1754: Preface). The mechanical was exactly what separated men-midwives from their female contemporaries. By law, apothecaries, surgeons and physicians were licensed to use forceps. Female midwives were not. While, as Moscucci suggests, this does not mean that female midwives did not use forceps, the transformation of the lay practice of midwifery into a profession dominated by men depended initially on tools, and on the legal right of men to wield them (Moscucci 1990: 48). For surgeon-accoucheurs, they were the 'key to the lying-in room' (Wilson 1985: 344). According to Elizabeth Nihell, a contemporary midwife and author of *A Treatise on the Art of Midwifery* (1760), 'the faculty for using these instruments is the sole tenure of their usurped office' (Nihell 1760: xii).

Andrea Henderson, in her article on models of childbirth in early industrial capitalism (1991), discusses the work of Smellie and Hunter. She suggests that the effect of Smellie's images is to represent 'the midwife as a worker at the machine of the maternal body', thereby eliminating the role of the mother

10 Jan van Rymsdyk, original drawing for William Smellie, *A Sett of Anatomical Tables*, 1754. The ninth table, 1751

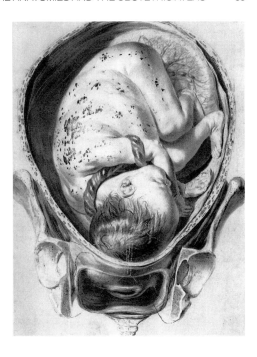

11 Engraving after an original drawing by Jan van Rymsdyk, for William Smellie, *A Sett of Anatomical Tables*, 1754. The ninth table, 'The Uterus in the eighth or ninth Month of Pregnancy'

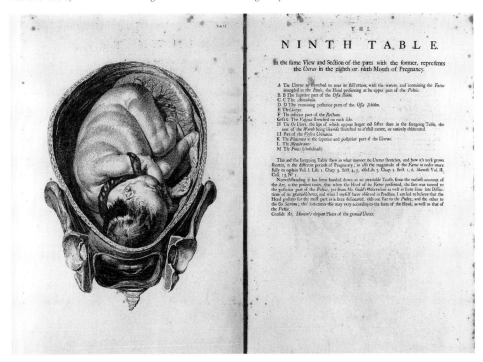

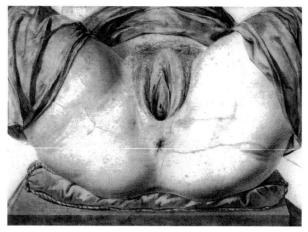

12 Jan van Rymsdyk, original drawing for William Smellie, *A Sett of Anatomical Tables*, 1754. The fourth table, 1751. Reproduced as 'The external Female parts of Generation'

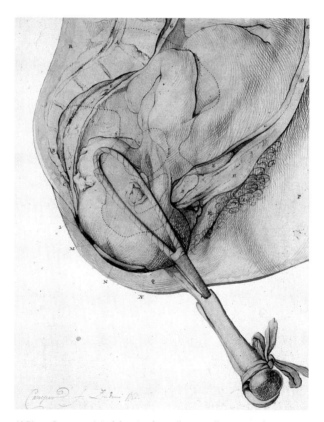

13 Pierre Camper, original drawing for William Smellie, *A Sett of Anatomical Tables*, 1754. Reproduced as 'The Manner the Head of the Foetus is helped along with the Forceps, as artificial Hands', 1752

in the process of childbirth (Henderson 1991: 102). Women were not themselves labouring but were subject to labour. Moreover, that labour was less the travail of flesh than the mechanical work of a machine. Midwifery became operative; it was managed or governed as if the body of the mother was a machine. Where nature was deficient, as it increasingly became, it had to be improved by actual mechanics or by imagining the whole process of birthing as being similar to a mechanical structure fit for improvement. The mother was perceived as an inanimate, hard, inactive object who blocked entry into the world; only the foetus was pictured as fat and fleshy. Woman did not give birth, but was delivered of a child. A poorly constructed pelvis or an inefficient uterus were mechanical deficiencies that hindered or prevented the extraction of what was literally a vital commodity. Consequently, the narrow pelvis or slow uterus required intervention, instruments and tools. The natural process of generation was to be recast in terms of industrial production and, in the course of the next hundred years, a newer modern term, reproduction, would enter into first medical and then general vocabulary.

Smellie began to train midwives (both male and female, but separately) and appears to have undercut the price and shortened the length of a course of training, thus alienating his peers and women-midwives. He appears in contemporary accounts as literally a 'man-mid-wife' (see Douglas: 1748 and Chapter 1). In his teaching he employed what Nihell called a 'doll-machine' (see Figure 14). This was 'a wooden statue representing a woman with child,

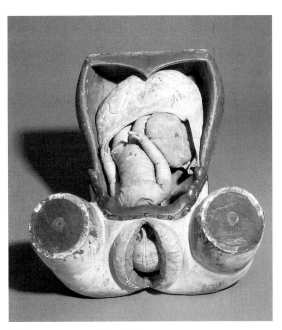

14 Eighteenth-century Obstetric Phantom

whose belly was of leather, in which a bladder, full perhaps, of small beer, represented the uterus. This bladder was stopped with a cork, to which was fastened a string of packthread to tap it, occasionally and demonstrate in a palpable manner the flowing of the red-coloured waters. In short, in the middle of the bladder was a wax doll, to which were given various positions'. Nihell added dryly: 'see the preface of this author. He speaks of his *machine* in the first page' (Nihell 1760: 50–51). Nihell contrasted the 'doll machine', a mere 'wooden woman' with the body of a woman, 'sensible, delicate, animated' (*ibid.*). The female midwives' hands of flesh, 'supple, dexterous', were set against 'iron and steel' (Nihell 1760: 36). Though Smellie covered his forceps with soft leather, this skin did not disguise them as anything other than artificial. Nihell described these new 'professionals' who employed the latest technology as little more than 'broken barbers, tailors and pork butchers ... trained up at the feet of [Smellie's] artificial doll ... for I know myself one of this last trade, who after passing half his life in stuffing sausages, is turned an intrepid physician and man-midwife' (Nihell 1760: 71). In Nihell's view, in the hands (or forceps) of such men, women's bodies were no more than meat to be butchered, trussed and stitched. It is frightening, even now, to read contemporary eighteenth- and nineteenth-century accounts of labours which lasted for days; of 'the wounds and lacerations made in the bodies of unhappy mothers', of foetuses removed piecemeal with a crotchet. Forceps had their place, but indiscriminate use by ill-trained practitioners was dangerous (Anon. 1825: 395–396).

Henderson suggests that Smellie's work concentrated on 'a maternal body of bone' and represented what was natural as hard, fast and mechanical. In contrast, the work of William Hunter (see below) concentrated on a maternal body of amorphous 'flesh'. She has characterised this difference as a part of the shift from neo-classical to Romantic ideals (Henderson 1991: 100). However, such a transition is perhaps too neat to be easily sustainable. The terms 'woman' and 'nature' were far more *elastic*, both chronologically and conceptually. 'Woman' existed in a zone between the natural and the mechanical, and mechanics was the frontier, or barrier, between men and chaos. 'Nature' was disorderly and had to be mastered or at least controlled mechanically (and, later, industrially). Henderson's approach is in itself an expression of the desire for order, and fails to acknowledge the untidy overlapping of beliefs. Her method places Smellie before Hunter in a teleological progression from neo-classicism to Romanticism, but events rarely unfold so evenly, except with hindsight. Smellie's work shows, as indeed does Jenty's atlas, published a few years later, that there was no smooth progression between the two.

Charles Nicholas Jenty and *The demonstrations of a pregnant uterus*

In 1757, Charles Jenty published *The demonstrations of a pregnant uterus of a woman at her full term. In six tables, as large as nature. Done from pictures painted after dissections, by Mr. Riemsdyk*. It was reissued the following year and published in France and Germany. It was clearly important to Jenty that Van Rymsdyk, who made the drawings 1755 and 1757, was acknowledged in the title. This inclusion emphasises the place of art in science, as a teller of truth.[5] Jenty is clear:

> The Publick is to take notice, that the originals of the tables were taken from this woman by Mr. Van Riemsdyk, and not done at Random, from Fancy, as some have been, which having the Impunity to be obtruded upon the Publick for real Delineations after Nature.
>
> It is well known, that the Subject, when the TABLES are done, has been seen by eminent Persons in the Profession, while Mr. van Riemsdyk was painting them; who have acknowledged the pictures to be the greatest master-pieces of his Performances that have ever yet been produced, and perhaps such as will hardly be rivalled. As for my part, I may venture to say, that nothing of this kind, has, as yet, been published on this subject in such a State of Pregnancy, and disposed in the manner that those TABLES are, tho' there are only six of them, which give a full Demonstration of all the necessary and useful Parts of the State. (Jenty 1757: 8)

Jenty's atlas has few plates and, despite the two editions, there are few remaining copies. Moreover, Jenty has an uncertain, that is to say unestablished, place in the history of medicine. He was an outsider, trained in France, working in London. There is no evidence that he practised medicine, surgery or midwifery, or indeed that he even lectured (Thornton 1982: 60). He was, then, scarcely part of the profession.

Besides the atlas, Jenty also published in that same year *A course of anatomico-physiological lectures on the human structure and animal oeconomy*. This work ran to several editions. Here Jenty was critical of Smellie, although he did not mention him by name. He wrote, 'as for the use of Forceps, Fillets or Crotchets, I reject them; the best Thing is the Hand, for the Delivery of a Child alive. In fact, I am inclined to think, that the Author or Inventor of Forceps & c contrived them to supply the Deficiency or Enormity of his Hands'. 'Therefore', he continued, 'women should examine the Hand of the Midwife she intends to employ' (Jenty 1757: 383).

Not only was Jenty an outsider, and one who complained of current methods, but he persisted in using artistic renderings of scenes and flesh, when the modernisation of midwifery seemed to require engravings that emphasised the mechanical relation of parts and dimensions. The illustrations in the atlas

have neither the clarity and number of Smellie's line-drawings, nor the detail of Hunter's work. To translate Van Rymsdyk's work for the printer, Jenty employed mezzotint, a softer method of reproduction that relies on tonal range. Jenty also had the images printed on soft paper. This was in keeping with his writing and his view of women's bodies. He emphasised organs, what he called the 'soft parts', rather than the bones; for example, in one plate, the rib cage appeared cut open and the organs seemed to burst out. Jenty obviously felt obliged to disclose his reasons for choosing this artistic method in an anatomical atlas. These were partly financial and partly related to the best method of picturing the reality of nature:

> If it should be asked, Why, in these plates, I chose Mezzotinto, instead of Engraving? I answer, that not only the difficulty and Length of time requisite to have executed these TABLES, by able persons, nor the expence [*sic*], which would have been considerable, prevented my Determination to Engraving; but the Engraving itself, how well soever performed, would not have answered my intention for Colouring, so well as Mezzotinto; as this method is softer, and capable of exhibiting a nearer imitation of Nature than Engraving, as Artists themselves acknowledge that Nature may admit of light and shades, well blended and softened, but never did of harsh outline: So it must be confessed, that these Prints may want the Smartness which Engraving might have contributed; but the Softness which they possess, may approach nearer to the Imitation of Nature, when coloured, than any engraving possibly could, merely thro' the unavoidable Delineation of the Outline.
>
> Gentlemen may have these Mezzotinto Prints, coloured after the original Pictures, of different Degrees of Perfection, according to the Price allowed to the colourer. (Jenty 1757: 9)

The 'Smartness' of engraving, a certain incisiveness, was replaced by 'Softness', an 'approach nearer to the *imitation* of nature'. Mezzotint was a method of printing that remained closer to painting, or rather a method that met painting half-way, by allowing colour to be added.

It is significant that Jenty employed the same artist as Smellie and used his work in such a different way, and that Smellie's and Jenty's books were published within a few years of each other. Rather than being a difference of development, 'hard' and 'soft' were intertwined; nature exhibited structure in so-called 'iron laws', but 'her' boundaries were also amorphous, excessive and difficult to contain. Jenty's atlas was a testament to this, but it was too grey, too undifferentiated, too soft for the precise or detailed style of Enlightenment science. Instead, the images demonstrated that art and science were not yet clearly separated, and this fact alone meant that the atlas belonged to medicine's past rather than its future.

The difference between the modernising techniques of the professional and the work of an outsider can be seen in the angle at which the body was depicted.

Smellie laid the body horizontally, as if on a slab, to be worked on, or presented it in section (see Figures 12 and 13). Jenty used a three-quarter angle with the figure semi-upright (see Figure 17). This is closer to the older works such as that of Bidloo (see Figure 15). The pose derived from the older tradition of renaissance anatomical models, ambivalent depictions that incorporated religious iconography, the aesthetics of art and medical motif. Jenty's image was not purged of those older signifiers. The woman's figure sat as if in a classical painting, suggesting, curiously, a degree of life. The drawing style allowed the subject to appear to meet the viewer's gaze, and at the same time satisfied the sexual desire to see without fear of punishment. However, the arrangement also suggested a less than scientific model, something other than a dead object of study.

The first plate showed the torso in one piece (see Figure 16). Although the focus was tighter in the second and third image, the figure was not yet entirely

15 Gottfried Bidloo, *Anatomica Humani Corporis*, 1685, Plate 55

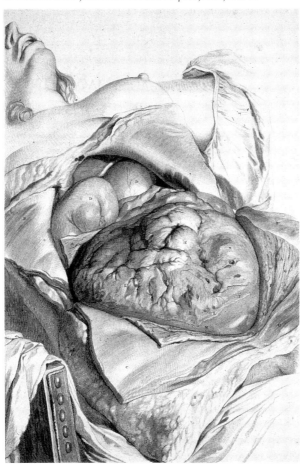

cropped (see Figure 17). She still possessed (one) breast and thighs; a sheet (or a gown) was pulled up to reveal what lay beneath. This represented the idea of lifting the veil at a moment of revelation, a moment of anticipatory, theatrical excitement that engages the viewer. This image gave spectators a sense that they had not just lifted the sheet, but boldly thrown it back on nature's cabinet. This style was maintained in other plates. The covering sheet was raised on the scene as if the onlooker were participating. The arms and legs were cast open, inviting the viewer to look in, as if the body itself could reveal its secrets. However, what was revealed was not the surface of the body, intact and sexually inviting, but the torso peeled of its skin. This image was not unlike the wax anatomical doll brought to life, and in the same way there were no marks of excision, no peeling back of loosened flesh. Everything appeared tightly packed, pregnant in its literal sense. Like the wax doll, the figure in the illustration hovered between life and death. 'She' was animate and inanimate; not quite vertical, and not horizontal, but somewhere between the two. 'She' was partially complete, not completely 'reduced', in Smellie's terms to a 'more simple and mechanical method'. The foetus was clearly still a body contained within another. Observers were invited to view an incredible scene and, as in nature, looked up to it. Eyes were drawn into the image, not only to the foetus, but also to what surrounded it; it was one body among other organs embedded within the body of the mother. The contradiction of the image of life in death suggests a more magical understanding of the body than is apparent in Smellie's work.

Neither the pose nor the technical methods used to produce the plates was entirely modern. The practice of midwifery underwent further modernising changes almost immediately, changes which caused a crucial difference between Jenty's and Hunter's atlases, an increasingly narrow focus on parts and the eventual disappearance of the whole woman's body. At the end of his introduction to the plates, Jenty stated:

> If these Tables meet with Encouragement from the Publick, I propose, some Time hence, to publish Two more; viz. one representing Part of the Cavity of the Uterus, where the internal Surface of the Placenta adheres; and a view of the internal Surface of the Placenta, with the Foetus injected and opened for the Inspection of those Parts which are peculiar to that State; the other representing a woman who died in the seventh Month of her Pregnancy, and her foetus in a preternatural situation. (Jenty 1757: 9)

However, Jenty produced no more work. He disappeared from view and his collection was sold, much of it coming up for auction in 1766.[7] Hunter purchased some of Jenty's work, and had by then been employing Van Rymsdyk on his own project for some fifteen years.

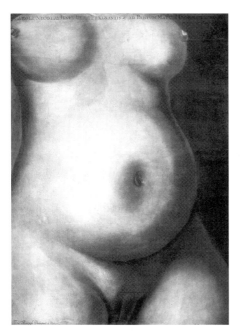 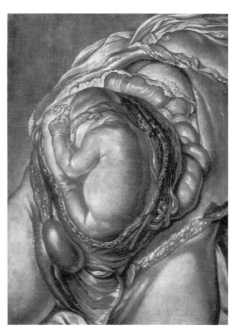

16 Charles Nicholas Jenty, *The demonstrations of a pregnant uterus. Done from pictures painted after dissections, by Mr. Riemsdyk*, 1757, Table 1

17 Charles Nicholas Jenty, *The demonstrations of a pregnant uterus. Done from pictures painted after dissections, by Mr. Riemsdyk*, 1757, Table 3

William Hunter and *The Anatomy of the Human Gravid Uterus*

Hunter's atlas, *The Anatomy of the Human Gravid Uterus, exhibited in figures,* was published in 1774, by which time Hunter had been engaged in both anatomy and its representation in pictures for more than twenty years. He had obviously exhibited these. Indeed, Smellie acknowledged Hunter's work in 1754 by stating in his description of the ninth of his anatomical tables, 'Consult Mr. *Hunter's* Elegant Plates of the *gravid Uterus*' (see Figure 11). Not surprisingly, Hunter's views and methods are a mingling of science and art, of detachment and excitement, of a cold eye and hot blood. What separates Hunter's work from that of Jenty and Smellie is its consistency and the scale of its visual and linguistic rhetoric. This ensured that Hunter's atlas came to dominate the field.

Hunter was both an eminent anatomist and a surgeon-accoucheur, as well as being Professor of Anatomy at the newly established Royal Academy of Art (see Richardson 1987: 37). He was also an entrepreneur and *The Anatomy of the Human Gravid Uterus,* sold through subscription, was an expensive book.[7] However the investment paid off, for it was through this work that Hunter made his mark. He organised the work of a number of assistants, including his younger brother John; all of them were subordinate to him and

some received little consideration at his hands. In the business of making his atlas, Hunter subjugated everything (and everyone) to his point of view. This subjugation certainly included the dead women; they never had a voice and Hunter had precedents for picturing them in parts.

Hunter was able to draw on conventional ways of acknowledging and dismissing assistance; weakening or eliminating the credit due to others was quite normal. He lectured to the Academicians on the superiority of Nature over Art, but Science represented the ground on which man might establish his superiority over both. The *Anatomy* was in the tradition of mixing science with art and of placing science above art. It was also in the tradition of self-advertisement prevalent among surgeons, which was accompanied by the simultaneous running down of competitors and of other professions and trades. Hunter's choices in the *Anatomy* strengthened and underlined his position as a surgeon-anatomist and declared exactly where the others stood in order below him: lesser surgeons and engravers were barely mentioned, Van Rymsdyk was ignored, and nameless women were dissected. However, Hunter put some of their parts on display in rich, excessive illustrations.

Looking at the atlas, it is important to keep in mind the discourses of art and science; both were required to produce the finished work. Ever present were the traditions of professions, the growing tensions between practices, and the absolutely modern need to captivate an audience. The *Anatomy*, then, was not simply concerned with Hunter's position as a skilled surgeon; this in itself depended on the ability to give to the public what they would never otherwise see. Hunter the surgeon was also Hunter the showman, the stage manager of a vivid spectacle. Hunter had mastered the different languages of art and science long before publishing the *Anatomy* in 1774. Consider the measured, matter-of-fact description of how a corpse, and everything else, falls into place:

> With respect to the present undertaking, in the year 1751 the author met with the first favourable opportunity of examining, in the human species, what before he had been studying in brutes.[8] A woman died suddenly, when very near the end of her pregnancy; the body was procured before any sensible putrefaction had begun; the season of the year was favourable to dissection; the injection of the blood vessels proved successful; a very able painter, in this way, was found; every part was examined in the most public manner, and the truth was thereby well authenticated. (Hunter 1774: Preface)

In contrast, consider his animated commentary on the means of representation, engraving:

> The art of engraving supplies us, upon many occasions, with what has been the great *desideratum* of the lovers of science, an universal language. Nay, it conveys clearer ideas of most natural objects than words can express; makes

stronger impressions upon the mind; and to every person conversant with the subject, gives an immediate comprehension of what it represents. (*ibid.*)

In the first quotation, a dispassionate voice speaks of what was once human in dead, languid prose. In the second, a vivid, animated voice speaks of the inanimate means of reproduction that will bring the dead body to life. Both discourses revealed the 'truth' about the woman's body. In the first case, 'a very able painter' was used to authenticate the truth as the anatomist saw it; in the second, engraving offered not only a means of disseminating this truth but one that could be readily be understood by the public. Engraving was a 'universal language' in the hands of the anatomist; it was superior to words; it had clarity and precision; it was immediate and impressive; it had an incisiveness that matched closely or simulated the processes of anatomy; it communicated truthfully and made a strong impression on the mind. These are images, Hunter suggests, 'etched' into the imagination. Their production process meant that they were, literally, impressions, while more metaphorically they made an impression on the viewer. The engravings have depth, allowing them to throw the body into startling relief; they are as large as life and this scale gives weight to the images; they are immediately perceived, even if not taken in at a glance; they are pressing and demanding, and invite prolonged and detailed looking.

Hunter's coup is also a linguistic one. While images dominate the field of vision, the plates are captioned and letters or numbers refer the viewer/reader back and forth from the image on the left to a detailed, classificatory list printed on the right-hand page. Objects are named and then described in more detail. They are labelled and given reference numbers. The lists are separated from the images, which makes the eye work at tying image to text. Scale is triumphant, but meaning is not found directly in the imagery. Rather, it is produced in the space between image and word, so that as soon as the observer sees a picture, he or she is compelled to make a reading. That immediacy of reading is made possible only over a period of time, during which viewers learn to knit together seeing and reading on the same plane. Details provide the viewer with a guide to the map of the labyrinthian body, its armature of bone and its layers of muscles, fat and skin. In Hunter's atlas, this has a powerful effect. While older texts on generation combined scientific and popular belief, medical lore and narrative description, poetic language and few anatomical prints, Hunter's atlas, posing as purely scientific and strictly anatomical, and seemingly without visual or narrative flourish, relies heavily upon the powerful visual image tied to a sparse text which is little more than captioning.

The comparisons with photography are inviting; it too has all the qualities Hunter attributed to engraving and both technologies were described as providing a 'universal language'. It is commonly supposed that the realisation

of a 'universal language' began with the optical consistency of photography but, as Hunter's remarks make clear, the claim has an earlier history and was attached to an earlier technology. That desideratum of science, a universal language in the form of an authenticating visual language, is part and parcel of the Enlightenment ideal. For such claims to become truths, public witnesses were needed. Hunter set out to use the so-called universal language of engraving to create *persuasive* images, as close to the aims of advertising as to those of science. There was nothing to be gained by obscurity. Given the limitations of medicine in the eighteenth and early nineteenth centuries, persuasion and advertising mattered.

The majority of the drawings for the *Anatomy* were made by Van Rymsdyk, who had worked for Smellie and Jenty. But this atlas was of a different order from theirs. It is an epic work: large, expensive, dazzling. It is weighty, printed on heavy paper; rich. Moreover, part of the success of the work lay in Hunter's astute decision to publish the atlas with plates on one side and parallel columns of English and Latin on the other. Latin, Walter Ong suggests, was a 'polemic instrument which from antiquity until the beginnings of Romanticism helped keep the entire academic curriculum programmed as a form of ritual male combat centred on disputation' (Ong 1971: 17). Indeed, Ong describes the ancient rhetoricians as 'the first media buffs' (Ong 1971: viii). Unlike the work of Jenty or Smellie, Hunter's atlas could be widely accessible in his own country while also travelling across linguistic barriers without translation. This catering to a wider market was innovative.

What 'truth', then, was this substantial, expensive, heavy tome advertising? Whatever it was, it had to be made persuasive as it was carried from one site to another (from anatomy theatre to studio to printer to book) and through different means of representation (from ink and chalk drawing to engraving). Every stage demanded alteration until the image reached perfection, or at the very least its finished form in the engraving; changing site, scene and image, right up to and including the actual engraving, was unavoidable and even desired. This made the whole process of the transfer of reality into representation one of accommodation and translation, as was to be the case also with photography, that later 'universal language'.

Unlike Jenty in his use of soft mezzotints, or Smellie in his line drawings, Hunter used the roundedness of engravings to see and show off the body of a woman as meat. In Table I of Van Rymsdyk's original drawing the body is swathed in a cloth, but in the print this has already been partially removed; drapes are perhaps perceived as ornamental (see Figures 18 and 19). The engravings show body parts: thighs cut through, legs sawn off, stumps in view, the body emptied and rendered in outline. By Table VII the body is emptied (see Figure 20).

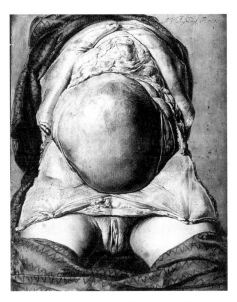

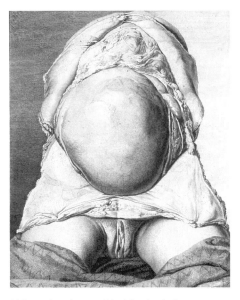

18 Jan van Rymsdyk, original drawing for William Hunter's *The Anatomy of the Human Gravid Uterus*, 1774. Table 1, 1750

19 Engraving after an original drawing by Jan van Rymsdyk, 1774. Reproduced as Plate I, 'The abdomen opened by a crucial incision'

Hunter knew that medical illustrations were distinguished from art not only by clear delineation but by their lack of any artificial, ornamental framing devices. The device of the frame had helped to emphasise perspective, which always directed the gaze to a specific point. The frame had encouraged viewers to focus tightly on a particular object (though it could never guarantee that viewers would take the hint). Yet the absence of frame worked even more strongly in directing what viewers saw in Hunter's tome. It suggested that the object was powerful in its own right and did not need explicit framing to draw the scientific or curious gaze. This lack, or more correctly invisibility, of a frame, suggested an unmediated gaze based on purely scientific interest and having direct access to whatever was in view. Science made this type of unadorned and undirected looking legitimate.

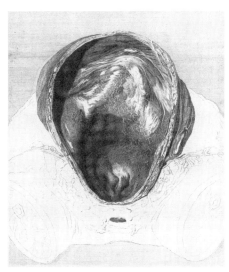

20 Jan van Rymsdyk, original drawing for William Hunter, 1774, Table VII. Reproduced as Plate VII, 'A foreview of the cavity of the womb'

In the second image, the body part is a more dramatic image than Van Rymsdyk's, with the severed legs displayed, unframed and floating as if defying gravity (see Figure 19). It is presented to the viewer in both its grisly and its cleaned-up dimensions. This is a body rationalised. The instruments, such as knives, saws and the workbench, are missing from both drawings and engravings. This differs from the practice in earlier atlases. Occasionally a minor detail, which adds nothing to the strictly anatomical value of the image, is included. These incidental details added to the dramatic realism of the image, by functioning as a mark of authentic eyewitness.

Translation from one site to another and from drawing to engraving pre-supposed that an idea would be carried forward by this persuasive rhetoric. The idea of 'Woman' started and stopped at the womb. In contrast to the foetus, which was granted integrity, the woman was much less than herself, greatly cut away and incomplete; so much dead meat. Though the engraving offered up the woman's body as meat, however, it was not so much hacked into chunks as carefully and precisely dismembered. Anatomy, as it appeared in idealised engravings rather than as it was practised in the theatre, had a violent precision. There was little left of the woman; she had been cut away, peeled back in layers to reveal the truth, and stitched up. The woman's body was no more, and no less, than the site of something else: generation.

This process required interrogation. Hunter managed to 'procure' the dead bodies of thirteen pregnant women. The first was freshly dead, a corpse from which much could be made, and the other twelve were cadavers. This procurement was no small feat. Hunter got more than his fair share of bodies and informed the viewer of the atlas that 'the opportunities for dissecting the human pregnant *uterus* at leisure, very rarely occur. Indeed, to most anatomists, if they happen at all, it has been but once or twice in their whole lives' (Hunter 1774: Preface). Hunter celebrated his good fortune and made the most of his collection of cadavers. A cast of one woman still exists and is permanently displayed in the Hunterian Medical Museum at the University of Glasgow.[9] Hunter managed to produce thirty-four plates from the thirteen corpses. The first ten came from the freshest corpse and he originally planned to publish these as 'a ground-work for further improvements in this branch of anatomy' (*ibid.*). Work had to begin quickly, and 'the blood vessels were injected with coloured wax, so that accurate drawings could be made' (*ibid.*). The other twenty-four plates were based upon the dissection of the additional twelve pregnant cadavers.

The images were meant to dominate; the text consisted merely of cap-tions, integrated with the plates. This was high quality work. Hunter employed the finest artists, the most skilled engravers and the best printing methods and materials. He was an entrepreneur of the female body in dissec-tion. The anatomical atlas was its shop window; his anatomy theatre was its

showroom. Hunter was greedy for objects, for material; he acquired, col-lected, bought and sold bodies, works of art and specimens; he orchestrated anatomists, bodies, artists, engravers, printers. He solicited subscriptions and the price of the work was high. His role was to conceive and execute a grand project. A Protestant work ethic legitimated the expenditure of money, time, and bodies. Hunter is described as 'tireless' and this is an exhaustive work.

Hunter revealed that he had 'actually kept back several drawings which had been made, and two plates which had been engraved, that the work might not be overcharged; and would have withheld more, for that reason, if he had not thought that it would probably be long before a more perfect system of figures would be offered to the public' (Hunter 1774: Preface). This consideration induced him to risk the [sic] being censured rather for having done too much, than too little' (ibid.). It was an excessive work in every sense: large, expensive, scientifically dubious. He knew this, and was anxious to pre-empt any criticism:

> With regard to this work, which is a faithful representation of what was actu-ally seen, the judgement of the public will probably be divided. Many will approve of the labour and expense which have been bestowed upon it and commend the largeness, elegance, and variety of the figures. Others will think that a great part of the expense might have been spared, and the work thereby rendered of a more general use, if the figures had been made to a smaller scale, if the engraving had been less finished, and some of the figures, which are very similar to others, had been omitted. (Hunter 1774: Preface)

Excessive financial outlay might sully scientific truth. What was the func-tion of the book? To advance anatomy? To impress the viewer? To display Hunter's power? This was a work on the cusp of a acceptable opulence and a base commerce, and by the late-eighteenth century, it was a fine line which separated the two.

Hunter claimed authorship of the work, and he did so by asserting owner-ship of the bodies, drawings and prints. He wrote that, 'if it be allowed that the *author* has spared neither labour, nor time, nor expence [sic] in improving an important part of anatomy, this is all the merit which he can claim' (Hunter 1774: Preface, my emphasis). This false modesty served, of course, as an important display of social standing and good manners. It was Hunter who had conceived, nurtured and brought to fruition this project. He had paid for the bodies and labour of others, women, assistants, artists, engravers, and so they or their work became his property.

But although William Hunter took all the credit, he clearly did not do all the work. By the eighteenth century authorship was managerial. Hunter relied on his brother John to acquire bodies, and it is also likely that John was responsible for most of the dissections. In this respect John Hunter operated,

in the early stages of industrial capital, as both supplier and consumer (Richardson 1987: 57). He was, however, given only a passing (and back-handed) acknowledgement in the introduction: '[his] accuracy in anatomical researches is so well known, that to omit this opportunity for thanking him for his assistance, would be in some measure to disregard the future reputation of the work itself' (Hunter 1774: Preface). There could be only one master and John Hunter was relegated to second place, as assistant.

There were also numerous artists and engravers, eighteen in total. Some of the better known, Cozens, Blakey and Edwards signed their work, but only the supervisor and engraver, Strange, who one imagines to have been a toady, was singled out for praise, and 'for having by his hand secured a sort of immortality to two of the plates' (Hunter: *ibid*.). Van Rymsdyk, who had worked for Hunter over a twenty-two year period and had produced most of the images for the book, did not even warrant a mention. It is little wonder that this lack of recognition angered him; in his later work *Museum Britannicum* he cursed Hunter, stating that, 'it is dishonest mean cunning, in making one self a great Man with other People's Merit' (see Thornton 1982: 65). Hunter's omission of Van Rymsdyk's name may, however, be a consequence and a reflection of the high regard in which engravers were held. In his preface Hunter describes Van Rymsdyk as a 'very able painter'. Engravers are described as 'our best artists' (Hunter 1774: Preface). The artists' original drawings were, in themselves, of little value and might be exhibited for a small fee; it was the plates, which could be printed and reprinted, distributed and circulated, that were the source of real profit.

This division between artist and anatomist reveals several factors of importance. First, it demonstrates that the concepts of the high value of originals, and of authorship resting with originators, were not clearly established in the late eighteenth century; on the contrary, status was determined strictly by ownership and by reproducibility. Our modern preoccupation with the circulation of information and with the question of whether it can be mass-produced and owned at the same time appears to have its roots in the late eighteenth and early nineteenth centuries. Second, the obsession with ownership and reproducibility has led, conversely, to a fascination with and search for originality. The current demand for original copies and limited editions results directly from the new scale of unlimited production that emerged in the eighteenth century. A third factor, which was not in itself a consequence of what was happening in Hunter's world, but which was nevertheless central to his work, was that authorship was already a gendered category in an essentially patriarchal discourse.

In the interests of scientific veracity, Hunter emphasised that 'in the course of some months, the drawings for the first ten plates were finished, and from time to time the subject was publicly exhibited, with such remarks as had

occurred in the examination of the several parts' (Hunter 1774: Preface). This was part of the process of authentication; private dissection had to be made public to an audience which would bear witness. This was a necessary part of the quest for objectivity and truth characteristic of Enlightenment science. Hunter went to great pains to ensure that his work bore the mark of objective truth and pointed out the contrast between his methods and what he perceived as opposing ways of anatomical drawing:

> Anatomical figures are made in two very different ways; one is the simple portrait, in which the object is exactly *as it was seen;* the other is a representation of the object under circumstances *as were not actually seen,* but conceived in the imagination … That figure which is a close representation of nature and which is finished from a view of one subject, will often be, unavoidably, somewhat indistinct or defective in some parts: the other, being a figure of fancy, made up perhaps from a variety of studies after NATURE, may exhibit in one view, what could only be seen in several objects; and it admits a better arrangement, of abridgement, and of greater precision. The one may have the elegance and *harmony* of the natural object; the other has commonly the *hardness* of a geometrical diagram: the one shews the object, or gives perception; the other only describes, or gives an idea of it. A very essential advantage of the first is, that as it represents what was actually seen, it carries the mark of truth, and becomes *almost as infallible as the object itself.* (my emphasis) (*ibid.*)

Human subjects were mutable and fallible, while objects were immutable and infallible. The solution to this problem was to have live subjects that were as much like inanimate objects as possible: cold and hard. Hunter acknowledged that compromises must be made for publication:

> [E]ven when attended with the most favourable circumstances, the anatomist must fix upon a plan, without loss of time, and at once carry on two schemes which are hardly compatible; that is to say, he must dissect for his own information, in the first place, and yet conduct the inquiry so as to have good drawings made of the principle appearances: and it is more than probable that he must alter any plan that he might have proposed, and adapt it to a variety of circumstances in the subject that could not have been foreseen; and much time must be lost, and the parts must be considerably injured by long exposure to the air before the painter; especially if the work be conducted by an anatomist who will not allow the artist to paint from memory or imagination, *but only from immediate observation.* (my emphasis) (*ibid.*)

'Immediate observation' was, of course, engineered looking, aimed at persuading viewers distant in time and place from the original scene that it had been faithfully transcribed and looked to them, as nearly as engraving will allow, as it looked to the anatomist or artist-under-supervision. Engraving

allowed an almost exact rendition of what-was-seen, despite its obvious dif-
ferences from eyesight itself, and this made it a 'universal language'. It was the
intention of the anatomist to convince readers or viewers of the atlas that,
first, he had himself seen what they are seeing now and, second, that the artist,
or more importantly the engraver, had faithfully translated what the
anatomist saw. Any adaptations or alterations in the engravings were not mis-
directions; they were in fact getting closer to the truth. All these claims were
made, years later, on behalf of photography: authentic, eye-witness; an accu-
rate translation; virtually a transcription; objective; truthful; realistic. Again,
the notion of objectivity and therefore truth depended on the management of
imagery with an intent to persuade, and (in a fully realised industrial era) this
intent depended in turn on image reproduction, rather than image uniqueness.

In his work Hunter cited two anatomical atlases as his sources: the works of
Bidloo (1685) and Eustachius (1714). Hunter considered that the heavily
stylised, unrealistic illustrations of Eustachius were not based on direct
observation; Bidloo, with his attention to detail, provided more truthful repre-
sentation. Bidloo's work is worth commenting upon because it included many
extraneous details, such as a fly landing on the sheet or the inclusion of the tools
of the anatomist's trade: knives, scissors and strings and pins which manipulate
the corpse like a puppet. In one plate a uterus lies pinned down on a slab.
Moreover, in two plates (55 and 56) the head of the mother appears (see Figure
15, p. 75). This body appears like a cabinet opened up. In contrast to Hunter's
atlas, Bidloo understood that the foetus is one part of the mother's anatomy. He
illustrated the fact that the small body was deeply, and clearly, embodied,
embedded within the mother. The relation of viewers to her body was also such
that they could feel that they might pick her up and hold her. She was not supine,
but rested at a diagonal angle across the page, as if the body might be embraced.
Although the corpse is opened up, it is still partially clothed; to the modern
viewer, the sleeve of her blouse seems out of place.

The schemas of the two atlases were very different in their ideas of how to
achieve realistic representation but they were not incompatible. Realism is not
absolute but is rather an attribute of the powerful, persuasive systems of the day.
Wherever it appears, it is always shot through with fantasy. There is always a
two-way traffic, or interdependency, between actual bodies and their images.
The seeming actuality of 'immediate observation' cannot be separated from
memory or imagination, any more than the head can be severed from the body.

The desire for boundaries was reflected in both anatomy and engraving,
but they were not easy to maintain. The lack of clear boundaries, or of distinct
organs, is in the nature of being human. (It is also what makes the body the
source of our greatest pleasure as well as of our greatest anxiety.) Even so, sep-
aration was imperative. Hunter, for example, was well aware of the necessary
division of head and heart, with detachment built on a substructure of

emotion. The danger of feeling, of being touched by something rather than touching it, was that it would compromise his scientific detachment. For Hunter, 'Anatomy is the Basis of Surgery. It informs the Head, guides the hand, and familiarizes the heart to a kind of necessary Inhumanity' (Richardson 1987: 30–31). Richardson comments that this 'necessary Inhumanity' is what we would now call 'clinical detachment', with its positive (objective) and negative (emotionless) connotations (*ibid.*). To further the ideals of Enlightenment science, heads must win and hearts be hardened.

The potential for two-way traffic, however, meant that the idea of 'clinical detachment' could easily be described as a 'passionate attachment' to the object under scrutiny. Such a reversal would not be acceptable in everyday situations or ordinary relations. The very fact that one version, 'clinical detachment', is preferred over its opposite, 'passionate attachment', is a consequence of the way in which we are generally encouraged to think of the power of the subject has over the object; we are not generally reminded of the power of the object over the subject. We are not invited to think that the object of study might breach boundaries and overpower the subject, and indeed thoughts along these lines always derive from and lead to anxiety, defensiveness and different forms of censorship. This is especially true of images of bodies. No image has more power over the subject than the image of the body; and for the male, perhaps, this is especially true of the female body, the place where his life began. This can be fascinating and threatening. The womb, as Rosi Braidotti suggests, has always held men in 'suspense' (Braidotti 1994: 68).

Passionate attachment, to be legitimate, must become clinical detachment. Hence it was acceptable, in the field of medicine, to imagine the woman's body as a mechanical toy with hidden workings, something that could be taken apart so that it might be better understood. Killers destroy the object, and usually there is nothing precise about their act. Anatomists, on the other hand, in their desire to look into pregnancy, took dead women apart rather precisely. Some kept an eye on the woman as a whole, others did not. There was no simple path from one to another, but rather a number of points of view. It remains a fact that the most elaborate atlas of the eighteenth century, the one that set out to persuade viewers of its objectivity and truthfulness by means of the most realistic pictorial device then available, also chose to eliminate the woman's body, to cut her up and push her out of the picture. This might be read as a denial of male human embodiment.

What mattered in Hunter's work was the integrity of the foetus. The body of the mother had no such integrity; she was disembodied, dismembered, dislocated. She ceased to exist. She was sliced open, propped up. In the first three images Hunter shows us around, then he takes the viewer into the body. By Plate IV, 'A Fore-view of the Womb', the descriptive list begins with 'The thighs cut through', followed by 'The womb. All over its surface the injected

vessels are seen projecting through its substance'; 'the body of the *clitoris* cut through'; 'the bones of the pelvis being drawn a little asunder that the contents might be better seen' (description to Plate IV). In Plate VI Hunter writes, finally, 'The navel string is cut' and 'Every part is represented just as it was found; not so much as one joint of a finger having been moved to shew any part more distinctly, or to give a more picturesque effect' (description to Plate VI). The mother in the picture had no arms, let alone fingers, and even her womb and her bones have a life separate from her own; they have become merely 'the womb' or 'the bones', and are so posited as having no relation to her, or indeed any body.

This disarticulation of the woman's body conjures up something like the farce of a funeral parlour, where the action goes into reverse; a dead object is prodded and poked into some vestige of what was once life. In thinking about what Hunter actually did, it is necessary to imagine the hauling, injecting and cutting, the pulling and pushing and so on. The claim that not so much as one joint of a finger was moved was a deliberate diversion of attention away from the frenetically active hands of the anatomist and his assistants, which cannot be shown if an image is to remain plausibly objective. The hand of the anatomist was invisible; the foetus untouched. In Plate VII, 'A Fore-view of the cavity of the womb as it appeared when the child was taken out' (description to Plate VII) (see Figure 20).

The cutting of the 'navel string' or umbilical cord was an event of symbolic significance for Hunter. It was the moment when one body irretrievably became two. Hunter, anatomist and man-midwife, delivered a foetus from a corpse and then dispensed, literally, with the mother. Within Hunter's schema, the cutting of the chord allowed the foetus to be moved freely in such a way as to offer the best views, and even to be removed altogether. The aim seems to have been, however, to make the mother disappear. Even before opening, the body is cut away and there then begins a process whereby the mother vanishes, goes outside the frame. Hunter writes that the adjacent parts of the subject 'expressed by out-lines' (description to Plate VII). Hunter tightened the focus and confined detail to those parts he deemed the most important. He claimed that viewers saw what he himself saw, but in fact they saw only what he showed. This was a staged pre-sentation; Hunter selected and organised the field of view in ways which were familiar then, and which are not dissimilar to our own experience of camera-angle, focus and cropping. These devices were designed to conceal the fact that the foetus was also dead.

Bodies and books

There is one image that is little commented upon, Plate XXVI, figure IV (see Figures 21 and 22). In talking about this image, 'From the tenth subject, in the

fifth month, shewing the circumstances of a retroverted womb', Hunter remarked that 'the convex surface of the transparent membranes, reflected a distinct miniature picture, of the window which gave light' (Plate XXVI, description to Fig. IV: The womb opened, to shew the secundines and their contents). This motif and its inclusion marked the image's realism. The source of light was clearly indicated in the form of an astragal window: a miniature grid is reflected on the amniotic sac of a retroverted womb. This formed a double 'reflection', one obviously intentional, the other less so. Hunter deliberately drew attention to this detail because he knew it to be a hallmark of truth, of having-been-there, of presenting the object to viewers in black and white 'exactly as it was seen'. However, the grid is a (probably) unintentional reminder of the grid of the image, of the way in which viewers saw through a screen, both literally and metaphorically. I say 'probably unintentional' in this case, not because contemporary viewers were unaware that they were seeing an image (they were not), but because Hunter did not discuss the complexities of vision and perception. Though he mentioned engravers and praised their work, what he enthused about was their skills of authentic and truthful depiction of his labour. All transcription was to serve the end of faithful representation, to offer a window on to the world; indeed this image seems to represent an entire world in itself, one that is opened to our view.

If there was more significance, unremarked by Hunter, to the reflected window, it may have been its blackness, which also served the central purpose

21 Jan van Rymsdyk, original drawing for William Hunter, 1774, Table XXVI. Reproduced as Plate XXVI, Fig. IV, 'The womb opened to shew the secundines and their contents'

22 Engraving after drawings by Jan van Rymsdyk for William Hunter, 1774, Plate XXVI, 'From the tenth subject, in the fifth month, shewing the circumstances of a retroverted womb'

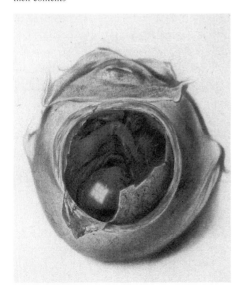

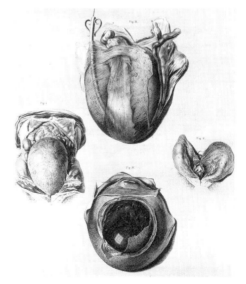

of realism. By the eighteenth century colour had negative associations as a cosmetic adornment that served artifice. This meant that an image in black and white was perceived as less likely to seduce; it was closer to truth, if not actually a reflex of it. With all its connotations of stiffness, black and white gave a certain rigour to images. It also mimicked the printed text; thus they both carried a degree of weight and so became more smoothly integrated. The discrepancies between drawings and engravings become strikingly apparent.

The reflected window in black and white suggested not only the presence of the artist at the scene but the reality of image production faithfully carried through. Someone placed this plate upon a sheet of damp paper. The reader can feel the paper's weight and see the marks of the printing plate as the machinery pressed down, binding plate and paper to produce an image in black and white. These engravings have a depth that is tangible. Compared to contemporary images and texts, this makes for a very different experience in reading and looking, mobilising the sense of touch as much as sight. The traces of production are still there: the uneven pages, the errors and, not least the smell. It is this that gives a density, a living quality, to books and suggests that some of the pleasures of reading and looking are in the realm of other senses: touch, smell and sound. These senses have become repressed in modern technologies.

In looking at old books we are aware of them as objects-in-use, not simply as information. There is a space between reading and looking that emphasises both a radical discontinuity and the possibility of continuity between words and images, books and bodies. The space between word and image broke the circuit that in later years would bind vision to knowledge. In that space, something important happened, something that smacks less of anchoring and more of evocation. Wrapped and bound in leather, the books themselves become like the bodies they represented, bearing secrets that may, eventually, be disclosed. In his original drawing for Hunter, Van Rymsdyk placed a book between the thighs of the woman (see Figure 23). This was much reduced and reproduced in Table XXVI, figure I (see Figure 22). It was an older pictorial convention to use an open book to represent female genitals; this also suggests that nature, and woman, are open books. But the book was removed in the engraving, as it was from figure II (see Figure 24), possibly because it aligned the image too closely with art and metaphor rather than with science and fact.

Though he rejected Van Rymsdyk's use of a book, Hunter was himself committed to book form; he made a book out of bodies. Perhaps he thought that Van Rymsdyk's original drawing made the connection too obvious. Hunter's atlas stood in place of thirteen cadavers and their dead children. His was a master's text and the mothers' bodies were the raw material, the stuff out of which a master discourse about life would be fashioned. The atlas was

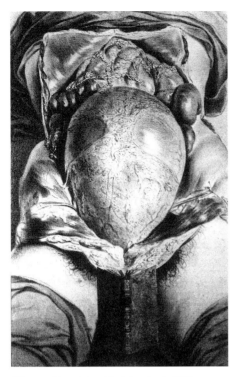

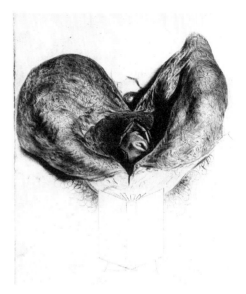

23 Jan van Rymsdyk, original drawing for William Hunter, 1774. Table XXVI. Reproduced as Plate XXVI, Fig. I, 'Shews in miniature the abdomen fully opened by a crucial incision and the bladder enormously distended'

24 Jan van Rymsdyk, original drawing for William Hunter, 1774. Table XXVI. Reproduced as Plate XXVI, Fig. II, 'Drawn in miniature to the same scale, shews the bladder cut down through its middle, and opened, at its lower part, to shew the situation of the os uteri'

part of a cultural discourse closely linked to questions of intellectual and material property, ownership and copyright. An 'issue' stands as both human and textual object; a book has a period of gestation, and giving birth to and creating a text are spoken of in the same breath. In this sense the brain is understood as the mind's womb (see Thomson 1996: 8). We conceive of an idea and bring it to life through words and pictures; but we too are formed through images, through texts. The mother's body is a long-lost, archaic referent, not a point of origin. No record exists of the women in these texts. They are not named; do not feature in the accounts. Their lives, like all mothers, are in the past tense.

Engraving, with its associations of death, mimics the processes of anatomy by digging, gouging, cutting and embalming. It marks a shift from public spectacle to second-, third- or even fourth-hand mediated illustration, which opens up new uses of private circulation and consumption. Books travel and pass through individual hands and gradually public, organised displays within theatres of anatomy recede. It is as if the book is animated

and brought to vivid life while the body becomes limpid and immobile. It is life that is cadaverised. In Debord's words, 'everything that was directly lived has moved away into a representation' (Debord, cited in Friedberg 1993: 15). In the modern world, there are no clear means of separating 'life' from 'representation'. They are both woven of the same material: the mother's body.

John Lizars and *A System of Anatomical Plates*

By the early nineteenth century, midwifery had come to be taught as part of the medical and surgical curriculum. John Lizars (*c.* 1787–1860) studied at the University of Edinburgh and later went into partnership with the anatomist John Bell (who had been his teacher) and Robert Allan. Lizars was highly successful, both as a teacher of anatomy and as a surgeon. He later worked alone and by 1831 he had become Professor of Surgery at the Royal College of Surgeons. However, in a public quarrel with James Syme he fell foul of the establishment and his death in 1860 was thought to be the result of an overdose of laudanum.

Lizars' work, *A System of Anatomical Plates of the Human Body,* was published in twelve parts between 1822 and 1826. Part XI of the atlas detailed the abdominal viscera and the organs of reproduction and Part XII illustrated the gravid uterus and lymphatics. 'Midwifery', wrote one Edinburgh reviewer, 'has not been neglected by students at the Edinburgh School. A competent knowledge of the theory and practice of this art is required by the Royal College of Surgeons, and those who commence their studies after 1824, and wish to graduate at Edinburgh, must produce testimonials of having paid due attention to midwifery' (Anon. 1825: 397). Lizars' work continued to reflect the changing curriculum and was reprinted, with additions, in 1856. One testimony to the longevity of the *Anatomical Plates* is the various editions and copies, used long since, that lie gathering dust in the Royal College of Physicians in Edinburgh. These also demonstrate that atlases were put to a variety of unintended, incidental uses. In one copy in the Royal College, the plates of the gravid uterus are missing, leaving only a faint trace of the image on the paper below. In another, a red rose has been carefully pressed between two pages; hand-written notes appear in the margins.

The atlas was unusual in that Lizars was not only the anatomist; for much, though not all, of the work; he was also the artist. What mattered here was that the anatomist was both observer and recorder. Students learned through recording and drawing, which sharpened observation. Sight and drawing had long been tied to knowledge, and Lizars' work was stamped with the authenticity of someone who had dissected and sketched. The original paintings and drawings have been bound into a single volume, with the

artwork carefully folded so that it could be accommodated in the format of a book. Lizars' aim of 'scrupulous correctness' also required that he oversaw how the drawings were turned into engravings for the published work. He employed his brother William, a painter and engraver who specialised in portraits and domestic subjects, and trusted 'the Plates [would] be found worthy of examination' (Lizars 1822: vii). These are sepia engravings, some of which were hand-coloured while others remained plain. Lizars certainly used vivid colour to give life to his drawings. Despite the mechanical means used to produce prints, individual copies of the atlas differ from one another because the prints were pasted into the book by hand. In the early editions the engravings were printed on fine, thin paper before being pasted on to heavier, indented paper; they were sometimes placed askew, with the result that the various editions or copies of the atlas do not have a uniform appearance.

Reviewers found a number of advantages in Lizars' work. The letter-press was published in octavo size, which made the written part of the atlas convenient for reference, while the engravings were published separately in folio. The work was also moderately priced, costing 'not more than others of diminutive size and confused representation' (Anon. 1823: 315). Borrowing heavily from Lizars' own text, the reviewer commended the 'scrupulous correctness' of the plates. Just as importantly, until this publication there had been 'no complete system of anatomical plates' (except for Caldani's, which were so expensive as to be accessible only to a few individuals) and those already published did not embrace surgical anatomy (*ibid.* and see Lizars 1822: viii). Lizars' work had the advantage not only of personal observation and correct translation into engraving, but he had also brought together and made available in a cheaper form a range of anatomical illustrations. He announced the fact that his work relied heavily on already existing images and there was obviously no shame, and probably considerable pride, in listing these. Lizars had taken 'whatever advantage might be derived from the works of Albinus, Haller, Sue, Caldani, Cowper, Hunter, Vicq D'Azyr, Scarpa and others' (Lizars 1822: viii). Originality was not something Lizars sought.

Lizars had produced drawings intended to aid the student in dissection by offering 'some substitute for the subject' (Lizars 1823: xii). These images were not so much an atlas that represented the body as a means of approaching the body by way of the atlas. By 1825 the price of a body had risen to an extortionate twenty guineas, 'a sum sufficient to enable a student to go to Paris, study his profession and return home' (Lizars 1826: x). The high price and scarcity of bodies meant that, as well as drawing from cadavers of his own, Lizars was actually forced to rely on existing images and specimens. The fact that the atlas was a collation derived at least as much from necessity as from business foresight. In the Preface, published almost

ten years before the passing of the Anatomy Act, Lizars railed against 'the scarcity of material' caused by 'prejudices as illiberal as they are alien to true philanthropy', which had led to 'a lack of subjects for dissecting'. If, as John Bell had suggested, 'a school of anatomy [is] a school of dissection', then, Lizars claimed, without bodies the medical schools faced ruin. Edinburgh, he warned, was 'doomed to dwindle into comparative insignificance' (Lizars 1823: vii–viii). In these conditions, Lizars was unashamed of copying and collating.

In what sense was Lizars the author of what was, in fact, a composite book? Lizars made it perfectly clear, in a way that Hunter did not, that there was no direct observation of bodies and no means of separating representation from reality. The images were a mixture of already existing work (often single images drawn from a number of bodies, producing a pictorial average) and the work of more than one observer. The anatomist then made his own contribution by producing some of the illustrations and authorising as well as supervising additional drawings. He had substituted paintings for bodies and prints for paintings, copied other people's specimens and reproduced existing copies of specimens. Authoring was a matter of organising material, mostly other people's, whether bodies, prints, paintings or morbid specimens.

Despite this, the overwhelming appeal of the book is that the original art works demonstrate, if only by contrast, what the book itself was designed to conceal. These drawings and paintings reveal a high level of immediacy and intimacy, a degree of heat or engagement that could not appear in an objective, reliable atlas substituting for the body. The viewer of the original art works not only has to open a heavy volume, but must carefully unfold the pages in order to view the images. In other pages, paintings that have been roughly cut out are pasted down. The images fit awkwardly into the format of a book. The paintings were not designed to fit the shape and size of the binding, nor were they reduced or enlarged in order to provide overall uniformity. They were merely collated.

The effect of these images, however, is not determined by the atlas format. Unlike the engravings, or (more properly) when compared with them, the ragged and unfinished paintings jump out from the page. These are bright, startling images. Because the colours have not been exposed to light, they remain vivid, with brilliant rose pinks, inky and turquoise blues, and deep alizarin crimsons applied either as washes of thin colour, or as saturated detail. They also remain vivid precisely because they are necessarily imperfect in detail. Despite the careful half-inch grid drawn in pencil, there are uneven and dirty marks and signs of rubbing out. Splashes of paint and blood have spilled on to the page. These images look like work-in-progress; they are neither finished paintings, nor sketches, and it is the very detailed incompleteness

of the work that allows for a different understanding of the processes of making (see Figures 25 and 26). While we can see the similarities with the earlier atlases discussed here, the surgeon–anatomist as artist has struggled over these pictures. From the flat and two-dimensional paper emerges something substantial, something that locates viewers in a different place from their counterpart prints. Unlike the atlases of Smellie, Jenty and Hunter, where a professional artist was employed to produce unambiguous smart works ready for translation into print, and unlike William Lizars' engravings, the original images make us see differently. The surface of the painting shows the work of the painter and provides a focus for identification with a subject who has *laboured* over expression.

This confrontation would have been startling to any viewer, and was not what was required in medical books. It remains striking to a modern viewer, used not only to the style of medical illustration but also to flat, unengaged imagery in the everyday world. Of course, most of these images are reproduced photographically or electronically, and they have their own peculiar distancing effect. As Karl Figlio has noted with regard to photographs, they 'often create a nostalgic mood that is absent in paintings. The photographer dissolves into the picture, leaving a sense of loss in the viewer, who has no subject *with whose emotional work he or she can identify*' (my emphasis) (Figlio 1996: 83 n. 43). Figlio claims that viewers who look at paintings are not going to give way, initially or at all, to a disquieting nostalgia with its

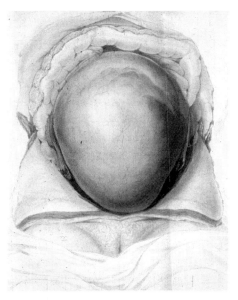

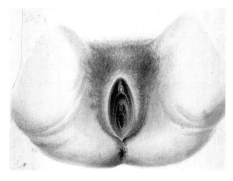

26 John Lizars, original drawing for *A System of Anatomical Plates*, 1822–26. Reproduced as Plate XCV, *Gravid uterus and lymphatic system*

25 John Lizars, original drawing for *A System of Anatomical Plates*, 1822–26. Reproduced as Plate XCI, *Viscera of the abdomen and pelvis and the organs of generation*

sense of loss and displacement. Instead, viewers of paintings are able to identify with the artist because of the visible evidence of emotional work. He links psychic work in the act of observation to the emotional and physical labour visible in the painting.

This difference between how photographs and paintings are received can be extended to include the difference between Lizars' paintings and the engravings. It is not simply a question of the loss of the aura of an original, but something far more material, bodily and visceral. Something emotive and felt in looking at the paintings is usually absent when looking at engravings, lost in an image that fuses, binds, and dissolves itself into surface. The power or authority of paintings derives in part from their capacity to muddy the boundaries between subject and object, to put viewers in touch with both subject and object. Lizars would have looked at, and may have touched, everything in sight, everything to hand. The viewer who wants to look at Lizars' drawings has to touch them first, has to open them out in order to see them. The connection here is sensuous, a sort of 'tactile knowing' (Taussig 1993: 25). To have things in our grasp also means a conceptual understanding. At the same time, touch is 'the least intellectual and the least aesthetic of the senses' (see Taussig 1993: 26). The tangible is more primordial than vision, more affective. It is both erotic and violent. Touch is deemed problematic because it is necessarily subjective.

This process might be contrasted with a sense of keeping the object at arm's length, of attaining the necessary distance for objectivity, in order to have a perspective *on* the image, rather than establishing a relationship *with* the object. The usual necessary distance offered in (and sustained by) flat, unengaged reproductions dispels any anxiety that the viewing subject will be overwhelmed and no longer be in control of his object. Such fears are threatening to bodily integrity. In Western culture, even to stand too close to a picture in public, let alone touch it, or worse, kiss it, is seen at best as suspicious and more usually as perverse.

However, such proximity is socially sanctioned in books, and is one of the pleasures of looking at them. This relationship suggests privacy, a particular closeness which allows for greater control, where the image is more easily bent to the will and desires of readers or viewers who hold it in their hands, keeping their power within their reach. Science and medical books busily engage in keeping the necessary or correct distance, but can never sufficiently close the gap of fantasy. Their so-called objective processes of abstraction, excision and classification all signify their attempts to order knowledge of the body, but cannot dispel the body's recalcitrance or hide the ways in which the body is a dramatic object. The body is excessive, disruptive and awkward. All these large folio medical atlases were an attempt at containment through abstraction and also an invitation to get in close and see the body bursting out. They

were designed to fulfil the intended, dominant purpose of objectivity and at the same time served the countervailing tendency to give way to curiosity, to enjoy looking at the body in bits. As such, the atlases were a strange hybrid between public displays and private pleasures, between correct ways of socially sanctioned scrutiny and a more illicit voyeurism.

When viewed in libraries, the medical atlases are caught in a system of looking more akin to surveillance than ordinary reading. The books are too heavy and awkward to lift, and viewers have to bend to them, lowering their head to the page and possibly getting much closer to it than is necessary in reading script. Observers poring over precious prints in libraries know very well that they are being watched, and a series of interlocking gazes comes into play. This complexity of viewing invokes other systems of looking at imagery, such as peering at it close up, or older ways of relating to iconic images, such as kissing them. Observers do not have to see the world from a fixed vantage point, with everything in order before them. To look at these medical atlases is to question any assumption that Cartesian perspective 'definitively replaced whatever scopic regimes preceded it' (Willemen 1995: 101). Cartesian perspective is often thwarted. That is one of the attractions of maps and atlases, since they invite the observer's gaze to wander all over the place, giving a strange sense of finding one's own way. This appeal may be one of the reasons why medical science has maintained a flattened, two-dimensional map or atlas of the body.

Scopic regimes, older than perspective, are incorporated into, or exist alongside, new regimes of looking. Dissection requires that an anatomist's eyes go close to the corpse, adopting an incorrect, indiscreet lack of distance. The anatomist becomes absorbed, suggesting an emotional attachment to the object, a kind of immersion that questions the certainty of detached perspective. None of this is evident in the finished publication, but it is re-enacted in viewing the book. Of course, it is a partial experience. Whereas the surgeon saw and sensed everything about the body, those who look at medical atlases are spared almost every sensory aspect, and see only what the surgeon decided was fit to print. Anyone examining these large-scale prints teeters on the edge of the body and, at the same time, is saved from falling in. But the tension of the abyss is ever present.

Science and medicine trade on a supposedly unemotional, totally detached image, as if such an image is ever a possibility, other than in theory. Preference is given to a particular style, coded as unambiguous and unemotional. Subjects appear uprooted from any particular location. They are reduced to clean-cut lines, crisp images without any shadow of doubt, situated in empty space. The body is, preferably, made into a technical drawing, seemingly sprung fully formed in its abstraction, and purged of all idiosyncratic traces of culture. The medical image, in its ideal form, must not knowingly be

evocative. To this end, flourishes are removed. There must be no shadowy recesses, nothing hidden from the light of scientific reason. Print, or a style of painting that resembles the mechanical, is favoured for medical illustration. Clarity becomes the desired end, the clean and orderly substitute for an ambiguous, chaotic body.

But an examination of Lizars' original work reminds us of something that is only suggested in the print. Proximity is never fully eradicated from the anatomical print, if only because it must be looked at closely. Anatomy involves pressing close to the body in order to enter it. In Lizars' chosen, well-worn analogy, the surgeon was compared to the watchmaker; the body was a mechanical (and chronological) instrument which could be opened up, taken apart and eventually might be reassembled. He wrote, 'without *subjects* it is as absurd to attempt to educate a surgeon or a physician, as to instruct a watchmaker without permitting him to inspect the mechanism of a watch' (Lizars 1823: xi). Lizars instructed students that 'The knife should not be held as a pen, but with its cutting edge at right angles to the surface of the skin, so that the operator may sweep and not piddle with the scalpel' (*ibid.*). He was suggesting the action of a sword. There was an indicative mixture of professions, muddling soldiers with artists; knives were mightier than pens in the cut and thrust of 'heroic' surgery, where anatomists sculpted at the open body. But Lizars' own carefully observed images suggest another, more contemplative, narrative that preserved the corpse beyond its destruction in a different way. Unblinking, Lizars goes into the corpse to salvage an image for the viewer's steady gaze; but the image returned to the observer is one that is less certain.

Notes

1 See, for example, Jordanova (1985 and 1989) and Kemp and Wallace (2000), Henderson (1991) and Thornton and Reeves (1983).
2 Thornton notes that Van Rymsdyk worked in London from 1750–*c*.1789, but there is no record of his death (Thornton 1982: 9).
3 Lizars employed his brother, William Lizars, to produce the engravings and some of the drawings.
4 Camper's illustrations are in the Royal College of Physicians, Edinburgh, AA4.71. There are twelve in total, dated 1752; one is unsigned. Van Rymsdyk's drawings for Smellie, purchased by Hunter, are held in the University of Glasgow, D1.1.27. There are twenty-five in all.
5 These art works had a significant afterlife. Most of Jenty's materials were dispatched to the University of Pennsylvania, along with three cases of specimens and the skeleton of an adult and a foetus, but the remaining prints continued to come up at auction in 1760s (see Thornton: 1982).
6 See Samuel Paterson, *A Catalogue of the Remaining Part of the Stock in Trade of Mr. Robert Withy of Cornhill, Print-seller,* which includes, under the heading 'Several Curious Anatomical Pictures, Prints and Models of Dr. Charles Jenty', Lot 180: 'Dr. Jenty's

Demonstrations of a pregnant uterus, highly finished in oil, upon canvas and Rollers, with printed Descriptions'. These paintings went to Pennsylavania University. Lot 455 (really 355), 'The pregnant uterus of a woman at Full term, cast in Plaster, and coloured after nature' (1766), British Library c. 131. ft. 20 (4).

7 On publication in 1774 the book cost 6 guineas, but ten years later it was sold at 3.5 guineas.
8 It was, as Thornton states, 1750, not 1751 (Thornton 1982: 29). Hunter states in the description to Plate I, 'the first ten plates were made from the dissection of a woman who died suddenly in the ninth month of pregnancy. The arteries and veins were injected with wax of different colours'. The original drawing for Plate I is signed by Van Rymsdyk and dated 1750.
9 In all, Hunter left over 2,500 jar-specimens and over 400 bones, but the work that grew into the atlas constituted the 'largest and most valuable' part of the collection (Teacher 1900: 660).

4

Fractures and dislocations: radiography, the new photography

In the late eighteenth century, the skeleton or human frame came to represent a kind of geological sediment in the mutable geography of the human body. This skeleton was usually male. When anatomists began to study the female skeleton in greater detail, it was caught in an already existing web of beliefs about the body of a woman. Unsurprisingly, the female pelvis became the object of obsessive study, which always revealed the same thing: women were not only different from men, but also less than them. Anatomists found out what was already known: woman was malformed.

Medical discourse on the female skeleton was shaped as much by popular belief as by scientific knowledge, and when the skeleton made its appearance in the eighteenth century, it was as much through the visual image as through written description. Until the mid-nineteenth century, these images were primarily engravings, but at the end of the century a new way of seeing skeletons suddenly appeared in the form of radiography. Radiography, more than any other visual medium, connected bodies directly to images, and there was also a close connection between photography and radiography. Indeed, photography and radiography are so linked together at the end of the nineteenth century that they seem to merge, and were often confused. The image produced through radiography attained the status of a blueprint, and not only in a metaphorical sense. Many early radiographs, like early photographs, were cyanotypes.

The late nineteenth century marks a particular turning point in medicine, which was on the very threshold of a new, scientific age. Yet it was also a period in which the older systems of belief which had provided the context for anatomy were still in place. Scientists were driven by established ideas, and with unsurprising frequency discovered new evidence for what they already knew. However, what was different about the latter half of the nineteenth century was that people were used to seeing photographs. They were also used to

attending shows, and to participating in the popular fads and crazes adver-
tised in magazines and offered in entertainments. What remained largely,
although not entirely, unchanged was the role which women played within
late nineteenth-century culture; if anything, beliefs that women were essen-
tially 'other' intensified during that period. In both scientific and popular
culture, they figured as being peculiarly subject to the vagaries of their unique
anatomy; as both more sexualised and less rational than men. It was unlikely
that radiography would prove otherwise; indeed, it was much more likely that
it would prove to be confirmatory.

However, one effect of radiography was certainly unexpected. In the early
nineteenth century, skeletons had made a frequent appearance in popular
phantasmagoria; at the end of the century, they reappeared in the form of the
X-ray. Formerly out of sight in the living world, they were now ever present.
This was a disconcerting moment, not only for medical practitioners but for
the public, who did not usually see much of what lay beneath the skin. X-rays
had a peculiar impact on the subject's sense of bodily integrity. The boundaries
between life and death were no longer impermeable, but had been breached.

Perhaps X-rays would not have had such an effect if they had appeared at
a different time; they might, in that case, have remained a type of scientific
quirk. But they happened to emerge at the precise historical moment when
both the scientific and the popular periodical press was expanding. They fitted
in with beliefs about the power of photography, and in fact depended on it;
they confirmed, as well as contributing to, the primacy of vision in under-
standing the modern world. Finally, X-rays were a clear sign that there was
something odd and deficient about vision, about human subjectivity, and
about what had previously been a clear boundary between life and death.

The Edinburgh skeletons

In the early 1990s, a number of late eighteenth and early nineteenth-century
osteological specimens, which had long lain forgotten, were rediscovered in
the Department of Anatomy at the University of Edinburgh (Kaufman 1995).
They were pelvic skeletons malformed during pregnancy by rickets and osteo-
malacia, diseases that were once common but are now rare in the western
world. These pelvises, pathological examples, had once been part of the uni-
versity anatomy collection. No longer of any use, they were put aside in boxes
and gathered dust in basement cupboards. Found in a rummage through long-
forgotten presses, these tiny, frail objects are now carefully displayed in a glass
cabinet and can be seen in the anatomy department (see Figure 27).

These are strange objects; darkened and hardened with age, they have a
peculiar power over the viewer. To look at these pelvises, polished with han-
dling, is to understand something physical, tangible and melancholy about the

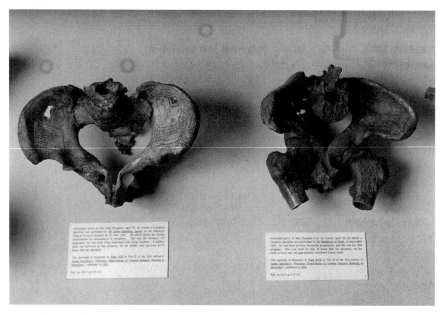

27 Part of a Case of Pelvic Skeletons, University of Edinburgh

materiality of the body. They offer an experience radically different from con-
templation of the cleaned up, sanitised images of print or book. These bits and
pieces were once part of larger skeletal frameworks, which in turn were part of
the complete bodies of women who laboured hopelessly, and on whom cae-
sarean operations were performed unsuccessfully. These pelvises belonged to
women, all of whom died in difficult childbirth; few of their infants survived.

All that remains of them now are their twisted and misshapen pelvic
bones, with neat sawn-off stumps of thigh bone or with a few lumbar verte-
brae protruding. Labels have been pasted directly on to the pelvises and
inscribed with museum marks of identification, a catalogue number, a date or
measurement. These details have allowed their finders and keepers to trace
the body parts back to names, places and dates and to show, as Kaufman has
done, that one of the pelvises was certainly acquired illegally through grave
robbing (see Kaufman 1993, 1995; Kaufman and Jaffe 1994). This fact indi-
cates a particular interest, an investment, in retrieving such bones. At the end
of the eighteenth century and early in the nineteenth it was not usual to col-
lect entire female skeletons, but it was common to collect and catalogue
female pelvises. The female pelvis was the crucial, indicative skeletal part that
distinguished women from men, a visual emblem and metonym for femi-
ninity. It became the foundational object of an essential difference. It was a
distinct entity, severed from spinal column and femur, an object of curiosity
and scientific investigation, the marker of anatomical sexual difference.

Sexual difference was osteological, it could be proved to exist in the bones, at the very core of the female body. The Edinburgh specimens, pelvises which were incapable of allowing vaginal birth, were the exceptions that proved a general rule: that medical intervention was necessary in childbirth.

Flesh and bone

Long before these pelvises were laid out neatly, they had a different, messier context as part of a working environment. Taken out of their glass coffin and put back in the dissecting room, they present a different, more chaotic picture (see Figure 28). The photograph of this dissecting room of the 1880s shows a large apartment, well-lit with large windows and substantial skylights. It is an airy space, rather like a warehouse or a factory, with an orderly arrangement of tables, wall charts and a clock. The orderliness of the room jars with the chaotic condition of the bodies, shown in various stages of dissection and decay. This picture is more frightening than the cleaned up and carefully arranged bones in Edinburgh because it reveals what is usually hidden, the necessary violence with which human flesh is separated from bones; these are bodies disassembled, hollowed out, broken, simultaneously wrapped up and undone. To the left of the image a neat pelvis, cut out, thigh bones sawn off, is propped up against a cadaver, which is a formless wreck; to the right, at the back, a corpse has had its legs raised and propped up to allow access to the interior of the body.

28 The Dissecting Room, Department of Anatomy, Cambridge University, by Stearn, Cambridge 1888/1893

There is no living person in sight, but the dead make their presence felt: part of a skull is placed with the eyeless sockets 'looking' towards the camera and the viewer. Death hangs in the air, symbolised by a whole skeleton suspended from a hook which oversees the whole scene. The living are absent. Anatomical dissection, or so it seems in the photograph, turns out to be a more purposeful and modern form of dismemberment. But it is not quite that. The raggedness of the bodies, the mixture of raw flesh, clumsily bandaged and trussed limbs, the general disarray, all suggest a link to the older, admonitory punishments that left bodies to rot. By the 1880s the vagaries of that irrational public display of death had been replaced by a ritualised dismemberment. Anatomical dissection was a rational solution, abolishing the stages of decay by cutting away the flesh and other soft, rotting matter to get to the bone. But this image suggests otherwise. This photograph, taken in Cambridge, is indicative of a process that was underway long before bodies became widely available for dissection following the Anatomy Act of 1832 (see Chapter 3). Gradually the body, and particularly the female body, was imagined as being in bits and pieces, already anatomised. The skeleton was little more than a rackle of bones; liberally scattered around the room, as in this image, they remind the dissector of the solid structure that lay beneath the rotting form. As the image makes patent, bones are never bare.

The question posed by these bones filleted out of the body is not answered by piecing bodies together again, reconnecting bones with wires, or discarding them as outdated (as may well have happened to the Edinburgh skeletons). The bones urge us to consider and understand how the female pelvis became a distinct object of study in the first place. Curiously, perhaps, understanding the anatomisation of the dead is a necessary step towards understanding how the living saw their own relationships, in particular the relationship of men to women. In order to understand this relationship, we must first ask not just how but why the female skeleton came into view. We should also ask when this happened; the female skeleton is a late arrival to the anatomical scene.

The female skeleton

No description of the female skeleton existed before the eighteenth century and Londa Schiebinger notes that there was only one 'crude' illustration, made in 1605 (Schiebinger 1987: 54).[1] The anatomist Albinus, writing in 1734, declared that he wanted 'something' as 'the base or foundation' upon which 'muscles and veins and nerves were to be drawn' and decided that 'this is the skeleton' (Schiebinger 1987: 53). Accordingly, Albinus produced one of the first closely measured, accurately proportioned drawings of the male

skeleton. However, he lamented the lack of a female skeleton to complete the skeletal picture (Schiebinger 1987: 54).

It was in the course of the eighteenth century that descriptions of the female skeleton began to appear. Alexander Monro *primus* (1697–1767), professor of midwifery at Edinburgh, wrote one of the first descriptions in 1726 (appositely in an appendix), but he provided no illustration (Schiebinger 1987: 58). Monro described 'the distinguishing marks of the female skeleton'. Female bones were 'different from those of the robust male'. Negatively, women had a weak lax constitution with 'a sedentary unactive life encreasing (*sic*) that constitution'. The pelvis was the focus for the difference and Monro described that structure, positively, as 'a proper frame for being mothers' that [afforded] 'lodging and nourishment'. However, he commented that even the pelvis contributed to the structural weakness of women. Negatively, he ventured that the increased distance between the thigh bones which left 'a larger Space for the Procreation and Birth of Children' was 'one reason why Women in running generally shuffle more from one Side to the other more than Men, to preserve the center of Gravity of their Bodies' which would otherwise 'endanger their tumbling to the Ground' (Monro 1746: 295–299).

It is neither arbitrary, nor surprising that drawings of the female skeleton began to appear in the eighteenth century, a time when the ideas of the Enlightenment, particularly its ideal of universal equality and the consequent political and social upheaval, were at odds with the capitalist ethos and with the pressures for demographic growth which came in the wake of industrialisation. As Schiebinger suggests, anatomists' interest in the female body was shaped in part by changes in the broader culture (see Schiebinger 1987: 53). Until the eighteenth century there had been little need to enquire closely into the nature of generation; it was neither economically nor politically important, but simply a fact of life. In the early part of the eighteenth century, however, this began to change. Economic prosperity depended upon a growth in population. The establishing of clearly delineated, fundamental differences between men and women was driven as much by political and social anxiety as by economic exigency. Certainly sexual stability was no less crucial than class or race to contemporary social stability; indeed, it was perhaps even more essential. The appearance of the female skeleton was the outcome of modernisation and of the effect of industrialisation on gender.

Thomas Laqueur suggests that prior to the eighteenth century there was simply a shared vocabulary, a 'one-sex/flesh model' (Laqueur 1990: 8). It is tempting to regard that failure to perceive differences between the sexes as an oversight, a denial of or blindness to woman's distinctive anatomy. However, this does not mean that recognising distinction, 'the distinguishing marks', would necessarily be an acknowledgement of human difference. The two-sex/flesh model (to use Laqueur's terms) that emerged in mapping women's

different anatomy in the eighteenth century had the effect of narrowing defini-
tions of femininity. Indeed, as Elizabeth Grosz puts it, 'it is far from clear that
representability is in itself always a virtue' (Grosz 1994: 147). Mapping
always requires a certain projection, so that the knowledge supposedly discov-
ered in the map is in fact the knowledge that is already useful. In short, maps
lay out what is conceived as important, rather than revealing unknown terri-
tory. They are confirmations, not interrogations.

Anatomists thought of the skeleton as a solid substrate for mapping
sexual difference, and the process of mapping was required to prove an
absolute, essentialist perspective on sexual difference, which then permeated
the entire female frame. Sexual difference had to be shown to be more than
skin deep, and laying bare gender difference in the female skeleton provided a
permanent foundation for understanding sexual differences as not simply
superstructural, but infrastructural, penetrating 'every muscle, vein, and
organ attached to and molded by the skeleton' (Schiebinger 1987: 53). Such
differences were classified as immutable and bones were exhibited as proof.
The distinctive interior of the female body was evidence not only of differ-
ence but of disparity. The otherness of woman was fundamental. Anatomists
had found in the female skeleton incontrovertible evidence of woman's
pathology.

In the latter half of the eighteenth century both the female pelvis and the
uterus were made to bear a heavy burden of human meaning (see Chapter 3).
In the early years of industrial production, labouring bodies were increas-
ingly valuable commodities and, like commodities, they were also easily
replaced. Women were envisaged as productive, as both labour and repro-
ducers of labour. In the nineteenth century, as the mechanisms of industrial
production were applied to human generation, 'generation' became 'repro-
duction'. Women's bodies were not subjects in their own right; they were
body-machines whose power of reproduction could be harnessed and con-
trolled.

The pelvis was a basin with a brim and an outlet, a mechanism in the
machine of life. It represented a special kind of object, a different frame which
could give birth to a whole new discipline. Mapping the pelvis was the focus
for those anatomists whose professional ambitions lay in obstetrics. This field
would expand by the mid-nineteenth century to include gynaecology, with its
aim of producing a 'science of woman' (Moscucci 1990). But in collecting and
measuring the bones that displayed gender differences, and in picturing and
naming them, anatomists placed strict limits on the discourse of the female
body. Rather than the difference between the sexes being, literally and posi-
tively, a fact of life, the female pelvis and uterus were laden with negative
value. Anatomists defined the female body in comparison to the male and,
unsurprisingly, found it wanting. These discoveries, or rather confirmations,

meant that the divisions between men and women were more clearly demar-
cated and the social and sexual boundaries far more rigorously policed.
Women's role in, and indeed their knowledge of, generation subsequently
narrowed.

Comparative anatomy: Barclay and Mitchell

Though drawings of female skeletons began to appear in the eighteenth cen-
tury, it was not until 1820 that John Barclay (1758–1826), an extramural
teacher of anatomy associated with Surgeons' Hall in Edinburgh, compared
male, female and foetal skeletons. His written description of a skeleton
'family' first appeared in *A Series of Engravings Representing the Bones of the
Human Skeleton with skeletons of some of the lower animals, by Edward
Mitchell with explanatory references by J. Barclay,* a two-volume work which
was published in 1819 and 1820. Barclay oversaw another single volume edi-
tion in 1824. The final edition of 1829 appeared under the name of Robert
Knox, who had by then succeeded Barclay. The book then appears to have
fallen into disuse and this may be because Knox was ruined by his close associ-
ation with the body-snatchers, Burke and Hare. Ruth Richardson records that
Knox displayed the body of a young woman to 'all and sundry in his school,
that men had come to draw her body, comments had been made upon her
physical attributes and that Knox had even had her body preserved in spirits
so that he could continue to indulge in necrophiliac voyeurism' (Richardson
1987: 96).

In the first edition of *A Series of Engravings*, Barclay outlined similarities
and differences in the skeletal 'family'. He noted that the child and woman
were similar in their 'proportionally larger heads'. As Schiebinger suggests, it
was common in the eighteenth and early nineteenth centuries to compare
women to children and 'primitives' whose brains, like theirs, were less devel-
oped (Schiebinger 1987: 64). But the single, absolutely distinguishing feature
of woman is her pelvis: 'It is in the pelvis, and pelvis alone, that we perceive the
strongly marked and peculiar characters of the female skeleton … it is there
that, in deviating from those characters which at one time were common to
both, we regularly find it deviating farther than that of the male – the pelvis of
the foetus being the smallest of the three and the pelvis of the female being pro-
portionally the largest' (Barclay 1819–20: description to Plate XXXII) (see
Figure 29).

While Schiebinger implicitly acknowledges the importance of visualising
the skeleton in establishing unequivocal proof of sexual difference, she does
not explicitly discuss the fact that these emerging definitions were formulated
as much by artists and engravers as by anatomists. Indeed, Barclay stated
clearly in the opening sentence that 'the following work originated entirely in

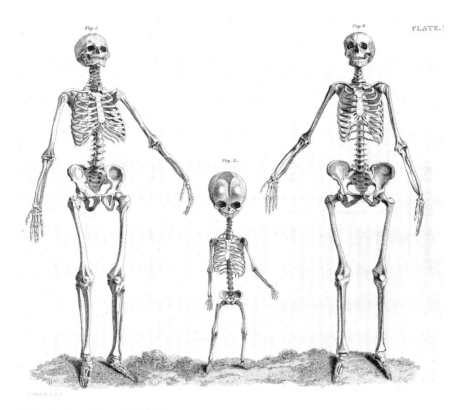

29 John Barclay and Edward Mitchell, *A Series of Engravings Representing the Bones of the Human Skeleton with skeletons of some of the lower animals*, Plate XXXII, 1819–20, engraved by Edward Mitchell

the suggestion of the Engraver', Edward Mitchell (Barclay 1819: 3).[2] The various editions of the book were the result of the political and social exigencies of self-promotion in the emerging or uncertain professions of that period; anatomists needed to advertise their skills, while artists and engravers needed to sell their work. The books also marked a significant shift from an older text-based society to a modern visually-based culture. Such visualisation was central to the process of Enlightenment.

If we compare the title pages of the first and second editions of *A Series of Engravings*, the importance of the engraver becomes clear. In the first, Mitchell's name has pride of place above Barclay's, and was printed in only a slightly smaller point size. By the second edition of 1824, however, perhaps because of the work's success, or possibly because Barclay had purchased the plates, a reversal has taken place: Mitchell's name comes second. From the start, Barclay seized the opportunity to boost his profession. 'Surgery', he stated, 'in the estimation of every enlightened and educated mind, is not a trade, but a liberal profession' (Barclay 1819: 4). He explicitly acknowledges

the role of visualisation in advancing the status of surgery from trade to pro-fession and gives an account of Mitchell's contribution. The aim of the engraver was to adopt 'a middle course with regard to size of engravings … and produce a Work at once cheap, elegant and useful' (Barclay 1819: 3).

According to standard practice, Mitchell copied most of the images from representations already in circulation: Albinus, Sue, Stubbs and Cheselden, though he also added a few new images from specimens in Barclay's collec-tion. Copying existing engravings was not enough; readers and viewers wanted novelty. Barclay claimed that Mitchell cherished 'a wish to produce, at the same time something that was new and had procured a Work that was very little known, in this country – a compilation published in Rome in 1696, by Domenico de Rossi, chiefly for the use of sculptors and painters' (*ibid.*). Barclay, however, advised Mitchell to lay aside these artistic images in favour of copying from Sue. Art was not an appropriate reference for science.

At Barclay's suggestion, the image of the male skeleton also included that of a horse, 'taken' from Stubbs, and the image of the female skeleton included that of an ostrich, 'taken' from Chelselden. These were not arbitrary choices, and nor was the decision as to how the skeletons were viewed; in the 1824 edition, only the male skeleton was granted three-dimensions in front, side and rear elevations; while the female was seen only from the front. It is equally revealing of the practices and beliefs then current that Barclay made it clear that, in his opinion, it was undesirable for Mitchell to copy from nature; after all, the engravings had been done under the supervision of esteemed anatomists. Therefore 'it was not likely that MR MITCHELL, though an eminent artist, could, with all his exertions, produce any thing of the kind superior; and besides, I imagined him in less danger of falling into errors, with accurate designs and modes of execution constantly before him, than if he had copied from nature herself' (Barclay 1822: 5).

Barclay held the same views with regard to his own abilities; he consid-ered it unlikely that he could 'improve on Monro's description of the bones' (*ibid.*). Clearly, he saw his work as a compliment to Monro's. On balance, the authorities were to be followed and the temptation to alter them for the sake of novelty was to be resisted. On the other hand, the book had to have some distinguishing qualities if it was to compete in a growing market. Barclay held definite views about this. He considered outright novelty to be a 'silly passion'. Similarly, he deplored writers who elevated form over content or manner over matter, a technique developed 'more by the shadow than the substance' which fed the 'weak appetites, or the depraved tastes of readers'. Such writers adopted 'the vague and flowery style of the novel, for that of the sober, unadorned narrative'. Barclay's preference for unadorned narrative was an attempt to establish what might be called the 'hard' discourses of science and to develop a scientific vocabulary, one which traded on fact rather than

metaphor. This vocabulary was distinct from 'fancies' and 'superficialities' (Barclay 1819–20, 1824: 5–6).

This tendency was equally applicable to visual discourse. Barclay ended with a warning, reminding the reader that the role of engravings was to 'elucidate descriptions … assist memory … when originals are imperfectly remembered, or cannot be procured'. Barclay concluded that the plates were to be viewed 'in no other light' than as untrustworthy, secondary, and weak copies of nature. They were 'never to be called to interpret for Nature, where Nature is at hand to interpret for herself' (Barclay 1819–20: 7). He expected the text to guide the reader, rendering the image less misleading. But, as Barclay acknowledged by that admission, nature was not self-explanatory, nor were viewers looking at primary material. The engravings stood between nature and viewers, and represented nature to viewers. The book did indeed adopt a conservative course. Barclay wished to preserve the primacy of the material world, of natural science, while simultaneously asserting the power of the visual to elucidate words and assist memory. His book, however, despite his warning, is a good example of the primacy of visual representation, because it comprised, for the most part, copies of copies for which there were, quite simply, no originals. Barclay's comments testify both to the inadequacy of, and the need for, visual representation. He was, after all, practising at a time when there was a shortage of bodies and a substantial and growing trade in visual inscription.

Barclay's attempt to separate uninterpreted nature from its representation was, of course, a fiction, but it was (and remains) conventional. Then as now, science is understood as a culture of no culture, as if a distinction can clearly be drawn between the natural and human sciences. How nature was interpreted in imagery, how one was to make sense of the representations, could not be disentangled from the cultural meanings of that piece of nature under review, whether it was the skeleton of a horse, an ostrich, a male in three dimensions, or a female in one. Barclay was writing in Mitchell's shadow, as it were, in an age in which the mass reproduction of engravings was increasing dramatically and of necessity. Images, like bodies, were literally multiplying. Whatever viewers looked at was shaped by what they had already seen. Nor could viewers separate what they looked at from what they were looking for. The books of skeletons, like maps, were concerned not so much to interrogate as to confirm a recognisable world, a known point of view.

Despite the hope that the images would pin down nature without embellishment or error, there was always room for ambiguity and, notwithstanding Barclay's endeavours, language could not guarantee correct reading. Engravings of the skeleton had shadowy, indistinct outlines, as if the bones could not quite be, or had not yet been, completely separated from the flesh. Traces of gristle appeared to lie along or between the bones. Boundaries were not particularly sharp, a lack of definition, with its suggestion of lack of clear

meaning, which reappeared in early radiography (see below). Lack of clarity is commonly blamed on an imperfect technique or on the limitations of an emergent technology. That line of argument, however, ignores the cultural meanings of the shadow (and its close relation to its opposite, the substance), which predated the invention of the radiography. Flesh receded only gradually, giving way slowly as bones, more rigid frames, appeared. While in older engravings the skeletons appeared to be on solid ground or at least seemed to inhabit a recognisable landscape, in the nineteenth century engravers began to detach skeletons from any sort of ground. Rather than having them standing, rooted in place, engravers made skeletons appear to float in space.

Until the end of the nineteenth century, the notion of 'living bones' was a contradiction in terms. Bones were dead and the skeleton was a relic. As Barclay commented, 'the human skeleton, so far as I know, has undergone no specific alteration' (Barclay 1824: 5). But this idea changed towards the end of the nineteenth century, and woman was about to play a central role in this reconfigured topography of the human body. Capable of giving life and dealing death, the female body was both alluring and dangerous, and the tension of opposites was so great that it seemed unworldly, symbolising something indistinct between life and death. That quality made the female body an especially suitable subject for radiography.

Deconstructing the female body

In *Screening the Body*, Lisa Cartwright reminds the reader that while for film historians 1895 is the year of the birth of cinema, for historians of technology and medicine it is the year of the discovery of the X-ray (Cartwright 1995: 107). These two discourses, cinema and radiography, have a shared vocabulary in the term 'living pictures'. The same year, 1895, also marks the invention of a discourse on sexual difference: psychoanalysis. All three are essentially discourses on the body, and within each, woman plays a leading role. Cinema, psychoanalysis, and radiography coalesced around fears of femininity. At root and in practice, they all revealed, advertised or depended upon the close association of woman with death; she was both a graphic reminder of mortality and a literal harbinger of dissolution. The ties between radiography and death meant that both were readily associated with (and potent symbols of) a death-dealing, sexualised femininity.

Within these disciplines, the female body, as spectacle and spectre, makes a recurring appearance, not just as some*thing;* but as the *thing* that haunts the male psyche. Woman is deathly; the ruin of representation; a ghost-like figure, not quite alive and not quite dead. The popular nineteenth-century idea of woman as enlivening muse or source had its obverse in the idea of the living (male) haunted by the dead (female). This other woman is a staple of Gothic

fiction and Symbolist art (see Showalter 1991: 178–181). Here woman inspires dread, and fear is invoked in the male by the traumatic sight of the female body. Death and femininity, the two enigmas of western culture, are bound together in the concept of castration (see Bronfen 1992: 32–35). Conceived as spectre, the female body becomes a site of trauma and a source of dread. The terror woman inspires derives from the way in which only she gives life, thus starting the individual's more or less lengthy dance with death. The navel, as Bronfen points out, is a scar which never quite heals (see Bronfen 1992: 35). The subject separated at birth can do nothing but embark on a cycle of loss which leads in one direction only: towards death. Woman is a one-way street.

For the audiences of the late nineteenth century, the X-ray was the very image of death in life. These 'ghost pictures' were images of life, but life reconfigured as death; pictures of the living dead, they suggested something haunting, archaic, suspended in air. In the X-ray the body appeared as if already 'dissected out and articulated with wire' (Glasser 1933: 40–41). The ghostly experiment which photographed the body's interior invoked simultaneous horror and fascination. This was exemplified in 1896 when the popular *Longman's Magazine* published a short story, 'Röntgen's Curse'. The author, C. H. T. Crosthwaite, describes an Oedipal narrative of a scientist who has acquired X-ray vision. At first, the narrator is ecstatic to find himself in a scientific Garden of Eden, the possessor of a key to nature's cabinet: 'I had in my grasp a talisman that would unlock for me the secrets of the universe. The fruit of the tree of knowledge hung within my reach. Ambition, desire, curiosity, tempted me. I must eat of it, even if the penalty were death, or worse' (Crosthwaite 1896: 475). This is an image of omnipotent knowledge and vision. Granted the 'eye of the Creator', the scientist pictured himself as 'being able to see into the bowels of the earth or the depths of the sea'. Significantly, 'far above and beyond those [aims] rose the hope of snatching from Nature the secret of life itself and of making biology the supreme science' (Crosthwaite 1896: 470). Omnipotent vision is, however, unbearable. Scientific paradise turns out to be hell on earth: 'The horror lay in the life of the skeletons. They were not like the dry bones in the museum of anatomy or in the valley of death' (Crosthwaite 1896: 478).'I have torn away the veil mercifully spread over our eyes. Blindness itself were preferable to the perfect vision I have sought and acquired' (Crosthwaite 1896: 482).

The discourses of cinema, psychoanalysis and radiography are also linked in their fascination with bringing to light what is repressed or concealed beneath the surface. In radiography, boundaries between exterior and interior begin to disintegrate and dissolve. New light is shed on what has been buried deep within the secret recesses of soma or psyche. Radiography was quickly imbued with the extraordinary magical powers of psychic penetration and revelation. The new invention could, it was believed, bypass conscious

thought and penetrate not just the physical body but the conscious mind, leaving an indelible impression. Reports appeared in the American journal *Science*, claiming that at the College of Physicians and Surgeons the rays had been used to 'reflect anatomic diagrams directly onto the brains of medical students, making a much more enduring impression than the ordinary methods of learning anatomic details' (cited in Glasser 1933: 204–205). Images have the power to penetrate and thus manipulate and stimulate not just the subject's body but the mind. This suggests a redefining of what subjectivity is. The human subject becomes a shadow of its former self; its innermost secrets are revealed; its boundaries are rendered permeable and finally breached. The body is thus invaded. As Cartwright notes, 'this model of visual knowledge as corporeal penetration and invasion … previously had currency as popular fantasy and public spectacle' (Cartwright 1995: 114). It was a form of representational body-snatching.

Science and popular culture: radiography and the narrative of photography 1895–1906

Between 1895 and 1906 *The Photogram*, a popular British photographic magazine, produced a regular supplement, as well as several books and pamphlets, on radiography. Radiography's appearance in the popular photographic press demonstrates something important about the relationship between scientific and popular culture. The optics of photography are, however, radically different from the electronic technology of radiography. Far from being a photograph of the body's interior, the skeleton or the organs, the X-ray is a mere record of 'variations in density' throughout the different regions of the body' (see Cartwright 1995: 153). It is a deflected image, thrown back as light waves to register a pattern of interference on film. X-rays are not photographs. Photography was simply the medium through which images were relayed. However, photography instantaneously adhered to radiography so effectively that at its inception, it formed both the conceptual parameters and the linguistic context within which the discourse of radiography was framed.

From the moment when the discovery of X-rays was publicly announced at the end of 1895, significantly in the popular rather than the scientific press, Röntgen lamented the fact that while photography was a means to an end, the popular press made it the most important thing. At the end of 1895, Röntgen had sent details of his discovery, accompanied by photographic images as proof, to the major scientific publications in Europe. These details had been widely taken up by the popular press, with the result that radiography quickly acquired sensational status, a status based primarily on the imprint of a skeletal hand, a striking image which accompanied the reports. The invention was described by *McClure's Magazine* as 'The New Marvel in Photography' (Glasser 1933: 5).

The Photogram called it 'The New Sight' (see Figure 30). However, this signalled the widespread belief that X-rays merely extended, albeit dramatically, photography's ostensible capacity to see deeply into nature's cabinet.

Vision, as Crosthwaite's story also suggests, is corporealised. Sight is equated with radiography and X-ray vision is popularly believed to be a possibility. This is of course a failure to distinguish between what is shown and what can be seen. Photography was merely the medium through which X-rays were circulated, and it is the medium which has currency here. A photogram is a camera-less print, and photograms preserved a mimetic contact with the object imaged, a process repeated in producing an X-ray. The shadowy image was obtained by pressing the body against a plate containing sensitive film, and this is suggestive of an object which has had contact with, has touched, the image. X-rays had the metaphoric connotations of an ability to bypass the surface of the

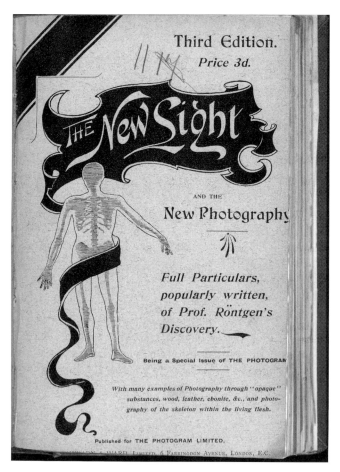

30 Cover of *The New Sight and the New Photography*, 3rd edn., 1898

body. The body itself is thus perceived as literally ghost-like, immaterial, only flesh, as being merely a thin veneer, literally a skin, covering a hidden, deeper reality which will, like truth, be uncovered, revealed.

The images produced by the new 'wonder' cameras were described in the vocabulary of the supernatural: radiography was 'a photographic discovery that seems almost uncanny' (see Reiser 1978: 60). This suggests that the new discovery was seen as belonging to the realm of popular amusement rather than to that of scientific truth. Indeed, even at the end of the nineteenth century, a separation between entertainment and science had yet to be clearly established. Röntgen, it should be noted, maintained an interest in lay physics, and he kept a magician's box which contained what he called simplified X-rays and which was in reality a trick which used magnetic blocks and a compass (Glasser 1933: 157). This kind of trickery had been part of the older popular shows, and it was still being passed off in end-of-the-century entertainments.

Otto Lummer, who recorded his feelings about the first report of radiography, recalled, 'In reading the preliminary notice ... I could not help thinking I was reading a fairytale ... there it was in black and white ... that one could print the bones of the living hand upon the photographic plate as if by magic. Yet only the actual photograph proved to everyone this was a fact ... and not the trick of a practical joker or exploited by spiritualists as a manifestation of the fourth dimension' (Glasser 1933: 29). From its invention, photography had the hallmark of truth, as being *'being more true to nature than the performance of any hand'* (Anon. 1839a: 182). (see Figures 31 and 32). In circulating this particular image, Röntgen, was in fact, making use of the hand to show his own; indeed it remains unclear as to exactly whose hand this is. This image is most usually captioned as Frau Röntgen's hand, but here it is captioned as belonging to Professor Röntgen. However, Röntgen was demonstrating that there was no trickery; nothing was hidden. Yet Lummer betrays a deep underlying anxiety about the authenticity of these new images. Hands and hearts played an important role in the emerging media image of radiography as a truthful science, not the trickery or fake spiritualism which also held considerable sway at the end of the nineteenth century. In the exchange that took place the woman's hand became important and became a popular token of exchange. Röntgen, however, refused to have the petrifying gaze of the camera turned upon himself, and would not consent to being photographed by the journalists who beat a path to his laboratory.

In 1896 the technology of radiography, like that of early photography, was slow, with a minimum exposure time of twenty minutes which sometimes stretched to as much as an hour, depending on the thickness of the bones. Within two years, however, this was cut to just a few minutes (Reiser 1978: 65). There was one crucial difference between radiographic and photographic equipment: when photographic equipment appeared on the market in the

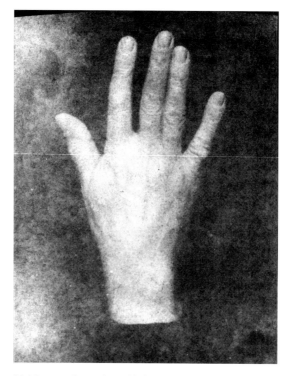

31 *A Portrait of a Hand*, possibly from a calotype negative, *c*. 1840s

32 'The Hand and the Living Heart in situ', Adolf Isenthal and Henry Snowden Ward, *Practical Radiography*, 1896

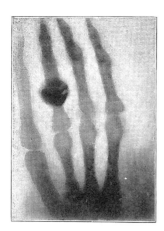

THE EARLIEST RADIOGRAM.
nd of Prof. Röntgen ; radiographed by himself.

THE HUMAN HEART; *in situ*.
Earliest radiogram of this subject.
(By Dr. Macintyre.)

1840s it was expensive. In contrast, radiographic apparatus was cheap and it was therefore widely taken up. Like the first photographs, the shadow pictures of early radiography sat uncomfortably between sensational popular spectacle and sober scientific demonstration. Its status unresolved, radiography was perhaps the last modern invention to be haunted as much by popular belief and superstition, by the irrational, whether telepathy or magic, as by scientific or rational thought. At the end of the nineteenth century these were not easily separated, although by the 1890s it was also widely held that the most significant advances in medical diagnosis would result from new ways of visualising pathology (see Reiser 1978: 56).

For the first ten years, the status of radiography remained undecided and it was therefore employed in almost equal measure in popular entertainment and in a scientific context. A special issue of *The Photogram* devoted to the invention described the images produced through radiography as 'shadow pictures'.[3] Radiography was mass entertainment, a side-show which drew the crowds in the same way as the older spectral phantasmagoric shows had done. Magazines such as *The Electrician* stated bluntly, 'We cannot, however, agree with the newspapers in regarding this discovery as a revolution in photography … there are very few persons who would care to sit for a portrait which would only show the bones and rings on the fingers' (cited in Glasser 1933: 40). *The British Journal of Photography* deplored 'the indiscriminate use of the fluorescent screen … on the revolting indecency of this there is no need to dwell' (Anon. 1896b: 187). But dwell on it, and in large numbers, is precisely what audiences did.

Photographers announced their studio work in X-rays in the popular magazines and advertisements for radiographic apparatus appeared in *The Lancet* and *The British Journal of Photography*. Early twentieth-century department stores, such as Selfridges in Oxford Street, included X-rays in their heady mix of shopping and entertainments. There were requests for opera glasses to be fitted with X-ray lenses and adverts appeared in the photographic press for X-ray proof underwear (Glasser 1933: 44). Radiography followed fashion. Looking at a hand or foot was legitimate, but looking below the waist was illicit. A lucrative postal trade in images, similar to that in pornography, left some viewers, understandably, disappointed and led to complaints that the images received were 'very tame'. In a rare public display of anatomic lust, one recipient provided his own shopping list: 'send more sensational ones, such as interior of belly, back bones, brains, liver, kidneys, head, lungs etc.' (Anon. 1896c: 766). Thus the living body was quickly stripped bare and dismembered. It had been reduced to its component parts, organs and bones, by a viewer who was obviously hungry to see more.

At the end of 1896, *The British Journal of Photography* published a poem by Mark Oute entitled 'The Living Pictures – The Skeleton', which described the new photographs as:

Producing pictures – gruesome things –
Skeleton hand and beating heart
Bony fingers adorned with rings. [Oute 1896: 93]

No doubt 'Oute' was describing the book published in 1896 by Snowden Ward, *Practical Radiography*, which reproduced on its cover an X-ray of a deformed hand, while John MacIntyre's picture of the heart *in situ* was placed alongside Röntgen's hand, opposite the title page (see Figure 32). These images are not arbitrary choices, but signal the ways in which medical technology would reconfigure life. Thus bone and muscle, death and life, are imaged. The layout isolated parts of the body and was a metaphoric dismembering, repeating in pictorial form the ways in which specimens were arranged and displayed in bottles. Both object and image were relics, eviscerated remains, the thin trace of a body that had ceased to exist. The glass of the specimen bottle or the museum case was replaced by the surface of the image. While the body itself became unreachable, its boundaries were entirely breachable by the end of the nineteenth century. Radiography was a technological dream, the fulfilment of science's desire to see into the very heart of the body; the hand suggested the possibility of keeping in touch.

Gradually, however, the hand withdraws, only to appear in the X-ray as literally severed, symbolically cut off from the human body. Sight and touch were reversed, with 'the sense of sight, therefore, instead of being the pupil of the sense of touch, as Berkeley and others have believed, is, in this as in other cases, its teacher and its guide' (Brewster (1849), cited in Wade 1983: 137). Severed and dematerialised, the hand stands as the very icon of radiography; of what is left behind, a kind of human relic. More than any other body part, the hand is the trace of what had been lost in the modern techniques of the observer: material, erotic, reciprocal contact. In its radical disjuncture and dislocation, severed from the rest of the body, the hand is eternalised in the X-ray image. It figures as a symbol of the ways in which, in visual culture, a disembodied eye had become the substitute for the embodied hand. X-rays are used in both human and industrial production. The heart, which appears in the book as a frontispiece, is a kind of residue, a symbol of feeling that signals what has been lost in the withdrawal of the hand. The heart is now understood as little more than a motor for driving the body with its pumps and valves (see Figures 31 and 32). Hands and hearts are pictured in Snowden Ward's book, alongside inanimate objects: money, keys. Finance and property are the motors of modern life. Bodies are disintegrated and become bits and pieces, things or commodities that will, in future, be bought and sold in parts. The hand literally becomes a dead hand, while the heart symbolises radiography's power to see into the heart of matter. An X-ray of a 'living' heart *in situ* could be held in the hand, and X-ray icons of hands were

popular love tokens. It is also, of course, the woman's hand, and by analogy her heart, that is given in marriage. In this sense, Röntgen's image was a significant cultural exchange; it too is a kind of ritual amongst scientists, both a giving and a taking. Radiography might be read, as indeed photography was, as handmaiden to science.

The hand, highly prized in the eighteenth century, was in demise by the end of the nineteenth. Most industries relied on 'hands', and entire workforces were described as such. These hands were sharply separated from hearts and minds. The hired hands were employed either for their brute physical strength or to 'operate' the machines that replaced their labour. Such associations meant that hands were simply interchangeable. The professions did not use their hands. Physicians distinguished themselves through intellect and regarded surgeons, who worked with their hands, as little more than butchers. The hand then is both classed and gendered. By the end of the century it had all but disappeared from representation. In anatomical illustration the cutting hand recedes; only its labour is revealed. If, on occasion, the trace of a hand does appear in visual culture, it is not connected to a body but seems to have a life of its own, in, for example, a fingerprint or a severed hand, in a time and motion study, or indeed in early calotypes (see Figure 31).

The hand appears in radiography as an object of study (not an agent of action). Most of the many radiographed hands produced in the early years of radiography wear wedding rings. A selection of these are reproduced in a double-spread in pages 34 and 35 of Otto Glasser's book (not reproduced here). This set of pictures of hands has a curious effect. The display twice positions left and right hands as if they were a pair, although this is clearly not the case. The suggestion is that all hands are interchangeable and can simply be substituted. The layout displays hands as viewers might see their own, encouraging them to recognise some relationship with these disembodied hands. However, it would not be desirable to identify with them too far because these hands were severed, and the bony structures, wounds and other deformities are evident. X-rays valued sight more than touch, and at the same time warned that the enhanced authority of the eye was bound to lead to intimations of mortality. These skeleton hands, with fingers slightly spread, seem both to be grasping or feeling their way towards something and simultaneously losing their grip. They are ambivalent images.

Within a matter of a few years the popular use of X rays, such as Thomas Edison's exhibit which had drawn thousands by 'inviting the public to examine its own anatomy' and by implication the hidden anatomy of others, came to an end (Glasser 1933: 237). Such widespread public display appeared, by the end of the nineteenth century, as dubious entertainment; examination, it became apparent, was simply a more scientific term for voyeurism. Soon, patients were protected from witnessing their own death-interiors. Edison, significantly, saw

himself as a middleman, mediating between science and entertainment. In 1896 he wrote in the *New York Times* that 'Roentgen needs men like myself, whose chief aim is to turn the great discoveries of science to practical use and adapt them, so that the world will receive the benefit of them' (Edison (1896), cited in Reiser 1978: 61). Popular demonstration played an important part in the development of radiography as a scientific technology.

By the end of 1905, the entangled web of popular spectacle and scientific application was at an end. The interest of *The Photogram* in radiography had waned; in January 1906 its title changed to *The Photographic Monthly* and the regular supplements devoted to radiography ceased.[4] Radiography's status was no longer uncertainly balanced between popular entertainment and élite scientific culture. However, 'popular and subcultural knowledges of the body [had played] a critical role in the development of specialized scientific and artistic techniques' (Cartwright 1995: 139). One example of this is to be seen in the way the new discovery was named. It was decided in 1905 that it should be known as radiography (see Glasser 1933 : 231), but in 1898, in the second edition of *Practical Radiography*, Isenthal and Ward had listed the vast array of terms used to describe the new photography: Röntography, skiagraphy, ixography, pyknoscopy, electrography, scotography, Kathnography, Fluorography, Actinography, Diagraphy and Radiography. They suggested that 'the latter term is the most suitable and popular: radiography is commendable for its Euphony, correctness and non-commitment to any theory (Isenthal and Ward 1898: 15). In the same year, an article in *The Lancet* entitled 'Wanted a Name', commented on the problem of naming suggesting that 'The term new photography is a mere stopgap ... Roentography is not beautiful and it would certainly be corrupted to Runtography'. However the author thought that radiography was 'a trifle vague' (Anon. 1896a: 677). Indeed the status of radiography was exactly that.

Science and radiography

In March 1896 Edison sent a telegram to Lord Kelvin stating that fluoroscopy, 'rendered photography unnecessary' (Glasser 1933: 236). Fluoroscopy, which enabled an X-ray image of a person to be seen directly, was widely taken up in the field of popular entertainment, but it was less successful within the scientific community and posed a particular problem for medicine. As an illustration in Bottone's *Practical Radiography* (1898) demonstrated, the use of a fluoroscope required a screen to be pressed against the body, resulting in an intimacy with and proximity to the patient's body that was by then perceived as an obstacle to knowledge. Unlike radiography, fluoroscopy was tainted with the older and less than noble sense of touch; it produced a closeness that by the late nineteenth century had become scientifically unacceptable. Fluoroscopy was also overdependent on the subjective interpretation of the

physician, which could not easily be checked by his peers; scientific results needed to be verified by the scientific community. Fluoroscopy did not present the viewer with an objective, repeatable, visual record that could be mobilised and, as with any scope, it offered fleeting immediacy rather than permanent lasting record. It was too close to popular spectacle; quacks might, and indeed did, snatch lucrative trade from qualified physicians.

Photographs had gained considerable currency as objective records, since they eliminated subjective interpretation and evaluation. Radiography followed suit. It was much more convenient and far less troublesome to examine an image rather than the living person, to examine the sign rather than the referent. The X-ray ensured that the patient's own knowledge and body could be dispensed with and the body's silent, incriminating traces perused separately. Radiography represented a kind of semiotic violence whereby subjectivity was erased and its trace, brought to life, exhibited signs of healthy life or deathly decay. The body was made silently to betray the subject.

This situation was further complicated because, as Cartwright suggests, 'It is difficult to analyze the distinction between subjects, objects and agency in the cultural apparatus of radiography' (Cartwright 1995: 128). Radiography effectively dissolves these boundaries: it is not always possible to tell who does the doing and to whom it is done, with a resulting convergence and condensation of the roles played in the processes of radiographic representation. Henceforth the subject is caught in a tangled web within which experience is dissolved into representation. This indicates that once vision is diffracted, boundaries become unclear. In the emerging process of radiography, as Cartwright notes, the subject was very often both object and agent. The first radiographers used themselves as objects and X-rays exposed the subject to death.

Moreover, the first X-rays quite literally dismembered the body piece by piece. Rays that could see through a book containing a thousand pages or a pack of cards were also powerful enough to destroy life. This was understood by the early twentieth century, when it was discovered that X-rays destroyed sperm; the process posed a threat not only to individual life but to future human reproduction (Reiser 1978: 67). The body is literally dematerialised by radiography. Early radiography had the power both to reveal the body's interior and to destroy, piece by piece, what it revealed. The subject, dissected out while still alive, becomes a shadow of its former self. Radiography fundamentally altered subjectivity by breaching what had been (other than in fantasy) a boundary between life and death.

Dissolving views: intimate versus remote technologies in medicine

Radiography might be read as a precursor to the increasingly remote electronic technologies which have emerged in the course of the twentieth century.

The outer layer of the body, the epidermis, was perceived as mutable, a mere surface covering. By the late nineteenth century, there existed a fashion for chemically macerating plants to display the underlying framework; to turn living objects into skeletons and to marvel at the beauty of their intricate structure. Radiography performed a similar function by spiriting flesh away. It was a labour-saving device, a means of virtually flaying a recalcitrant body and doing away with an unwieldy body-object. Early X-rays appear as ghostly, shadowy, fuzzy-edged, body images suspended in mid-air. Radiography made the body perform like a puppet; this was not dissimilar to the older displays of automatons.

Radiography is the prime model for visual culture as a command performance. Barbara Duden calls this 'visualisation-on-command' and suggests that only 'those things that can in some way be visualized, recorded, and replayed at will are part of reality' (Duden 1993: 17). The repetition and replication of the same consistent images untouched by human hand is crucial in securing their authenticity as scientific images. The result, Duden suggests, is 'a strange mistrust of our own eyes' (*ibid.*). The human body, penetrated by radiant light, is the site of visible shifts from surface appearance to interior depth. The embodied subject fades and finally yields to become a disembodied, fractured object; a thin slice of life; a shadow brilliantly illuminated. Radiography reverses visible and invisible; life and death. The visible surface dissolves to reveal the true reality of life beneath the skin. The black void in which the radiographed object floats is reminiscent of a body part which is not only without background but is as if suspended in space. It seems to glow and pulsate; it is an image both fugitive and fixed. These body fragments are not only decontextualised, but dislocated, suspended in space and time. Bones represent the densest objects. Viewed in the dark, with a strong light source behind, X-rays scarcely repress their status as spectres or emanations from another world. These are ghostly images thrown into light and life at the flick of a showman's switch.

In anatomical atlases, the dead body is brought to life, resurrected, resuscitated, through images; in radiography, the living body is rendered fleshless, bloodless, lifeless and dead. This is more than a metaphor; as Cartwright reveals: real human flesh and bone, real lives, were destroyed bit by bit by powerful light rays. Early radiography both made visible and simultaneously destroyed the human body (see Cartwright 1995: 108). Radiography represents a new kind of disciplinary subjugation. Subjective, lived knowledge of the human body is banished as unreliable. The body that emerges after radiography is a body that is no more than the sum of its parts. The historical and cultural experience of being human is stripped from it and its structure laid bare. Radiography dissolved flesh and decomposed a body that was shown, for the first time, to have the potential for death even before life had begun.

The foetus in the laboratory of life

The desire to see into the body is, in part at least, a sexual desire to get into the body. Radiography is penetrating and invasive. In 1896, Snowden Ward remarked on the ways in which radiography, photography and surgery might converge: 'Photographers [are] insufficiently acquainted with electricity, electricians insufficiently acquainted with photography, and surgeons insufficiently acquainted with both subjects' (Ward 1896: introduction). He ventured to suggest that 'surgical applications are far the most important at the moment … in obstetrics the enormous value of radiography must be obvious, upon reflection' (Ward 1896: 75). This is where the secrets of man's life and death are held. The woman's body becomes, for the first time, a living cabinet of curiosity.

In the late 1890s, articles began to appear in the European medical press on foetal and uterine radiography. The uterus was considered to be 'to the Race, what the heart is to the Individual: it is the organ of circulation to the species' (Smith (1847), cited in Poovey 1987: 145). The uterus was 'the largest and perhaps the most important muscle of the female economy' (*ibid.*). The year 1908 saw the publication of Leisewitz's and Leopold's work, *Das Geburtshilflicher Röntgen-Atlas*, which discussed the uses of radiography in obstetrics. This specialist atlas might usefully be read alongside *A System of Radiography with an Atlas of the Normal* (1907) which appeared at more or less the same time (Bruce 1907). An early textbook on radiography, it indicated the difficulties involved in reading radiographic images and the careful procedures that had to be followed in order to get any usefully legible image at all. To make a correct diagnosis, the doctor had to be able to interpret variations in density, to read light and shadow correlated with the age of the subject. The standards of normality were set by the older model of the male skeleton; masculinity was the prototype. Women were not pictured in this work; their skeletons did not qualify as normal, but only, to use Barclay's terms, as pathological, since they deviated from the male norm. The female skeleton, which had been absent from anatomy for so many hundreds of years, still remained invisible within general medical texts at the end of the nineteenth century. Woman only makes her appearance in her reproductive capacity.

However, radiography made it possible to picture, for the first time, the foetus inside the live female body. The price of this visibility is that the mother's body does not register on the radiographic plate. The foetus in *Das Geburtshilflicher Röntgen-Atlas* is first seen as a skeleton: not yet alive but symbolically, already dead. Like the older engravings, child skeletons are disproportionate. In the image reproduced here the skeleton performs a kind of dance of death (see Figure 33). Within the male psyche, woman bears a close resemblance to death, and the unbounded and threatening interior of the body

is usually coded as feminine. Thus to illuminate the reality of a new life behind the surface appearance, the thin veneer of flesh, is an inversion of surface and interior; it is both a turning inside out, and a reversal of what is visible and invisible, rendering life itself as deathly. In the foetus and neonate, skin has still the transparency of the unformed, or the yet-to-be-formed whose boundaries are unclear. This makes it easily accessible to radiography and renders it as a special kind of object. The foetus features in early radiography along with other small animals like frogs and rats.

And it has the same function. As a laboratory animal, it is a substitute for the adult male body. The female body itself, and the uterus in particular, becomes a laboratory, a controlled sanitised space where experiments on 'life' can be carried out. It is a kind of operating theatre in which the foetus plays the leading part. In early radiography the uterus appears as a dark empty space; its lack of density renders it as nothingness. Only the spectral formation of the skeletal foetus appears as complete and as if floating in a void. Woman is a culture for growing life and through radiography the progress of the foetus is

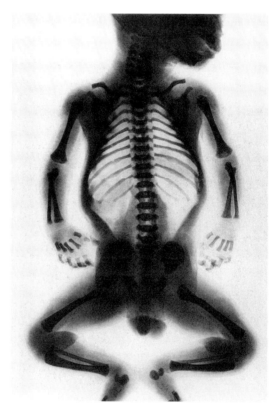

33 *A skeleton of a mature child.* G. Leopold and Th. Leisewitz,
Das Geburtshilflicher Röntgen-Atlas, 1908

monitored. It is both an identificatory figure and an understanding of the self as other. It is both like and different from a child; it is neither subject nor object; neither totally alive nor quite dead; until the moment of birth, the neonate is a product-to-be; a commodity that is not yet finished. This perception makes it easy to manipulate and ripe for experimentation, as if it were indeed merely a small living organism, such as a cell growing in a kind of fleshy Petri dish. The passage of the foetus from insensate object to sensory subject has been lengthy and controversial.[5] In radiography, pelvis and foetus appear as already separate objects. The mother's body, reduced to her racchitic pelvis, is a problem from which the foetal body, log-jammed, must be rescued (see Figure 34). The bones of the narrow or deformed pelvis could be cut and wrenched apart. The pelvis could be opened up through the operations of symphisotomy (or hebosteotomy) and pubiotomy, and the X-ray was employed to demonstrate the success of these operations (see Figure 35). Radiography might improve a surgeon's performance, and could be used to advertise and promote surgery. Pubiotomy, introduced in the last quarter of the eighteenth century, was not widely used because of the maternal mutilation that resulted. Howard Speert comments that it fell into decline with the increasing safety of Caesarean section (see Speert 1973: 285 and Spencer 1927: 170). However, the date of this atlas

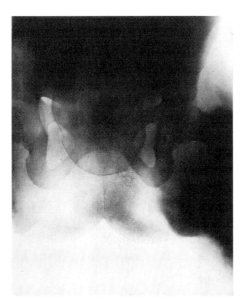

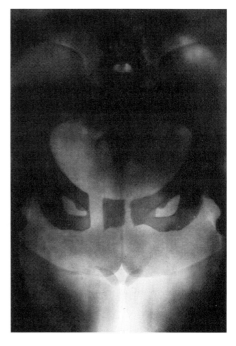

34 *A woman's narrow pelvis with child's head stuck in the middle of a labour.* G. Leopold and Th. Leisewitz, *Das Geburtshilflicher Röntgen-Atlas*, 1908

35 *A Woman's pelvis after a pubiotomy.* G. Leopold and Th. Leisewitz, *Das Geburtshilflicher Röntgen-Atlas*, 1908

suggests that it was still being performed in the early twentieth century. Looking at the skeleton body is in one sense to see pictures from a spectral home. These are uncanny images. If the pelvis registers on the X-ray, or the uterus appears as a miasma, the mother's body remains a shadowy phantom, a body everyone must pass out of, and into which no one can return. It is knowing the one-way nature of that street, perhaps, that makes the body of the mother and the related search for the secret of life such an enduring symbol: a holy grail of science. Whether consciously or not, in thinking about creating and controlling the environment where life begins, it is the woman's body that is revisited, interrogated and observed over and over again.

In *Window Shopping*, Anne Friedberg charts what she calls a 'gradual and indistinct epistemological tear' along the fabric of modernity, a change caused by the growing cultural centrality of a feature that is integral to both cinema and television: a mobilised gaze that conducts a flanerie through an imaginary other place and time (see Friedberg 1993, 1994 and Williams 1994: 8). The woman's body is also another imaginary place, set in another time. Through radiography the body becomes a showcase, cut through, exquisitely eviscerated. Radiographic images, read as narrative sequence, become part of the restless gaze that scans, cuts horizontally across the body, rendering it in thin transparent layers. Such images must be read alongside older images of the skeleton, both popular and scientific.

Through radiography the body was flayed without cutting away flesh and (so it appeared at first) without harming it at all. Lengthy observation from a distance was suddenly on offer. Looking intently without meeting the eyes of the subject was a characteristically modern experience. The result is a refracted, restless gaze; a gaze that is disembodied, unhinged in time and place. But such a gaze is also gendered. Radiography provided evidence that looking could indeed kill.

Notes

1 Schiebinger notes that in 1713 Cheselden recorded that he procured female bodies for dissection 'from executed bodies and ... a common whore *that* died suddenly' (Schiebinger 1987: 49).
2 Edward Mitchell was also the engraver for John Roberton's work.
3 It is worth noting that this pamphlet ran into three editions between 1895–96. In the copy held in the National Library of Scotland, this pamphlet is bound with theatre programmes. The article by F. J. Wall inside is, however, entitled 'The New Light and the New Photography'.
4 Snowden Ward went on to produce books about the supernatural.
5 For example, until the 1950s, anaesthesia was believed to be unnecessary for neonates. They were perceived as incapable of feeling pain.

5
Other dimensions: *The Edinburgh Stereoscopic Atlas of Obstetrics*

The Edinburgh Stereoscopic Atlas of Obstetrics (hereafter called the *Stereoscopic Atlas*) made its appearance rather late in the day: it illustrates a technology that was invented in 1834 and had its heyday in the 1850s and 1860s, but the atlas was published between 1908 and 1909. It is a strange work, which does not seem to belong to the worlds of either the nineteenth or the twentieth centuries, and it is, at first, difficult to know how and where to place it. Stereographs are, in any case, awkward images: they warp. They do not fit easily into the well-ordered, clearly defined historical narratives of orthodox photographic history, any more than stereoscopic images fit into the viewers or boxes designed to hold them.

Many authors have argued that the stereoscope declined after 1870 because of its extensive use in pornography (see Crary 1990 and Hunt 1993). It is certainly true that a vast industry producing pornographic stereographs developed rapidly in the 1850s and 1860s. But there is just as much evidence to suggest that, at the very point when its popular use diminished, its employment within a scientific context began to increase. By then, stereoscopy had 'become a necessary adjunct to the telescope and the microscope' (Mason (1870), cited in Earle 1979: 44). Moreover, in the United States between 1903 and 1905, more patents for stereoscopes were taken out than at any other time (Earle 1979: 76). These included patents for stereoradiographs and stereomutoscopes, fusing the older stereoscope to the new visual technologies of radiography and film. Thus, in the latter half of the nineteenth century the stereoscope bridged what was a growing chasm between the two-dimensional, fixed image and the three-dimensional world. Located between photography and film, and between print and sculpture, stereoscopy placed the observer at a bridging point between two slightly disparate images that appeared to converge into a single image of dramatic depth. Positioned at the apex of a triangle, the observer was plunged into a vivid hyper-reality. It is

therefore not surprising that the stereoscope operated at the very edges of both acceptable (scientific) and unacceptable (pornographic) verisimilitude (see Crary 1990: 127). The ambiguity of stereography may well be one of the reasons why the *Stereoscopic Atlas* fell into disuse.

Stereoscopy and double vision

It is important to emphasise that the invention of stereoscopy is quite separate from, and indeed predates, photography. Stereoscopy belongs to a cluster of inventions produced in the 1830s which often had little in common with each other. The invention of the stereoscope in 1834 had nothing to do with photographic processes. In 1852 Wheatstone, recalling his work on stereoscopes in the 1830s, wrote that 'at the date of the publication of my experiments on binocular vision, the brilliant photographic discoveries of Talbot, Niepce and Daguerre, had not been announced to the world' (Wheatstone (1852), cited in Wade 1983: 156). The invention of stereography was not dependent upon photography.

However, its mass appeal depended entirely on photography. Prior to the mid-nineteenth century, the stereoscope had been little more than an optical toy, but once it was amalgamated with photography it became a uniquely powerful medium. The optical device of the stereoscope gave a third dimension to the two-dimensional photograph; it provided the illusion of depth, while photography provided a sense of immediacy, of being there. Furthermore, stereographs were also combined with written text, guides and maps, thus closing the gap between word and image and bringing written and visual text into a new alignment. The stereoscope created a new configuration of information that allowed the viewer to return to a previously known terrain or to navigate a new, unknown one. Maps located the spectator. The observer was encouraged to imagine, fantasise about and absorb the image and to consult written, descriptive text in conjunction with viewing. Contextual notes were often printed on the same board as the stereoscopic images, thus making information compact. The reader–observer was given clear instructions: by 'carefully studying the map and facing in the direction indicated by the map, we go over the whole land, and see it just as if we were travelling in the land itself' (Osborne 1909: 57). Stereoscopes allowed the viewer to traverse a strange landscape: to enter into other worlds. If the viewer doubted the power of the stereoscopic experience, advocates could think of no better recommendation than pornography: 'to those who put a low estimate on the experience that can be obtained, even with the help of maps and books, in the stereoscope, compared with their experience in the presence of the place itself, we cannot do better than to remind them of the power of immoral pictures' (*ibid.*). Such images literally moved the body.

While it is important to bear this framework in mind when viewing the atlas, the stereoscope's primary use was as a popular form of entertainment

and education in a newly-created domestic consumer market. It was a means of educating through exploration, of navigating a world reconfigured by communication systems. Stereoscopes were ruthlessly marketed and by the mid-1850s upwards of 500,000 had been sold in Britain alone, from expensive and ornate monogrammed ebony and ivory models to cheap tin, and from stereoscopes as items of furniture mounted upon stands to portable, folding book stereoscopes adapted for pocket use. The London Stereoscopic Company's catalogue for 1856 consisted of views from home and abroad, sentimental narratives and illustrations from Shakespeare and the Bible and promised the consumer 'everything grand and beautiful brought to our own fireside' (Anon. 1856: 12).

But not all the material was either grand or beautiful. Its association with illicit, specifically pornographic, material linked stereoscopy to the obscene; indeed, the stereoscope was, as Crary suggests, 'inherently *obscene*, in the most literal sense a perversion of sight' (Crary 1990: 127). The *Photographic News* called attention to the brisk trade in such images. In 1858, in an article headed 'Questionable Subjects for Photography', it linked death, sentimentality and sex (the real subject of the article) by commenting upon the rush of images of the distasteful 'carousing skeletons' and their obverse, the sentimental 'namby-pamby broken vows', which together led on to the pornographic, 'another class of picture'. The anonymous author drew attention to what he saw as the distinction between stereography and lithography: 'in the case of lithographs there was at least the consolation that they had no existence except in the salacious mind of some immoral draughtsman, while in the slides we are alluding to we have the full assurance that the woman is the model ... a life like representation of courtezanship transferred in all its faithful hideousness – a very microcosm of impurity – this is one of the things we cannot look upon without disgust'. These 'stereoscopic pollutions' are 'vice under the garb of science and art' (Anon. 1858c: 135–136).

Photography combined with the stereoscope brought 'the remotest objects within the very grasp of the observer' (Brewster 1834: 5). However, a remote object is not necessarily one that is far away; the woman's body might well be described as a remote, unknown object that man desires to know. The stereoscope also extended vision, enabling observers to 'perform their journeys over and over again' (Earle 1979: 12). Physical immobilisation, while entering a realm of fantasy that was characteristic of the older diorama, is inherent in stereoscopy. The image produced appears to have greater depth of field; outlines are sharper; objects appear to jump out. Lack of physical movement is compensated for by repeated viewing in depth. The possibility of returning to, or revisiting, is essential to both photography and stereography. When linked to viewing the woman's body, such a return, whether in pornography or medicine, suggests a certain 'insistence ... constant pressure of something that is hidden

but not forgotten' (See Rose 1986: 228). It is the woman's body that is constantly revisited, its image endlessly repeated.

The Edinburgh Stereoscopic Atlas of Obstetrics

Perhaps the *Stereoscopic Atlas* may best be understood as an attempt to grasp the very processes of human reproduction by means of what was perceived as an enhanced form of mechanical reproduction: the stereoscope. Following the convention of earlier medical atlases, it was published as a series, in four parts over two years.[1] The four 'volumes' of boxed illustrations were made to look like books, with their titles printed upon the spines and the contents listed on the back. They fitted a library shelf and included a stereoscopic viewer which was constructed so as 'to fold into a case like a map'; this was considered by the *Stereoscopic Magazine* to be the most convenient portable form of stereoscope sold by booksellers (Anon. 1856: 12). Thus word and image came into a new, reversed configuration; rather than the photograph being in the book, it is the book that is in the photograph. As one writer suggested, 'one look through the stereoscope teaches more than hours spent in hearing or reading descriptions' (Osborne 1909: 27).

The atlas promised a condensation of information that bound visual spectacle to written material. Its narrative begins with the skeleton and it devotes its first thirty images to the pathologies of the pelvis (see Figure 36). It then fleshes out this picture with 'pelvic contents' up to the eighth month of pregnancy (see Figure 37). 'The authors are have been fortunate in getting an excellent series of specimens … special reference may be made to the

36 Plate 27: 'Pelvis of acromegalic gigant (by kind permission of Dr A. Campbell Geddes)', *Edinburgh Stereoscopic Atlas of Obstetrics*, 1908–9

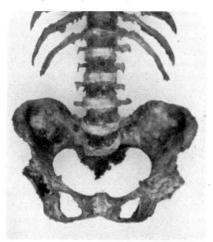

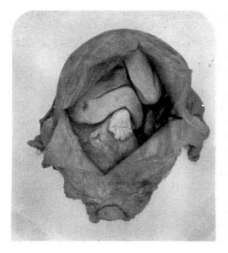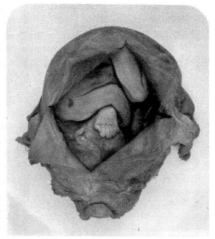

37 Plate 50: 'Gravid uterus at the eighth month of pregnancy (by kind permission of Professor Harvey Littlejohn)', *Edinburgh Stereoscopic Atlas of Obstetrics*, 1908–9

stereogram of the 8th. month of pregnancy [which] shows very *beautifully* the normal attitude and presentation of the foetus in utero' (Anon. 1909a: 93).

The atlas also includes some of the first photographic images of live birth. These images are however the exceptions; it is morbid specimens that dominate. The woman's body, and specifically the mother's body, is first understood through death and the observer is presented with a narrative of life shot through the prism of death.

The few remaining copies of the atlas, their poor condition and location in stores and stacks, may well be a testament to the unacceptability of both the subject matter and the technology. These are shocking pictures, scenes of carnage: images of bodies, not made, but unmade; fragments, *corps morcelés*; bodies that are made out of bits and pieces or remnants; works of both fantastic fabrication and crude manufacture. It is a record of the ways in which industrial processes can be applied to the pregnant body. Female bodies, frozen in the process of creating life or dissected by the anatomist, are dismembered and reassembled in a grisly parody of life. But what is clear is that the body cannot be put together again, and indeed the *Stereoscopic Atlas*, following the convention of older atlases, is made up of thirty, forty, or possibly even as many as a hundred different bodies. These bits and pieces, these pulverised fragments, are to be reassembled by the spectator through stereoscopy; out of death emerges a picture of life.

The embalming techniques of both pathology and photography seem to breathe death into life; the stereoscope reveals the brightness, and the depth, of death: 'When an object is, therefore, seen single with two eyes, it is in reality double, but the two images coincide so accurately that they appear only as

one, having twice the brightness of the image formed by either eye alone' (Wheatstone (1830), cited in Wade 1983: 308). Stereoscopes produce vivid, lively, startling images that jump out at the frozen, fixed viewer. These new ways of looking created new realities, constituted new objects, in effect, *generated* a new female body. This new body, manufactured in the hospital, that factory of the body which had developed alongside the modern state, was first and foremost an industrial and productive body which could only be understood by taking it apart, dismantling it, stripping it down into its component parts.

This was not a body that already existed but one historically created through the mechanics of industrialisation; like Frankenstein's monster, it is a horrible, terrifying body made out of corpses, roughly hewn, poorly sutured and ugly. Through the processes of anatomy, woman is cut down to size; which is to say that, in the end, she is nothing at all; her body disintegrates. Symbolically, the life of the perfect child is made out of the death and destruction of the mother. It is only in laying out these images that we can see the atlas as a kind of technical manual. Individually, the images seem to float in space, in a void of emptiness.

The two editors of the atlas were George Freeland Barbour Simpson and Edward Burnet. Burnet had collaborated with David Waterston on the *Edinburgh Stereoscopic Atlas of Anatomy*.[2] No further works were published. Simpson had been senior assistant to John Halliday Croom, Professor of Midwifery, and no doubt had hoped to succeed him. In the interests of professional advancement and self-promotion, the editors placed themselves in a hereditary line of great obstetricians. The atlas was dedicated to Alexander Russell Simpson, Simpson's father, and the authors enlisted the help of Croom to write the preface. Croom had assisted previous professors of midwifery, Thomas Laycock and James Young Simpson, Simpson's great-uncle.

The story of the *Edinburgh Stereoscopic Atlas of Obstetrics* is a patriarchal narrative; a story of forefathers, fathers and sons, either literal or metaphorical, but never a narrative of mothers or daughters. The son dedicated his work to his father, as 'friend and teacher', and Barbour Simpson's obituary in 1958 noted that he had been 'born into a distinguished obstetric heritage' (his mother was the sister of A. H. Freeland Barbour, lecturer in gynaecology). 'Not a prolific writer', the obituary ends, '*The Edinburgh Atlas of Obstetrics* was his only public contribution' (Anon. 1958: 1008). Just as we read nothing of G. F. Barbour Simpson's mother or wife (other than his mother's relationship defined in relation to her successful brother), we do not know who the women are in these photographs of delivery.

The atlas cements the relationship between the new anatomy and pathology and the old, between dissection and disease, and between obstetrics and gynaecology. It has its place in the forging of links between obstetrics and

gynaecology which was paramount in the nineteenth century. It was however considered, if not useless, then of extremely limited educational value. In the copy held in the library of the University of Edinburgh someone has written in the margin of the introductory pamphlet, 'PS Please note that the clinical material is quite insufficient and these plates can't fill up the vacancy'. The note is simply signed 'Pro Bono Publico' (for the public good), and what its writer saw, despite the fullness of the visual text, was inadequacy, emptiness of meaning; a work that was lacking. A review of Section 2, published in the *Edinburgh Medical Journal*, described the anatomical dissections of the interior of the pelvis as merely 'disappointing' (Anon. 1909a: 93). The images fail to satisfy.

In his preface to the atlas, Croom did his best for a poor work. He drew attention to the technological progress which had been made by contrasting the older illustrations with the exciting new plates, and emphasised the work's contribution to the advancement of medical science in the field of midwifery. Medicine had now superceded religion; ministering to souls had metamorphosed into the administration of bodies. Consequently, Croom adopted a liturgical tone in his preface: instead of working 'by the grace of god', the obstetrician worked 'with the aid of the stereoscope' (Croom 1908: vii).

Croom provided suitable puff for the work:

As the teaching of midwifery has advanced the illustrations have become more and more abundant; from the old wall diagrams and the woodcut of the textbook to the magnificent wall plates that now adorn our classrooms and the beautiful lithographs and chromo-lithographs which enrich our textbooks, not to speak of the endless diagrams of a more or less ornate and accurate description which are placed in the hands of the students daily to illustrate their notebooks ... By the introduction of photography they (the authors) have been able to reproduce with absolute accuracy the various specimens ... and by the aid of the stereoscope they have made those illustrations so pronounced, clear and definite, that the student can now study these stereograms with as much accuracy as if he had the actual preparation in his hands ... each illustration can be demonstrated with a realism which could only otherwise be attained by the examination of the actual specimen, which in many cases is either very rare, or too valuable for everyday handling ... They have made excellent use of the ample material at their disposal for making these illustrations of labour and gestation specially impressive, taken as they are from actual life. (Croom 1908: vii)

One might more accurately say, taken as they are from actual death. Drained of life and colour, most of the specimens are morbid. With its employment of skeletons, dead foetuses, the gravid uterus ripped from the body, the atlas hovers uneasily between fullness and emptiness of meaning, as it does between life and death. The grotesque combination of skeletal bones with soft

tissue and ligaments still attached does not observe the conventional boundary between bone and meat, between hard armature and the softer fleshing out of the body (see Figure 36). The images hover uncomfortably, the mark of a failure in the ordering of the corpse, which is not properly cleaned. It stands as a reminder that the business of separating flesh from bone is not easy, and that it is only achieved through the violence of the knife. The neat boundaries of the body promised by anatomy are neither clear nor distinct. These are *tableaux morts*, grotesque scenes of a hellish reconstruction which relocates a dead foetus within the frame of a pelvic skeleton. These are undoubtedly frightening pictures, which form an understanding of the female body as a deathly place, as a grave (see Figure 38).

In this image, Plate 80, the foetus, full-term and complete, lies as if asleep and merely waiting to be woken. It is carefully placed within a pelvis, hollowed out and scraped whistle clean and then rotated to demonstrate the various positions of presentation. The disembodied pelvis is merely a frame, an armature, a carcass within which the foetus floats. Life is pictured in death. Against the fullness of the plump, fleshy foetus, the emptiness of the bony pelvic basin has the appearance of a giant maw. This suggests that the child is as likely to be consumed by the maternal pelvis as delivered from it; it is a dangerous place. The foetus, as identificatory figure for the (presumed male) viewer, is granted bodily integrity and remains intact; it is to be rescued from the jaws of death.

Throughout the whole series we never see the face of a mother, nor, crucially, the sex of a foetus. The bodies of women, even when alive, are headless inanimate objects, things. We never see the face of a midwife, although we see

38 Plate 80: 'A. Right mento-posterior (R.M.P.) position of face. B. Left mento-posterior (L.M.P.) position of face', *Edinburgh Stereoscopic Atlas of Obstetrics*, 1908–9

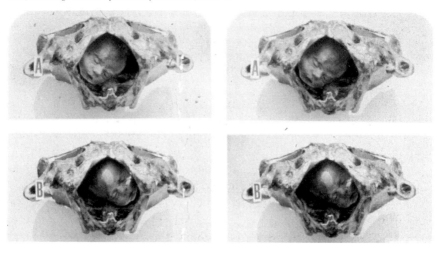

her hands. Her 'arbitrary' customs, the opposite of medical science, appear in the text as a warning in the description to Plate 88: 'This figure represents a third stage uterus with attached placenta in cavity. Her 8 previous confinements had all been normal. On this occasion the midwife who was in attendance stated that the placenta had come away and been put in the fire. Death occurred from haemorrhage which took place an hour after the alleged delivery of the placenta'. The general point is quite clearly made. The midwife was unskilled and that ineptitude caused death. This impresses on the student the need for medical intervention, management and supervision to ensure that delivery remains firmly in the hands of obstetricians.

In 'Lectures in Midwifery', delivered in 1905, Croom had issued students with diagrams, and many of the stereographs here appear to be based upon these earlier lithographs. The lithographic images have a clarity missing in the stereographic plates (see Croom 1905), but this did not prevent some reviewers from claiming the superiority of stereography, and confusing the representation for the object, the stereograph for the 'thing' itself. 'This atlas is superior in that it consists of the things themselves, not in drawings ... the student ought to learn from the subject itself, but during the hours when he cannot get at the subject, this atlas will be helpful' (Anon. 1909b: 1419). There is something livid, frenzied about the term 'get at' which is at odds with the idea of the more 'helpful', supposedly contemplative, nature of stereoscopic viewing. But the stereoscopic images have neither clarity, nor precision. They are murky and grey, lacking the clear linear boundaries of anatomical diagrams produced through the processes of engraving, and difficult to decipher. The idea of forming 'museums of photographic illustrations of anatomy and surgery' had been suggested in the *British Medical Journal* in 1858 (Anon. 1858a: 192). The reviewer suggested that 'especially if aided by the stereoscope, [this] would be a valuable auxiliary in medical schools' (*ibid.*). It solicited the approval of the Royal College of Surgeons: 'if photography had been known in the days of John Hunter, there can be no doubt that this illustrious man would eagerly have availed himself of the means thereby afforded him of representing nature' (*ibid.*). By the mid-nineteenth century, photographic images were seen as the way forward, precisely because 'matter must always be fixed and dear' (and this included human matter), while form was 'cheap and transportable' (Holmes 1859: 748). However, it was not easy to produce photographs which clearly distinguished different parts of the anatomy. Thus the *British Medical Journal* concluded that the *Stereoscopic Atlas* was 'not a substitute for a book on midwifery, but only an aid to impressing things on the reader's memory' (Anon 1909b: 1419).

This slippage from obstetrics to midwifery is as revealing as the invocation of 'things' impressed on the reader's memory. Croom used the older term, *Midwifery*, as the title of his book, but within a couple of pages he had

established the superior ground occupied by obstetrics and gynaecology. He describes obstetrics as 'in the last century an art for 1st part, 2nd part advanced to being a science', and gynaecology as 'a development of the last thirty or forty years' (Croom 1905: 11). It is thus that the art, or craft, of midwifery is superceded by obstetrics which is, ostensibly, a science. The division between midwifery and obstetrics was still unclear at the end of the nineteenth century.[3]

It is significant, therefore, that the atlas contains a few of the first photographs of the processes of live birth and delivery under anaesthesia. Introduced in 1847, anaesthesia quickly found a place in midwifery. The labouring female body is particularly unwieldy and recalcitrant. Anaesthesia transformed this body into an inanimate object, putting it out cold, rendering it passive, silent, as close to death as life can be. The live body appears frozen, stilled in the processes of giving birth, or rather of being delivered; the head emerges, the foetus is set to slip out. Other images concentrate upon the use of instruments in the work of extraction: something must be got out of the body, and the process of doing so looks like a site of excavation rather than a woman giving birth. She looks as if she has been tossed on to a slab; she could be dead. In nineteenth century post-mortem photography, the instruments – the knives, scissors and saws which cut the body open and carved flesh from bone, or the mallets which break it into bits – are rendered invisible, hidden or removed from the scene. In these images, however, we see the instruments of traction *in situ*, as well as the product, the delivered foetus. Something which borders on death is called life.

In Plate 71, a doctor is caught by the camera; suited, bespectacled, he is seated at the head of the patient, well away from what lies below (see Figure 39). He administers anaesthetic, which ensures her compliance in the process of making an image, producing a body. It would have been technically impossible to produce the images of traction without using anaesthesia to render the mother's body inert, unfeeling, numbed. She lies as if already dead, no longer part of the process of giving birth, but redundant, inefficient, an impediment to delivery of the product. Anaesthesia, significantly, emerged before antisepsis. It was anaesthesia which allowed untrammelled access to the body. Chloroform was capable of laying 'the most restless or ungovernable patient quiet on her pillow' (Simpson (1847), cited in Poovey 1987: 141), and as she points out, this produced 'a more tractable and therefore a more passive object for the accoucheur; epistemologically this meant that the unresisting body offered no impediment to the doctor's *interpretation*' (Poovey, *ibid.*). Chloroform produced a docile body.

In the texts, the voice the observer hears when looking at a picture is the anonymous voice of authority, that of the anatomist–pathologist. It is not accidental that the new and supposedly 'objective' positivist technologies of

39 Plate 71: 'Axis-traction forceps', *Edinburgh Stereoscopic Atlas of Obstetrics*, 1908–9

the nineteenth century elevate and promote the visual, nor that they run par-
allel with a decline in the patient's narrative, which becomes merely prelimi-
nary rather that primary. The viewer, like the ventriloquist's dummy sitting on
the lap of the operator, mouths and repeats words that have been in someone
else's mouth; these images have been seen through someone else's eyes and
they have the power to fashion and shape our understanding of the female
body. And the voice the viewer hears as he gazes at a spectacle is certainly not
the mother's voice, nor his own: it is his master's, the voice of paternal
authority, of symbolic fathers, those to whom the editors must pay due
homage if they are to take the father's place. The patient's own narrative is lost
for ever. The women pictured here have no record, no names. The female body
is merely made to perform, to hold still for the camera.[4]

The atlas stands on the border between life and death; between licit and
illicit; between text and image, forging, literally, a new relationship and a
direct connection between knowing and seeing. Every gaze, erotic or medical,
has the ability to 'hear a language' as soon as it 'perceives a spectacle' welding
words to things and thus producing 'the great myth of the pure gaze that
would be pure language: a speaking eye' (Foucault 1976: 108). The object,
woman, is clearly separated, brutally severed, from the male viewer. Through
the image he remains safely in control.

The cards on to which the stereographs are pasted have an accompa-
nying 'elementary' text which is intended to enlighten the observer/reader
about what is being exhibited, thus impressing on the viewer's mind what the
student, as one reviewer put it, could not 'learn with his own eyes and fingers
from the subject itself' (Anon. 1908b: 603). Another reviewer noted that the
explanations of the images provided by the text were inadequate; the student,

he suggested, will 'need more than the explanatory text to enable him to understand them'. The atlas was 'a luxury' (Anon. 1908a: 1181). This is a testament to the complications of photographing viscera and pathological specimens, a difficulty commented upon in the *British Medical Journal* in 1886. Early non-orthochromatic film was insensitive to red, and panchromatic film was not introduced until 1906, too late for the *Stereoscopic Atlas* (Davenport 1991: 24). Blood registers on film as blackness and, metaphorically, as dirt. The *British Medical Journal* described the disadvantages of using photography in anatomy. These were primarily pecuniary and aesthetic; the images were 'somewhat expensive and are not highly, if at all, ornamental. When taken from specimens hung up dry before the camera, they often assume the unsightly appearance of irregular masses of clinker or pumice-stone, with something like tendons or bones mixed up with ugly black objects representing flesh, muscle or mucous surfaces … photographs of diseased viscera often fail to instruct the observer, but rather remind him of Ovid's description of chaos' (Anon. 1886: 163). This description suggests that separating out bone or muscle from tendon or skin is no simple matter. The article argued that the most recent specimens, freshly dead, were the most suitable, 'since they had not assumed the uniform pale colour of old specimens, and pale surfaces do not take well' (*ibid.*). The object had to be carefully manipulated to fit the exigencies of technological execution, not the other way round. Like Hunter's bodies, it had to be prepared, suspended in alcohol, injected with fluid, or frozen and sliced. All these techniques were employed in the atlas. The main advantages of mass-reproduced images, however, were economic, since they could achieve uniformity and save authors from the expense of having specimens drawn. Thus mechanical production was eventually to produce the optical consistency necessary to disseminate the expanding discourses of scientific realism.

But the metaphoric clustering of disease, blood, blackness and chaos in relation to gender is neither accidental nor meaningless, and it should not be overlooked. Blood is matter out of place. It is that which has refused to observe the boundaries of the skin; it is associated with both life and death, birth and murder; the benign processes of menstruation and child birth, and the violence of disease and death. Blood is neither solid nor, strictly speaking, fluid. Rather, like meaning, it seeps, leaks, congeals. It is the mark of a body that has burst its banks. It is women's bodies, more than male ones, which are perceived as leaky.

From the eighteenth century onwards, human endeavour in the industrial west was geared to a philosophy of reproduction. Stereoscopy was part of a wider industrial drive to find 'a general philosophical instrument of universal application' (Brewster 1819: 5). This search was for a single instrument that could be used for a whole range of purposes in the arts *and* the sciences. In the

nineteenth century the world had to be remade and reconstructed to produce a new reality. The strength of bourgeois ideology was to construct its reality and then to naturalise its discourse and its vision, and to educate us to mistake it for our own. Photography and stereoscopy helped 'to train society from its topmost to its nethermost stratum' (Root 1864: xv).

The stereoscope, literally 'solid to see', gave depth, dimension, solidity to the two-dimensional fleeting image. It represents an attempt to construct a virtual world. The first stereoscopic images were daguerreotypes. Many were produced experimentally in the 1840s, and by the 1850s stereo daguerreotypes were produced commercially (see Darrah 1977: 1). It was within the context of the technological convergence of instruments that a machine for extending vision was created. The stereoscope was mass-produced and mass-marketed. The London Stereoscopic Company promised market saturation with 'a stereoscope for every home' and between 1854 and 1856 over half a million were sold in Britain alone (Darrah 1977: 3).

The stereoscope has to be understood as part of a wider techno-intellectual response to modernity. It aimed to give the appearance of solidity, of three-dimensionality, at a moment of rapid social shifts. It both documented these shifts and put them on hold. Stereoscopes provided the illusion of depth, but it is a theatrical depth created with flats; an image slotted together that resembles like a cardboard model. The stereoscope is itself a kind of sectioning and dissecting. Stereographs have a suspended, floating quality, making the viewer strangely aware that, despite the fullness of the image, there are gaps, spaces in-between. The pseudoscope, a parallel invention which reversed the stereoscopic image to make objects appear hollowed out, had little appeal or impact. It may be that it did not meet the demands for depth and dimensionality, but worryingly suggested the reverse, betraying the emptiness at the very heart of the image.

It is worth noting the similarity between the stereoscopic 'hood' and the 'headsets' of virtual reality viewers, with their shared aim of total immersion. The advantages of the stereoscope over the photograph were constantly proclaimed. An ordinary camera 'resembles a single eye'. The stereoscope is 'like a forehead with two eyes in it' (Abbot (1869), cited in Silverman 1993: 741). This suggests that the stereoscope accurately resembled human binocular vision. It was rapidly elevated from a mere philosophical toy to a trusted instrument of scientific truth. For Holmes, the 'stereograph differs from every other delineation in the character of its evidence. A simple photographic picture may be tampered with … but try to mend a stereograph and you will soon find the difference. Your marks and patches float above the picture and never identify themselves with it. … the impossibility of the stereograph perjuring itself is a curious illustration of the law of evidence' (Holmes 1861: 15). Its virtues were also extolled in the

medical press: 'Once its advantages over the ordinary single picture are realised it appears that many illustrations in medical journals and in scientific or other periodicals – even in books – will be reproduced stereoscopically. The observer will be able to use some simple form of stereoscope (similar to a pair of pince-nez)' (Davidson 1898: 1669). Brewster includes a sketch of 'stereoscopic spectacles' but comments that 'the effect is, however, not so good as that which is produced when the pictures are placed in a box' (Brewster 1856: 69). The box and the Holmes stereoscopes bracket out the surroundings and the interference of the everyday world. They cut the viewer off, allow him or her to enter another place or time; moreover, other viewers are also shut out and no one can see what the observer is looking at. This is not a publicly-shared experience of viewing but a plunge into a private, fantasy world. Stereoscopy effectively removes the observer from the material world and welds them to an image. The important point here is that, from the time of the stereoscope's invention, the three-dimensional, with its effect of solidity and substance, was located not in the image, nor simply in the eye of the beholder, but in the body. The stereoscopic effect is as much about the form of viewing as about the content of the image. It is an instrument that divides the subject as much as it welds the disparate elements of subjectivity together. In its dividing and doubling, it produces a compound image, and simultaneously a fragmented observer.

The stereoscope is an attempt to get hold of some depth, the substance of a *visual* reality. But while the stereoscopic image certainly has greater depth, it has less breadth and more limited narrative possibilities than film. The atlas is unable to match either the flow of film or the precise technical information of a print or drawing and thus its spatial acuity is diminished by its temporal limitations. It is, for example, impossible to view stereoscopic collections quickly, but 'if one is patient enough to use stereoscopes, the three-dimensional affect is remarkable, if somewhat artificial … one seems to be looking at an anatomical-diorama, as in a museum display' (Roberts and Tomlinson 1992: 608–609). Such anatomical-dioramas and museum displays shaped the mass visual appeal of the stereoscope. Crary is right to point out that no form of representation in the nineteenth century 'had so conflated the *real* with the *optical*' (Crary 1990: 124). With a rapidly expanding population, mediated, mass viewing became essential. In an age of disillusion and lies, the invocation of truth and fact had the upper hand. The *Photographic News* boldly declared that while 'the object of the painter is to make a picture, the object of photography is to tell the truth' (Briggs 1879: 230–231). Photography, linked to stereography, literally produced a deeper truth.

Stereoscopes fragment, pulverise and dislocate objects and isolate the viewing subject. To look through a stereoscope, the device which makes stereographs legible, is to experience an uncanny sense of mastery and control, as if

one had put everything in place with one's own hand. Like a portable peepshow, stereoscopes disconnect the observer from the time and place in which she or he dwells. Stereoscopes, in short, cater to fantasy. This is the observer's world, far away from the interference of the humdrum everyday. Even now, to look through the stereoscope is to experience a heightened, dizzying sense of perception: a peculiarly exaggerated three dimensionality, as if standing on the very threshold of a montaged scene, where objects are thrown into startling relief. In comparison, the real world seems to lack dimension.

In this sense stereoscopes are very much like portable dioramas, and for contemporary viewers, whose perception is shaped by the moving image, the stereograph viewed through its scope has something of the characteristic artificiality of a toy theatre or pop-up book or, indeed, the multiple fragments of nineteenth century scrapbooks. But what it offers has not been simply superseded; such heightened artificiality is replayed in computer games. This is a childlike fantasy. It is as if the observer can get into the image; as if we could really peek behind the flats. These images are cut-outs. Photography fragments reality and stereoscopy reassembles it, puts it neatly back together under a new law. In a very real sense, stereophotography produces an omnipotent view of the world. Brewster was well aware that the stereoscope traversed a fine line between noble truth and downright lies, and warned against the optical over-exaggeration obtained by setting two stereo cameras at an artificially wide distance, thereby obtaining 'unreal and untruthful pictures, for the purpose of producing a startling relief' (Brewster 1856: 147). Undoubtedly this was a perverse, exaggerated view rather the mere replication of ostensibly natural human vision, and it revealed the artifice, the trickery, the mechanism of stereoscopic vision, and the obvious manipulation of the observer. This placed stereoscopy in the realm of tawdry amusement, rather than the field of noble science. But the divide between science and popular culture is far from clear.

What certainly did exist was a social imperative to throw the flat image into another dimension. There is a close link here between the photomicrograph, with its flattened horizontal plane, and the vertical, depth-emphasising plane of the stereoscope. Stereoscopes cleverly blurred the division between two and three dimensions. If the spectator and the world were being unmade, taken apart and reassembled, then it was because the modern world lacked dimension and depth, a deficiency equally applicable to subjectivity. There is a sense in which modernisation is a work of reparation and reconstruction. It was in the nineteenth century that observers for the first time became addicted to the compensatory reality of the stereoscopic image with its deep space. Here the viewer entered a world that was more real, more vivid, more spectacular. This was an escape from the daily grind of modern life. At a single stroke, stereoscopy compressed space and time and abolished distance. The anxiety was that such technologies also reconfigured subjectivity, producing disengaged, dislocated

subjects who withdrew from the material world. Visually overstimulated, the observer becomes unmoved. For the first time, it is the image that is strangely animated, which comes to life, while the observer is physically immobilised.

Yet this need for reassembly is also a testament to fragmentation and death. The photograph is a slice through time, a frozen moment, that is closely related to the industrial technologies of preservation that allow goods to be transported over long distances. Like the specimen, photographs appear as preserved or frozen objects. Preserving is a means both of killing and of preventing further deterioration. Freezing enabled bodies, whether human or animal, to be sliced into transportable parts. It was also a means of dispelling the flaccidity which organs rapidly assumed after death, so that what was dead presented a more lifelike appearance to the viewer; a section, like a photographic image, is a 'slice of life' which mediates between two and three dimensions. The sense of fragmentation and death is compounded when one considers that many of the images in the atlas are of dead bodies that have been preserved through embalming, freezing and finally photography. Between life and death, between absence and presence, photography puts the world on a continuous hold. Photographs paper over the gaps and spaces in the discourse of modernity and the stereoscope epitomised this dislocated spatial relationship.

Stereoscopy only really works for objects in the middle distance. As Crary suggests, 'the most intense experience of the stereoscopic image coincides with an object-filled space, with a material plenitude that bespeaks a nineteenth-century bourgeois horror of the void' (Crary 1990: 125). Photography keeps those things, including woman, which are perceived as threatening at arm's length: neither too far away, out of sight and dangerously unknowable, nor too close to be threateningly overwhelming. We might also, in the case of the atlas, add a maternal plenitude. The interior of the body of the woman represents just such a space: a threatening void, a space which must be filled, stuffed with meaning. Its surfaces must be inscribed and its hidden depths transfigured into more manageable layers. The mother's body is an object of fantasy, in which can be conjured up the very secrets of life. The mother in these images is a frightening spectre. In undoing, in dissecting the body of the mother, the anatomist-pathologist is able to enact a sadistic wish to have total control over the body of the mother who was, after all, his first body of knowledge and who once had control over him. To cut her body open, to root out the hidden source beneath the false surface is an impossible quest for his own origins and their simultaneous destruction. It is a disavowal of maternal anatomy and authority. Pathological anatomy is not an unveiling, nor even a peeling back of the sheet of skin, but a violent ripping and digging: the stripping down of a body as if it is a machine which can only be understood by taking it apart, dismantling it into its components, its smallest parts. But once the layers are removed, the organs ripped out or bones broken, there is no core of meaning; nothing to be revealed.

THE EDINBURGH STEREOSCOPIC ATLAS OF OBSTETRICS.

32. EXTERNAL GENITAL ORGANS OF NULLIPARA WITH HYMEN INTACT.

(By kind permission of Professor Harvey Littlejohn.)

The **Clitoris** is an erectile organ situated at the anterior portion of the Vulva, and is described in Stereogram 33.

The **Vestibule** is a triangular area of mucous membrane which is bounded laterally by the Labia Minora, the Clitoris constituting the apex, and the anterior margin of the Vaginal Orifice its base. In the centre of the base is the **External Urethral Orifice** (1), which in the accompanying view has been artificially dilated and the specimen hardened in formalin. The **Vaginal Orifice** lies further back below the Orifice of the Urethra. In the virgin this opening is more or less closed by a fold of mucous membrane—the **Hymen**. When the Hymen is intact the opening is small, having in most cases the appearance of a vertical slit. It is well-seen only when the membrane is put on the stretch, when the aperture may be seen to be crescentic, opening anteriorly. Sometimes it is circular. The Hymen may be cribriform. An imperforate Hymen is likely to lead to trouble after menstruation has set in, because of retention of the menstrual fluid.

The Hymen is generally ruptured at the first coitus, and at parturition becomes still more broken up, and reduced to irregular projections of the mucous membrane—the **Carunculæ Myrtiformes**.

Between the posterior margin of the Vaginal Orifice and the Fourchette is a small boat-like depression, known as the **Fossa Navicularis**.

Figure 1 indicates the artificially dilated External Orifice of the Meatus Urinarius, immediately below it is the Hymeneal Aperture or Introitus Vaginæ. In this case the Orifice is circular, and has also been dilated.

32

40 Plate 32: 'External genital organs of nullipara with hymen intact (by kind permission of Professor Harvey Littlejohn)', *Edinburgh Stereoscopic Atlas of Obstetrics*, 1908–9

In the *Stereoscopic Atlas* there is one image that epitomises this (see Figure 40). Plate 32, is nothing more than a sad, tiny scrap of flesh suspended in space. It makes a neat zero. There appears to be nothing to be seen; the excision, coupled with the mixture of hair and dead skin, makes the observer uneasy. Looked at through the stereoscope, the viewer experiences an uncanny sense of complicit mastery. In the search for origins, the mother's body is cleaned out; it is turned inside-out like a glove. Our intrepid anatomist-explorer finds what he is looking for: no-thing. Emptied of life and meaning, the mother's body is dispelled.

Notes

1 Sections 1 and 2 in 1908; 3 and 4 in 1909. The work consists of 100 cards, 25 in each section and cost £4 4s.
2 Published in 1890, second edition 1905. This earlier *Atlas of Anatomy* had been a considerably larger work of 250 cards, and cost £6 5s.
3 It is significant that Croom's work appears as *Lectures on Obstetrics* in the library catalogue of the Edinburgh Royal College of Physicians. This shows that obstetrics and gynaecology is an emergent field whose nomenclature is not yet stable. It is applied retrospectively. Here visualisation, which advertised obstetric technological advancement, was crucial.
4 It was James Young Simpson, Barbour Simpson's great uncle, who in 1847 had advocated and promoted the use of chloroform in labour and advertised his painless operations in the Edinburgh newspaper, the *Scotsman*. For a year or so, the casebook of the Royal Infirmary (now in the Royal College of Physicians, Edinburgh) records its use and the attendance of doctors at delivery, but by 1849 there is no mention of its use. By the 1860s, it is the names of the mothers, and occasionally 'nature', that appears under the heading 'by whom delivered'.

6
Looking for life: microscopy and modernity

There is, perhaps, an unexpected continuity between the earliest microscopes and those of the present day. Clearly, there is an enormous gap between early and contemporary technology. In the seventeenth century Anton van Leeuwenhoek used microscopes so minute that they had to be hand-held and pressed close to the eye. Contemporary instruments are both too large and heavy, and too sensitive to be handled in that way; neither hand-held nor portable, they are fixed. The observer must come to them, and be harnessed as a component in the machinery. Nor is there much to connect the optics of earlier microscopy or, for that matter, photography, to modern electronic forms of imaging. The history of microscopy is not the history of improved technology, any more than microscopic vision is merely an extension of unaided sight. Technologies are always social before they are technical and microscopy represents a fundamentally diffracted, abstracted perspective characteristic of the rise of modernity.

What might, however, connect the microscopes of earlier and present times is a pattern of belief about women's bodies. Microscopes have been crucially involved in the search for the secret of life, and women's bodies, characterised by their reproductive power, are at the displaced heart of that endeavour. Microscopy has played a significant role in creating the paradox whereby pictorial representation has been used to take women out of the picture, especially in the matter of generation and reproduction. By the mid-nineteenth century, detailed, abstract visual imagery had cast up a new sense of what was meant by the concept of 'life'. That concept, however, had a long history, and ancient, residual theories of generation were incorporated into microscopy as the ascendant technology of the nineteenth century. The rise of cell theory and the 'discovery', at the end of the century, of an organising nucleus, a core of genetic information at the centre of the cell, meant that the narrative of generation finally and irrevocably gave way to one of reproduction. Women's bodies became, in theory at least, redundant; the uterus and the pelvis were displaced, and the female egg cell came to dominate the visual

field of human reproduction. Photography occupies a central place in this narrative.

Daguerreotypomania

In *All That is Solid Melts into Air*, Marshall Berman describes the rapid transformation of life wrought by industrialisation:

> The maelstrom of modern life has been fed from many sources: great discoveries in the physical sciences, changing our images of the universe and our place in it; the industrialisation of production, which transforms scientific knowledge into technology, creates new human environments and destroys old ones, speeds up the whole tempo of life, generates new forms of corporate power and class struggle; immense demographic upheavals ... rapid and often cataclysmic urban growth; systems of mass communication ... enveloping and binding together the most diverse people and societies. (Berman 1983: 16)

Berman asks how we might account for the unities that infuse the diverse experiences of modernity (Berman 1983: 19). It is a question which might, just as pertinently, be asked about photography. Photography's unity did not lie in its means of production, the instrumental camera, nor in its product, the photographic image. As John Tagg, among others, has suggested, photography 'as such has no such identity' (Tagg 1988: 63); perversely, unity lay in its diffuse, myriad applications. Photography exemplified a fractured, refracted modern life: it infiltrated personal, public, social and political spheres. It reorganised geographical space and reshaped human experience. Berman's description has a visual analogy in one of the earliest cartoons about photography, made by Theodore Maurisset and published in 1840 (see Figure 41). This image, neither photograph nor micrograph, takes us into another time and place and helps us to understand the amalgamation of photography and microscopy – photomicrography – within a wider historical context in which fantasy plays an increasingly important role. In this image, the spectacle of modern life unfolds before us. In the original, situated between two words – *Fantaisies* at the top and *La Daguerréotypomanie* at the bottom – the cartoon teems with life, signalling the rapid and drastic shifts which industrialisation had already wrought by the late 1830s. Life, Maurriset's image seems to say, will never be the same again.

Time and money, steam and gas, and above all human labour dominate the image. An artificial light shines down on the earth; at ground level gas lamps have been installed. Crowds swarm in every direction across a vast unmarked terrain. From an elevated viewpoint we are invited to look down on the ant-like creatures leaving the scene, who form a queue which stretches into the distance.

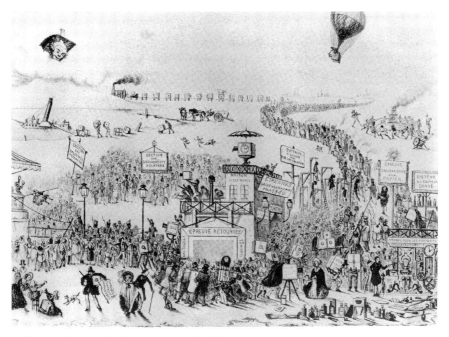

41 Theodore Maurisset, *La Daguerréotypomanie*, 1840

A cluster of *ad hoc* shows attracts crowds, who are transfixed by these public spectacles of life and death. Daguerreotypy is advertised next to, around, beside, behind, in front of – in short, everywhere. Hot air balloons borne on gusts of wind bear cameras; steam trains and paddle boats puffing billows of smoke transport them; weary horses and men bent double like beasts of burden carry the latest commodity, the daguerreotype camera. Demand, Maurisset suggests, outstrips production. Crowds are turned away. In the foreground, itinerant photographers pop up in any, and every, available open space. Cameras are transported to all corners of the country and are shipped abroad. The image seems to suggest that photography will also transport those who see it. Like steam trains and boats, it is a new, industrial communications system which will spread everywhere, joining the most diverse social groups; it will also be shaped as much by clouds of fantasy as by material reality. Cameras point in every direction and photography is about to take off. It has already found a home in a grand building right at the centre bearing the name 'Susse Brothers', which proclaims 'New Year gifts for 1840'. This is not an arbitrary choice on Maurisset's part. A successful shop-owner selling fancy goods, the archetypal jumped-up bourgeois whose rapid rise has placed him, in terms of class, just above the mass, Victor Susse, had shrewdly made 'the transition to daguerreotypy in 1839' (McCauley 1994: 46). As Maurisset's image suggests, a sound way to expand business was simply to stick a camera on the top of existing premises.

Crowds spread in every direction. The space is filled with staffs, pikes, bayonets, tripods, umbrellas, funnels and lenses. Around a new piece of equipment, a group wildly dances at a fiddler's bidding. Below, a sign invites engravers to hire gibbets. Commercial photography is a cut-throat business. Engravers might as well hang themselves and several appear to have done so already. In case there is any doubt, the caption, *La Daguerréotypomanie,* describes the picture as an image of industrial madness. Observers of this scene gaze upon 'Subjection of nature's forces to man, machinery, application of chemistry to agriculture and industry, steam navigation, railways, electric telegraphs, clearing of whole continents for cultivation, canalization of rivers, whole populations conjured out of the ground – what earlier century had even an intimation that such productive power slept in the womb of social labour?' (Marx (1848), cited in Berman 1983: 93). This is a crowd on the move and on the make. Soon it will be more orderly, more organised. Photography will play an important part in this too.

Maurisset's cartoon is an astute commentary on modern nineteenth-century life and on the meaning and value of photography; it is the kind of commentary which would not seem applicable to the languorous, dreamlike photographic image itself. Unlike a photograph, which is instantly freed from contextual or historical use, we learn from the cartoon something important about photography as an industry in the making, an industry that epitomises modernisation. Maurisset depicts photography as a commercial product and as a microcosm of industrialisation itself; he ignores what was later to seem important – its instrumental and aesthetic aspects. Unusually, the cartoon pictured the ways in which photography would be used throughout the length and breadth of the world: from the highest to the lowest; from the furthest to the closest; in the studio and on the street; in life and in death. Maurisset offered a wide-angle view of the havoc which photography would bring in its wake. From its inception, photography was an incoherent, crazily disordered and rootless discourse which, like a great tidal wave, would sweep along millions of people. Maurisset captured the panoramic breadth of photography and modernity, as a spectacle still unfolding, depicting derangement and mania characterised by vivid excitement and, in the end, by great violence.

On the far right hand side of this image, almost but not quite out of frame, a placard advertises 'Système du Dr Donné': photomicrography, which, as the image bears out, was part of the photographic system from the very beginning. But though it is there, it is placed at the extreme edge of the frame, at the limits of photography's discourse; its images have been ignored because they are strangely puzzling, abstract, recalcitrant images that do not easily fit into photography's narrow realist frame of reference. The framework needs remodelling and, indeed, this process was already beginning to take shape in the cartoon.

It is the commercial studio, the only permanent structure in sight, which splits Maurisset's image in two. It is at the centre of the cartoon and at the heart of modern life. It rises above everything else as a kind of factory for processing people. It stands as a wedge between the popular show and science. Those showrooms, galleries, halls and shops are the spaces in which photography emerges. Commercial photography quite literally springs up everywhere, takes off in every direction, pushing aside and supplanting the kindred popular spectacles from which it is formed, and of which, in the nineteenth century, it is a part.

Maurisset's image simultaneously shows connections and rifts in a world that is already split in two between life and death. This does not mean, however, that we cannot trace a different history. There is a relationship between the tightrope walker at the left-hand side, suspended in mid-air, and the floating busy world of the photomicrograph hinted at in the right-hand margin. Like circus artists, microscopes first appeared as popular entertainment, and both were elements in the broad spectrum of nineteenth-century amusements, often appearing on the same stage. Benjamin suggests in his essay, 'A Small History of Photography', that in its early days, before its industrialisation, photography was close to the arts of the fairground (Benjamin (1931) 1972: 5). Maurisset performs a clever balancing act. He juggles different perspectives that allow us to look at photography in closer detail and greater breadth. Instead of looking down upon the image, we can move through it and start to think both below and beyond the frame; by both scanning across it, and examining it closely in detail, new configurations may be formed and a different visual field might emerge.

Modernity was an urban phenomena, and the 1830s and 1840s were crucial years for its development. Maurisset's cartoon is the very microcosm of modern life; a world caught between the old and the new. Neither city nor village, it is a sprawling, amorphous terrain, the boundaries of which have yet to be drawn. There are no houses. The suggestion is that modernity is about to be built on ground that has been both materially and psychically levelled or razed. There is gas lighting, but as yet no boulevards. It is an unnatural, artificial topography without trees. It is as if an older pre-modern natural world had not only been made to disappear, but is being wiped out. The modern city has yet to be constructed and consequently the image has the look of both older, chaotic fairs and newer, more organised labour. What the image does suggest is that modernity is cut off from its past. This is a particular moment; historically, a radical break; geographically, a seismic shift.

Nor is it incidental that just below the engravers' gallows stands the 'apparatus for portraits', with its frightening mechanism for immobilising subjects, making them fit the requirements of the camera, nor that the apparatus resembles medieval stocks. The new addition is the clock, a metaphor

both for factory life, which fixed the body in rigid structures and extended its working hours, and for the simultaneously increasing tempo of life. Something was being destroyed, perhaps a looser, less organised way of life, and something new, modernity, was being built on the ground that had been cleared. This new world, about to arrive, would be incommensurable with the old.

Maurisset tried to picture a moment of flux before that older world disappeared. It has all but gone and the new is just about to begin. Our eyes are pulled in all directions, vertically, horizontally, diagonally. Although the image has perspective, its depth is limited to a peculiarly flattened dimension. We home in on this or that detail, only to find that our gaze is frustrated at every turn. We try to build a picture out of fragments; we think we can see the larger picture, but this disappears as we become lost in myriad detail. We scan the cartoon, looking for clues as if at the scene of a crime. We develop a facility in combining microscopic and macroscopic views as we struggle to make sense of what it is happening before our eyes. There is no solid ground upon which to stand. This is a society that is on the brink; like the busy microscopic image, it is simultaneously disintegrating and reforming. We are witness to the demise of integrated social life and to the very atomisation of subjectivity itself.

The terrain, already cleared, will soon give rise to arcades, parks, museums, railway stations and department stores. Maurisset's image still, just, juggles breadth and depth. But soon there will be compensation for modernity's shallowness and banality in a dazzling array of goods. Simultaneity, juxtaposition, montages of commodities and images give modernity a staggering breadth. Everything will become 'ephemeral, fugitive, contingent' (Baudelaire 1863: 13). These archetypal qualities of modernity are, of course, the absolute epitome of the photographic image. Restless, distracted and enervated, the modern subject, with the ground cut from under their feet, would become a 'mobile consumer of a ceaseless succession of illusory commodity-like images' (Crary 1990: 21). They would soon 'botanise on the asphalt' (Benjamin 1973b: 36), a remark which implied an uneasy but necessary fusion of mechanical and natural sciences in the unnatural space of the city. Modernity, as Maurisset's image suggested, heralded a dramatic intensification of nervous stimulation. Country and city, nature and culture, femininity and masculinity, bodies and machines are about to fuse in new, extraordinary and unimaginable ways. The modern city itself is a new space somewhere 'between the village and the State' (Grosz 1992: 244). It made possible both greater mobility and increased surveillance. Moreover, in the very early years of photography the body and city would rarely appear on the same stage. The city was pictured as deserted, a kind of building site that was yet to be inhabited. Bodies disappeared inside buildings and behind doors that were closed quite as much as they poured on to the streets. Modernity created not only a burgeoning

public sphere but also a vast private administration to manage its complex and contradictory tasks. What the new modern world lacked was a sense of stability, of any solid ground. Everything and everyone was replaceable, and experience was recast as something fleeting and shifting. The microscope and the telescope provided startling images of permanency and change. It was as if, in mapping out a macrocosm and a microcosm, man, who by mid-century was no longer the measure of all things, might find his own co-ordinates as a superior spectator.

In such a situation, it was hardly surprising that microscopes and telescopes were rapidly conjoined with cameras, and September 1839 saw both the discovery of photography and the founding of the Microscopical Society. The years between 1830 and 1880 marked a particular point in the development of the scientific visualisation of 'life'. Under the microscope, the body would become not merely fractured and disintegrated but dispersed and detached, macerated or crushed, and finally dissolved. Indeed, the body came to be regarded as an archaeological fragment, a cryptic tablet coded in a hidden language that would, with a little pressure, yield up its secrets. Carl von Baer was the first to see the mammalian ova in 1827 and Oskar Hertwig the process of fertilisation in 1876. With the publication in 1858 of Rudolf Virchow's *Cellular Pathology*, the cellular, the microscopic became 'the centrepiece for all understanding of the body' (Gilman 1989: 235). The body was revealed as a puzzling mosaic of cells and strangely mutating structures. If the overall picture was lost, then it returned in a sequence of incomplete and splintered details, safely trapped between two slivers of glass, permanently preserved, not in Nature's cabinet, but in the transportable photographic image. Those 'samples', another word for commodities, purport to tell a far deeper truth about life than any surface image ever could. It was modernity's very lack of depth which demanded an expansive breadth. As David Harvey describes it, 'Modernism, in short, took on multiple perspectivism and relativism as its epistemology for revealing what it still took to be the true nature of a unified, though complex, underlying reality' (Harvey 1989: 30). This was a significant shift in perspective, a framework that enlarged a spatial and geographical terrain by diminishing the historical, temporal frame.

Jonathan Crary suggests that during the second half of the nineteenth century 'any significant qualitative distinction between a *biosphere* and *mechanosphere* began to evaporate' (Crary 1995: 47). That lack of distinction between biology and mechanics was the outcome of industrialisation and the introduction of a mechanical technology that fused nature and culture, bodies and machines, into new arrangements. However, it was a development that had been in train from the seventeenth century, with its promise of 'artificial organs' that would act as a check on the vicissitudes of human senses (Hooke 1665: Preface). For biology and mechanics to

converge, bodies had to become more like mechanical instruments, rigid and more disciplined, whereas mechanical instruments had to become more flexible, like human bodies. The transformation was long in gestation and its realisation was gradual, but it gathered momentum in the nineteenth century and, as Maurisset's cartoon suggests, any idea of the past was erased. What is not in doubt is that it had a profound and underestimated effect on life, on how bodies have been, and indeed are, understood, and hence on human experience itself. For all the mobility of modern life, the modern body appears to be stiff, as if it is an object made of materials other than flesh. In a parallel shift, instruments have become more mutable. The modern microscope was a feat of engineering on a human scale that trapped and stabilised a body that was increasingly perceived as unruly. It was a means of imposing, at a moment of rapid and unprecedented change, a rational, modernist order at a substructural level. Essentially, bodies were made to fit the instrumental nature of modern life. Under the microscope, the unwieldy body was reduced to something more manageable: living matter. The parallel technologies of microscopy and photography transformed the human gaze. Detailed visual information was crucial to the rise of biological sciences and consequently there was a technical explosion of microscopic media in the nineteenth century. Microbiology was a microcosm of the processes of nineteenth century industrial engineering applied to the human body. Animate beings became the sum of separate parts, which could assembled, moved around or taken apart, like those of a machine. It is within this context that we might return to Donné's system, which makes its appearance in Maurriset's cartoon. The convergence of photography and micrography was due to a number of factors. Long exposure times, problematic when dealing with anything living, were immaterial in microscopy. But the convergence also stemmed from wider social shifts, the rise of 'scientific' (read technological) medicine and an increased dependence on visualisation. As Paul Durbin suggests, 'technology and medicine are more closely related in real life than science and medicine' (Durbin 1980: 92). Photomicrography represents the first application of photography to what was understood as 'scientific' medicine.

In the early 1840s, in its search for what underpinned human life, medicine shifted its gaze to the invisible. This was a retreat from the concrete world into the subcultural world of microbiology, where things seemed to be more secure, more containable. In order to bring another universe into focus, anatomist-microscopists literally turned away from their surroundings and moved into the image. They also turned away from the viscerality of the human body towards the finer substructures of health and disease, which could be detected in the cell made visible in the prepared slide or photomicrograph. The shift was not immediate, but marked a fundamental change in perspective and in the

cartography of the body. For a brief period the microscope was used at the patient's bedside. But the patient was quickly dispensed with and the use of the microscope receded into an (ideally) organised space of the laboratory, where it has remained ever since. The subjective experience of the lived body was finally lost, or at least rendered unreliable. Microscopists looked away from the unstable modern world towards something more reliable: the more easily controlled and malleable world of mechanical representation in which disintegrated components were cast adrift from corporeal roots. As Cartwright suggests, 'the measure of accuracy in microscopy was 'not an object per se but a representation' (Cartwright 1995: 86). Cartwright is right in suggesting that in microscopy, the 'introduction of the test-object is significant, because it suggests that from the early nineteenth century onwards, microscopists were more interested in verifying the accuracy of their instruments than in verifying the representational integrity of the microscopic scene they saw … the primary focus for the scientific gaze in this context is the instrument itself and not the object viewed' (*ibid.*). Scientists had, by then, turned well away from confusing three-dimensional objects. In the seventeenth century, Leeuwenhoek had relied on a grain of sand, and even in the nineteenth century microscopists still employed natural objects, such as butterfly wings, as their instrument of measure. This suggested a lingering faith in the accuracy of God's work that was soon to wane. By mid-century, mechanically ruled test-plates were introduced, culminating in 1878 in Nobert's 'finest' test-plate of twenty bands (see Cartwright 1995: 84–90).

In 1839 Alfred Donné made the first photomicrographs and in February 1840 he demonstrated his microscope–daguerreotype apparatus at the French *Académie des Sciences*.[1] By then he had already made photomicrographs of sections of teeth and bones (Gernsheim 1961: 85). In 1844 he published a textbook, *Cours de Microscopie*, and the accompanying atlas, *Cours de Microscopie, Complementarie des études Médicales, Anatomie Microscopique et Physiologique des Fluides de L'économie* followed in 1845. Léon Foucault, an optician, who had collaborated with Fizeau, made the daguerreotypes for the atlas. This was a large scale work with engravings made after original daguerreotypes.

In microscopy there is no clear separation between the technology and the object viewed. The very first image in Donné's atlas was of a micrometer: the technical test-object against which the microscopic object could be measured mattered above all else (see Figure 42). This image is followed by illustrations of sperm, ova, milk, vaginal mucus, urine and blood, with comparisons of human and animal types; older models, although in the process of being modified, had yet to be overturned and Donné's atlas is essentially a work of microscopic comparative anatomy. Plate XV, for example, compares the sperm of a man with that of a mouse, a frog and a bat; human milk is compared with

the milk of the ass, the cow and the goat (see Figures 43 and 44). While there was a limited degree of success in making prints – about forty were made from some of the eighty-six daguerreotype plates – this was still insufficient for commercial publication and the images had to be engraved (see Figure 42). As Alison Gernsheim states, 'this is the earliest publication with illustrations copied from photographs of medical specimens' (Gernsheim 1961: 86). The fact that Donné's and Foucault's daguerreotypes had to be translated back into

42 Alfred Donné and Léon Foucault, *Cours de Microscopie*, 1845, Plate 1 [781. 1. 34]

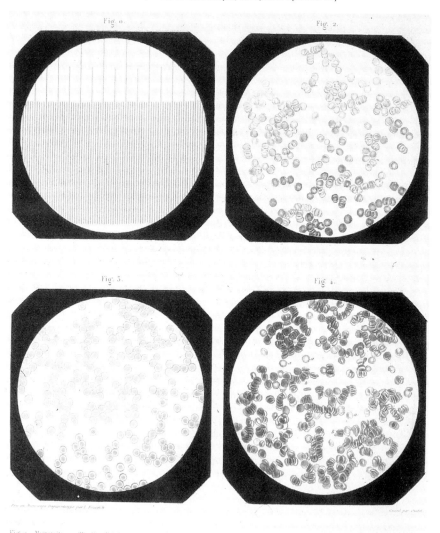

Fig. o. Micromètre millimètre divisé en 400 parties grossi 400 fois.

Fig. 2. Globules de sang humain avec le centre clair.

Fig. 3. Globules de sang humain avec le centre obscur.

Fig. 4. Globules de sang humain sous divers aspects.

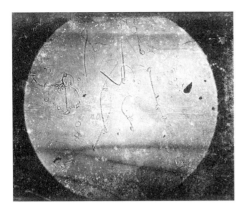

43 Alfred Donné and Léon Foucault, *Sperm of a mouse.*
Daguerreotype photomicrograph, early 1840s

44 Alfred Donné and Léon Foucault, *Milk of a woman.*
Daguerreotype photomicrograph, early 1840s

engravings indicates that photography had to rely on older systems of representation for its mobilisation.

Originally, Donné used the daguerreotypes as if they had been specimens. He handed them around to students attending his course on microscopy, no doubt alleviating the effect of the 'not too sweet and not too insanitary [*sic*] post-mortem treasures [brought] into the lecture room' (Edwards 1894: 151). These daguerreotypes were unique images, just as the older convention had shown unique specimens. Indeed, photographs were, for a time, described as specimens. To have power, however, such images needed to be circulated through either publication or projection. The older popular conventions of viewing did not disappear. Large meetings could view 'at the same time, an accurate picture of normal or diseased tissue' (*ibid.*). In 1743 Henry Baker made an important claim for the solar (or camera obscura) microscope: 'Numbers of people may view any Object, together, at the same Time' (Baker 1743: 25). Such viewing still required the presence of the object, and the gathering of a group, suggesting a moment of contact with the original, but this was fast disappearing. Photomicrography represented multiplication on every front. As Edwards knew, private collections of drawings had intrinsic value but, in contrast, 'the extrinsic value [of projected microscopy] cannot be measured' (Edwards 1894: 152). These projections, like the photographic image, abolished distance between spectators and objects, but in doing so, created even greater distance between human subjects. Donné's atlas is important because it represents a moment when the boundaries between patient, specimen, publication and projection had not yet been clearly sorted out.

The new technology was speedily grafted on to older beliefs. *The Wonders of the Microscope Photographically revealed by Olley's Patent Micro-Photographic Reflecting Process* (1861) promised

to realize ... a long existing scientific desideratum, namely, – to reveal to the
unassisted eye, the wonderful discoveries of the Microscope in all their
fidelity and beauty. The object, we believe, could only be accomplished by
enabling nature to delineate herself; in other words by the aid of photography
... These images may be pronounced strictly perfect transcripts of nature ...
an eminent philosopher observed that 'he believed that they were just as
faithful as the images of the objects themselves, formed upon the human
retina' ... thus revealing the wonders of a world, which to many, has hitherto
been wholly invisible ... (Anon. 1861: i–ii)

This ignores the fact that vision is learned, or as Hanson puts it bluntly,
'Cameras, and eye-balls, are blind' (Hanson 1965: 6).

Photography was harnessed to microscopy because of the latter's suppos-
edly high level of authentic, unmediated depiction. This was necessary: as D. G.
Thomson made clear, the photographic image is not unchanging or stable.
However, he quickly dismisses this fact by invoking the language of forensic
evidence: 'in spite of the fact that negatives may be touched and made up, a
photograph has an accuracy and truth in its rendering of a subject which are
always acceptable to the scientific mind ... these minute organisations are very
similar to each other and hence it is most important that exact and definite rep-
resentations and descriptions of these ... should be available to the student, so
that the propositions made by the above named investigators [Lister, Koch,
Pasteur] ... may be corroborated and verified by other observers' (Thomson
1884: 157). By the late nineteenth century, representation was the gauge of
accuracy; what the microscopist saw was measured against an image.

The amalgamation of photography and microscopy produced a new
framework for comprehending the body. However, it was not coincidental that
the conceptual framework of the older cabinets of curiosity, which ordered dis-
connected bits and pieces, was maintained. To photograph is not to collect
directly from nature but to add to the stock of culture. Photographs, like speci-
mens, were not so much portions of nature as fragments of culture, neatly
framed to disguise the ragged edges that marked their disconnection from the
world. Photographs are once-removed from the objects they depict; they are
always seen out of context, images that cannot be put back easily, if at all. This
isolation lends them their melancholic quality; they embody a moment or place
to which we can never return. Photographs preserve, but at a price. As small,
floating islands of meaning, they are not merely separated from their referents,
but irrevocably cut off from them.

In his essay 'Photogenic Drawing: Some account of the Art of Photogenic
Drawing, or the Process by which Natural Objects may be made to delineate
themselves without the aid of the Artist's Pencil', Henry Fox Talbot included a
section entitled 'Application to the microscope'. He suggested that the process
not only saved 'our time and trouble, but there are many objects, especially

microscopic crystallizations, which alter so greatly in the course of three or four days (and it could hardly take an artist less to delineate them in all their details), that they could never be drawn in the usual way'. Talbot declared that this branch of the subject 'appears to me very important and likely to prove extensively useful' (Talbot 1839: 116). His inclusion and discussion of microscopy signals a rapidly changing modern world that might, or indeed must, be stabilised; faster, mechanical systems of producing and circulating information would have to be introduced.

Such developments must, however, be placed within a longer historical trajectory. The capacity for surpassing the limitations of human sight, for enhancing vision, existed from the early seventeenth century. It was part and parcel of early modern life. When Robert Hooke published his *Micrographia or Some Physiological Descriptions of Minute Bodies made by Magnifying Glasses with Observations and Inquiries thereupon* (1665), he emphasised 'the limits, to which our thoughts are confin'd, are small in respect of the vast extent of Nature it self; some parts of it are *too large* to be comprehended, and some *too little* to be perceived' (Hooke 1665: Preface). Hooke expressed a fascination with what lay beyond and beneath the threshold of vision; something that might connect the infinite to the infinitesimal, cosmos and microcosmos. In his work he suggested that man's power on earth (no doubt like God's in heaven) might be increased by paying greater attention to minute forms. In this world, man might be king. It does not seem immaterial that his book opens with three images entitled *Of the Point of a Sharp Small Needle, Of the Edge of a Razor* and *Of fine Lawn, or Linnen Cloth,* or that the work's final image is *Of the Moon.* The link between the small, sharp instrument and the planet, between microcosmos and macrocosmos is clearly made. Moreover, given that in the seventeenth century the body was thought of as fabric, as more or less densely woven material, there is here a suggestion that it might be sliced, and stitched together. These images acquire a different meaning when studied alongside contemporary pictures of 'life' (see Figures 45, 46 and 50). They do not seem quite so far apart.

From its earliest days, scientists sought to use the microscope to illuminate human generation, though what they saw or discovered was initially fuelled by the Aristotelian theory of male preformationism: that the sperm contained a fully formed miniature embryo. 'Discovery', unsurprisingly, focused upon semen and the driving, life-giving force of masculinity. Illustrations that pictured sperm became a stock in trade of seventeenth and eighteenth century microscopic manuals (see Figure 47). This was not an arbitrary choice, but socially necessary at a time when medical literature still focused on generation as man's work on earth. (This is the foundation of later beliefs in a microcosmic universe: just as man inhabits the earth, so the sperm inhabits the egg.) As Lisa Cartwright suggests, such beliefs and their supporting images 'invite

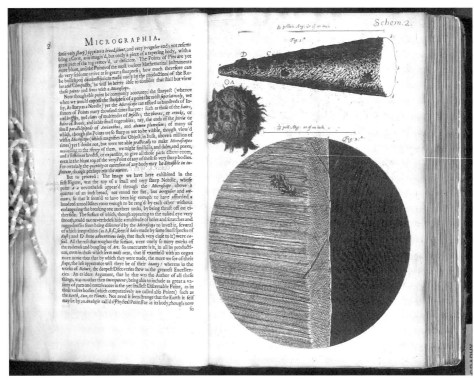

45 Robert Hooke, *Micrographia*, 1665. Schem. I: *Of the Point of a Sharp Small Needle, II. Of the Edge of a Razor, III, Of fine Lawn or Linnen Cloth*

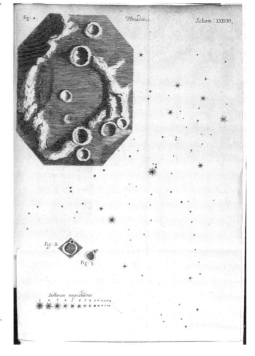

46 Robert Hooke, *Micrographia*, 1665. Schem. XXXVIII, *Of the Moon; Of the multitude of small Stars discernible by the Telescope*

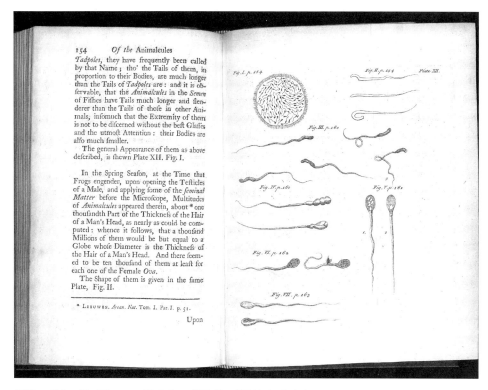

47 Henry Baker, *The Microscope Made Easy*, 1743. Plate XII, 'Animalcules'

an analysis of the genealogy of masculine fascination with the exaggerated image of [these] bodily organisms' (Cartwright 1995: 84). However, such images were more than supportive; they became an organising principle. But by the mid-nineteenth century the microscopist had turned his gaze away from masculinity, which became increasingly invisible, and turned instead to femininity. Male generation had, by then, given way to female reproduction.

However, historical narratives are never quite so neat, and contradictory beliefs about the processes of generation ran parallel with the discovery of the microscope. William Harvey's claim in 1651 that all life comes from an egg and Regnier de Graaf's discovery in 1672 of the ovarian follicle (which was thought to contain the egg) had already begun to raise questions about the ancient Aristotelian view of vaginal secretions as a thinner cooler version of ejaculate. Such interventions seemed to give preference to the idea that the female egg contained the foetus (Laqueur 1990: 171–172). Those who held this view became known as Ovists.

Such aberrations were conveniently cancelled out by Leeuwenhoek's (1677) and Niklaas Hartsoeker's (1678) claimed discovery of millions of mysterious 'animalcules' in male sperm. Animalculists, as they were called, believed

that this conclusively proved male preformationsim. Leeuwenhoek complained that Hartsoeker was not the first to discover spermatozoa but had simply plagiarised his work. Baker states that 'Mr. Leeuwenhoek is very angry at this Claim; and asserts that he himself first discovered the *Animalcules* in Semine' (Baker 1743: 153). Baker recounts that Leeuwenhoek 'found so much pleasure in observing this, that he called in some Neighbours to share it with him' (Baker 1743: 161–162). It was, however, Hartsoeker who made tangibly visible the existence of minute animalcules in semen in his work *Essay de Dioptrique* (1694). Hartsoeker's advantage had been to reproduce a visual image of a sperm containing a fully preformed embryo, complete with its own umbilical cord (Hartsoeker 1694: 230) (see Figure 48). For Hartsoeker, the female egg was 'no more than what is called the placenta' (Hartsoeker 1694: 230). This was a means through which 'social sex could be projected onto biological sex at the level of microscopic generative products themselves' (Laqueur 1990: 171). In other words, what was already believed about the different roles of men and women in generation was apparently borne out by what the 'truthful' microscope revealed, and as a consequence 'old distinctions about gender now found their basis in the supposed facts of life' (Laqueur 1990: 172). The narrative put

48 Niklaas Hartsoeker, *Essay de Dioptrique*, 1694, p. 230, spermatozoon [537. k. 19]

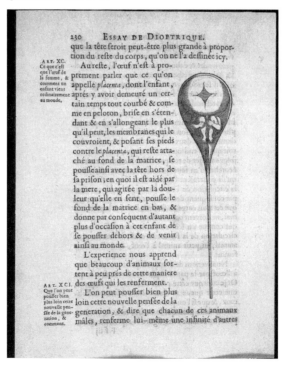

forward by the Animalculists was more reassuring. The egg (and by analogy woman) was no more than a growth nutrient.

Eighteenth-century ideas of preformationism (whether held by Ovists or by Animalculists) were therefore based on belief rather than evidence. Even in theories of epigenesis, the egg was at best, as Schiebinger calls it, a passive inanimate 'sleeping beauty' (Schiebinger 1999: 145), waiting, no doubt, to be pricked into life. Man penetrated woman; sperm the egg. Such narratives suggest that what the microscopist saw through the instrument was obviously shaped by older beliefs about the creation of life and about what he might expect to see. Nor have those beliefs disappeared. The image of a large, lumpen female egg surrounded by millions of male sperm, a single one of which will jerk it into life, remains a stock-in-trade in picturing what passes for the creation of 'life'. However, as Laqueur points out, 'in the eighteenth and nineteenth centuries, and indeed today, at any given point of scientific knowledge a wide variety of contradictory cultural claims about sexual difference is possible' (Laqueur 1990: 175).

In *The Microscope Made Easy* (1743), for example, Henry Baker described the male sperm, as an active hunter: 'some of the Animalcules it (sperm) contains in such Abundance, find an Entrance into the *Ovaria*, and lodge themselves in some of the *Ova* placed there by Providence as a proper *Nidus* for them. An *Ovum* becoming thus inhabited by an *Animalcule*, gets loosen'd in due Time from its *Ovarium* and passes into the *Matrix* through one of the *Fallopian* Tubes' (Baker 1743: 150). As Baker's observations suggested, it was simply not clear what the sperm actually did, and the view, whether put forward in the narrative of penetration or that of entrapment, that what it did was of a combative nature, was not always comfortable to contemplate:

> Some were of the opinion that the Semen being injected into the Matrix, these Animalculae devour each other; and that the last which was nourished by all the others formed the Embryo ... Others think that these Animalculæ entered the Ovarium through the Fallopian Tubes; then crawled on the first ripe Ovum they met with, which they entered through the Aperture, where there is a valve to prevent their Return. It is evident that this description is the mere Product of the Imagination which is very ill-found. (Jenty 1757: 308–309)

Even in the eighteenth century, ancient beliefs of female ejaculation were still held. It was widely believed that conception was only possible 'at the time when the female emits the Semen from her Testes, as the Antients called it' (Jenty 1765: 325). The 'one-sex model', which offered no escape to a biological substrate of fundamental sexual difference, still prevailed (see Laqueur 1990: 8).

Writing more that a century later in 1855, Robert Mann was equally dismissive of the imaginings of Leeuwenhoek and others and their 'discoveries'

with the 'high-sounding name of spermatozoa' and some who 'saw stomach and intestines ... or made the important discovery that they [animalcules] had mouths' (Mann 1855: 102). Mann declared that 'the more precise observations carried on by the appliances and aids of a more advanced stage of physiological science, have, however, completely overthrown these fancies'. Yet he could only comment that, 'It is now universally admitted, that these curious objects [sperm] are merely ciliated vesicles furnished with the appendage of a delicate hair which is always waving in virtue of some imperfectly understood property' (*ibid.*). Indeed, it was only towards the end of the nineteenth century that scientists provided any evidence for the process of fertilisation. In 1876, Oskar Hertwig discovered that the sperm did 'penetrate' into the egg.[2] However, remnants of previous ways of thinking retained considerable influence, and indeed, continue to do so, thus shaping future developments. For example, in recent debates about fertility, while it is no longer feasible to claim that female orgasm is essential to conception (as was believed well into the nineteenth century), it is still claimed by many that it may well improve the chances of conception.

The narratives that make up science are neither rational nor coherent. Scientific investigations, which include the development of instrumental technologies, the selection of objects of investigation, and the ignoring of other avenues of scientific inquiry, are shaped by the ideas which hold the greatest currency at any given historical moment. What has currency or credibility is, in turn, formed by social and economic demands. Within the context of modernity, this necessarily entails questions of sex and gender as visible differences. Hertwig's 'discovery' was made possible through the emergent theories of cellular development, improved microscopy and, perhaps most importantly of all, staining techniques, which made visible what had previously been invisible. It is not easy – it may even be impossible – to disentangle the relationship between perception and conception, between discovery and invention. What is clear, however, is that visualisation was central to this process.

Like other writers of the early modern period, Hooke established a close relationship between knowledge and visual perception, but this was tempered by the awareness that Man was observed by God. Hooke's word for self-surveillance, for observing one's place in God's universe, was 'watchfulness': 'The first thing to be undertaken in this weighty work, is a *watchfulness over the failings* and an *inlargement of the dominion*, of the *Senses* (Hooke 1665: Preface). However, man's ability to be 'watchful' was inherently flawed; by virtue of being human, he was a failed observer. This failing could not be entirely remedied, which would be against the will of God, but man's capacity for 'watchfulness' might be improved: 'The next care to be taken, in respect of the Senses, is a supplying of their Infirmities with *Instruments,* and, as it were, the adding of *Artificial Organs* to the natural'. For Hooke, 'Remedies can only

proceed from *the real, the mechanical, the* experimental *Philosophy' (ibid.)*. Supplementing and extending vision, making up and making real, inventing and discovering, were not contradictory. Hooke's work marks a stage in the disappearance of any clear separation between the human and the mechanical.

Hooke's main interest lay in ocular enhancement and his work concerned the microscope, but he had no doubt that 'there may be found many *Mechanical Inventions* to improve our other Senses of *hearing, smelling, tasting, touching' (ibid.)*. In the seventeenth century those other senses still had, for the time being, an important place in human knowledge and scientific understanding. Hooke was explicit about the problem of exactly what it was that the 'watchful' observer saw through the microscope. Nothing was obvious and everything had to be interpreted. He wrote, 'For it is exceeding difficult in some Objects to distinguish a *prominency* and a *depression*, between a *shadow* and a *black stain*, or *a reflection* and a *whiteness* in the colour' *(ibid.)*. Hooke acknowledged a connection between invention and discovery; in his experience, there was no clear separation between making up and finding out.

Seventeenth and eighteenth century microscopists seem to have been well aware of the instability and limitations of their instruments. It was no easy matter to see what they were looking at, let alone know what it was. Quite literally, nothing was clear. Throughout the nineteenth century, scientists introduced devices to correct the malformation inherent in microscopy. The price paid for microscopic clarity was increased distortion. Indeed, this problem persists and has not been eliminated in modern electron microscopy. The image produced with the microscope is not 'pure', 'but rather a map of interactions between the specimen and the imaging technology' (Slayter, cited in Hacking 1983: 190). Hacking writes, 'we do not in general see through the microscope, we see with one'. He suggests that 'looking through a lens was the first step in the development of microscopic technology, then came peering through the tube of a compound microscope, but looking 'through' the instrument is immaterial. We study photographs taken with a microscope' (Hacking 1983: 206–207). In short, the image is not the same as the object under the lens; the object under the lens is not the same as the object in the world. To return to Latour, this is a prime example of the fact that 'scientists start to see something once they stop looking at nature and look exclusively and obsessively at prints and flat inscriptions' (Latour 1986: 16). Such images excise any detail that might confuse the observer, who has already looked at, and possibly prepared, thousands of specimens.

There always was, and there remains, a trade-off between getting a clear sight of the specimen and distorting it. The microscope is not, after all, a window on to an unseen world. It is rather a re-jigging, an articulation to fit the exigencies of the instrument. This articulation is realised by moving further away from an overwhelming object, cutting it down to size and then enlarging it

again. Even so, looking at the result, no one could be sure that what was actually observed was the intended object of study, seen in its true form. The solution, or rather the resolution, to the whole problem presented by microscopes and their images necessarily rested in 'correct' preparation and interpretation. Standardising methods and instruments therefore took on a particular importance within microscopy. They were vital to its development.

It was, however, the very deficiency of microscopes that revealed something important about vision. Despite such devices as standardising measurements, magnifications and staining, the legibility of an image seen through the lens was necessarily read *into* whatever was visible. The specimen did not speak for itself but had to be read. Such interpretation is always marked as much by preconception and fantasy as by any conscious, rational project. Hooke, for example, had to project an idea of what he was looking at or what he might expect to see, and made a guess at what might be discovered through the telescope and the microscope in the next few hundred years: 'we may perhaps be able to discover *living Creatures* in the Moon, or other Planets, the figures of the compounding Particles of matter, and the peculiar *Schematisms* and *Textures* of Bodies' (Hooke 1665: Preface). It was the desire to expand the frontier of visual knowledge, to see both a world out there, above and beyond and in here, below and beneath, that shaped both telescopy and microscopy.

Telescopy and microscopy had emerged at more or less the same moment in the seventeenth century. While both instruments challenged 'man's conceptual framework', Gerard Turner argues that the telescope 'extended the details of an already existing picture' (Turner 1981: 7). The microscope took longer to develop because its use was less easily established. No one had a clear idea of what it might do. Thus throughout the eighteenth and early nineteenth centuries, the microscope operated as an instrument for entertainment and science. Baker, writing in 1743, described it as simultaneously: 'a meer Plaything, a Matter of Amusement and Fancy only' and an instrument of 'the Wise in all Ages … [who] as far as they were able, have studied and enquired into the Recesses of Nature' (Baker 1743: iii, xii). Nature may have been secretive, but until the eighteenth century it was always God's work and therefore superior to man. In *The Universe: a poem intended to restrain the Pride of Man*, published in 1734, Baker wrote:

> Extend thy narrow Sight: consult with Art:
> And gladly use what Helps it can impart:
> Each better Glass will larger Fields display,
> And give Thee Scenes of Life, unthought of, to survey. (Baker 1734: 35)

Along with other early writers on microscopy, he constantly stressed the inferiority and clumsiness of man's handiwork. For example, 'some *Brussels*

Lace worth five Pounds a Yard, looked as if it were made of a thick, rough, uneven Hair-Line, entwisted, fastened, or clotted together in a very awkward and unartful manner. But a *Silkworm's Web* being examined, appeared perfectly smooth and shining' (Baker 1743: 293–294). Even the very finest example of man's art was merely the poorest copy of God's work, betraying 'a Meanness, a Poverty, and Inability in the Workman; but those of *Nature* plainly prove, the Hand that form'd them was absolute Master of the Materials it wrought upon, and had Tools exactly suitable to its Design' (Baker 1743: 299). Here was something to aspire to.

For the time being, however, the best the microscopist could do was to copy carefully whatever appeared on the slide. The clear, line-drawn illustrations which Hooke made to accompany his work were absolutely central. Accurate visualising was essential and Hooke states that 'the Gravers have pretty well follow'd my directions and draughts' (Hooke 1665: Preface). Moreover, when he commented upon his drawings, he described a model both analytic and synthetic that has remained intact into the twenty-first century. He wrote, 'I never began to make any draught before by many examinations, in several lights, and in several positions to those lights, I had discover'd the true form' (*ibid.*). Scientific images were then, and remain today, complexly created rather than simply discovered.

The image derived with the use of the microscope was not simply a detail cut out but also a detail vastly enlarged. This was bound to be the case, whether the system of representing the specimen was a drawing made by the observer, an engraving or a photomicrograph. Crucially, and this remains the case, the manipulating hand always remained out of the frame. The increasing amount of labour involved in preparing the material was hidden from the observer of the image; the means of production, mechanical instrumentation and human intervention were all rendered invisible, and certainly the extent of manipulation and interpretation would be kept hidden from the non-scientific, wide-eyed public. The preservation of the myth of the objective, true, scientific gaze, of science as nature rather than culture, rested upon concealment. Even in modern microscopy, as William Ewing suggests, 'the amount of work in preparation of slides for microscopy should not be underestimated. Many hours may be spent with the samples, and literally hundreds of thousands of cells may be prepared, manipulated and studied closely before a choice is made for the purposes of image-making' (Ewing 1996: 13). But as we bask in the fantastic glow of such imagery, we never give a second thought to how such images were made, let alone what they do to the objects thereby produced.

The rules of microscopic preparation and observation depend to a large extent on the perception of the body as something infinitely divisible below the level of eyesight. Just as Nature's cabinet was unlocked, so the fabric of the body could be unpicked thread by thread and, eventually, rewoven. In microscopy a

'sample' was removed, first from the dead and then from the living body. The technologies employed increasingly became industrial, involving selecting, freezing, slicing, marking and staining. Rob Stepney describes the elaborate process involved in preparing a histological specimen; in a procedure not unlike the older methods of embalming, the preparation begins

> by taking tissue representative of the feature under study, and fixing it (often in formalin) to prevent putrefaction and degeneration. The sample is then placed in increasing concentrations of alcohol to remove all water. Once dehydration is complete, the alcohol is removed by immersion in an organic solvent ... The next stage is to embed the tissue in a medium that provides strength and support. In light microscopy, it is usual to impregnate the specimen with paraffin wax. The solidified block of tissue is then cut by a microtome. This machine shaves off a series of sections, each around 4–5 micrometres thick, forming a ribbon of samples. The ribbon is floated in water, and sections picked up on a glass microscope slide, ready to be dried and stained. (Stepney 1987: 12)

Viewers, presented with the recontextualised 'sample', accepted the scientist's claim that they were looking at a discovered fact rather than at a complex created artefact that had required large-scale manipulation in its manufacture. Those fragile, seemingly translucent fragments are in reality carved from a solid block, literally 'the fine edge' of a lengthy, detailed and labour-intensive process that has still further to go (see Latour 1986: 17). Without publication they are worthless.

All this elaborate but invisible work calls into question the common-sense idea of scientific observation as producing impartial knowledge. Evelyn Keller suggests that even the naturalist has 'to cut or otherwise uproot his or her specimens from the field, and preserve them for future study in the cabinet or museum' (Keller 1996: 109). These 'excursions into the field' were forerunners of modern techniques, to be used 'for future, massive incursions' (*ibid.*). The collecting, cutting and cataloguing procedures of the naturalists was further refined in cutting-edge microscopy with its harvesting of specimens. The body is, after all, the first and last cabinet of curiosity, and microscopy enabled the observer to get inside it before it was cold; to retrieve its secrets while it was still warm. Clinical microscopy made legitimate the minute anatomisation of the living and microscopy was closely tied to surgery on a miniature scale. By the mid-nineteenth century, microscopes with wings for stabilising the hands appeared on the market, enabling the microscopist not merely to look, but also to dissect under the lens with miniature surgical tools, thus turning the instrument into a miniature anatomy theatre. Contemplation of the microscopic object, often seen as dispassionate observation, was merely a forerunner to intervention. The microscopist was not content to view and file his detached facts, but worked up his finer motor skills as a micro-anatomist.

Here was a world that with a little practice could be taken apart and, later, reassembled under a new law.

The capacity to see the subvisible, or more correctly the invisible, extended man's power over the natural world. The microscope, as a counterpart of star-gazing, 'promised to do for the living what the telescope was already doing for the cosmic form' (Keller 1996: 110). Both instruments represented frontiers of knowledge *at a distance*. Telescopy brought celestial bodies closer, but not too close; microscopy distanced what was closest, the human body. Microscopy was literally a kind of navel-gazing, and what was inside was the secret of life. But that secret was not going to be easy to find; it remained distant and obscure. Indeed, the effect of the microscope on the human body was to reify it.

However, by the nineteenth century the microscope had one particular advantage over the telescope. It offered the opportunity for manipulation, while the telescope served only to make the observer aware of his trifling insignificance within a vast universe he could not hope to control. 'While the *telescope* enables us to see a system in every star, the *microscope* unfolds to us a world in every atom' (Chalmers, cited in Anon. 1866: 93–94). 'The one shows ... the insignificance of the world we inhabit – the other redeems it from all its insignificance ... there may be a world of invisible beings; ... a theatre of as many wonders as astronomy can unfold – a universe within a compass point so small as to elude all the powers' (*ibid.*).

For Samuel Morse, modern microscopy was 'about to open a new field of research in the depth of microscopic nature. We are soon to see if the minute has discoverable limits. The naturalist is to have a new kingdom to explore, as much beyond the microscope as the microscope is beyond the naked eye' (Morse (1839), cited in Gernsheim 1956: 87). Unlike the immutable solar system, the microcosmic universe was a world that might be brought within the observer's orbit.

Microscopy magnified man's power. Instead of looking up to a divinely-created universe which he could not hope to touch, let alone transform, the microscopist was placed in a God-like position and looked down on a subworld (see Keller 1996). In this microcosm, man was granted the ability to see deeply into the very structure of the creation of life – and death. Generation and degeneration were seen to be embodied in every single cell. For most of the nineteenth century, until Hertwig's discovery of the cell nucleus in 1876, the cell was considered to be the unit from which all life developed. The fundamental shift in perspective offered by microscopy suggested the possibility of a world within the microscopic world that might soon be put at man's, rather than God's, disposal.

In September 1839, the Microscopical Society was founded. This name (as opposed to the Microscopic Society) was chosen at the behest of Reverend

J. B. Reade to prevent 'the possibility of ourselves being mistaken for micro-scopic objects' (Turner 1989: 14). This suggests that fantasy still permeated nineteenth-century culture. For example, one writer went to great lengths to make clear the process of magnification: 'it is usual to say, that the microscope magnifies objects seen through it; but this is true only with regard to the apparent, not the real magnitude of objects; they appear indeed to be larger with than without a microscope; but in truth they are not' (Imison 1803, 1: 372). This laboured description is a good example of the problem of scale, of convincing viewers that what the microscopist could see were enlargements; not 'artificial aberrations' but not true representations either. It is also a reminder that it is not easy to separate 'new phenomena from the tools used to study them' (Silverman 1993: 756).

The other founders of the society were medical men. The brothers Edwin and John Quekett were both surgeons. Daniel Cooper, also a surgeon, was the son of J. T. C. Cooper, a chemistry lecturer at the Gallery of Practical Science and the Polytechnic in Regent Street. It was near there, in Bond Street, that the elder Cooper had first projected images from the oxyhy-drogen microscope in 1833. These vivid, enlarged images demonstrated to the public the existence of a thriving and previously invisible world that both amazed and frightened audiences (Cooper 1842: 2). Another founder, William Carpenter, was a doctor, as was Lionel Beale, the inventor of the Choreutoscope (a magic lantern that animated a skeleton). Richard Owen, the society's first president, was an eminent anatomist. In his address to the British Association in 1858, Owen stressed that the microscope was 'an indispensable instrument in embryological and histological researches' (Owen (1858), cited in Turner 1989: 20). By then, 'the greater number of microscopes had passed into the hands of the medical profession, to whom they have become almost as necessary as the scalpel or the lancet' (Owen (1858), cited in Turner 1989: 28). The 'final conquest of the invisible is to be found in Virchow's ground-breaking cellular pathology of 1858' (Gilman 1989: 231). Throughout the 1840s the society accumulated a considerable collection of slides and also standardised measurements and slide size. In the 1850s, its headquarters in Regent Street was listed in general directories as a place to visit in London. By 1866 it had royal patronage and scientific recog-nition, eventually, in the twentieth century, finding a home within the British Medical Association. These geographical relocations point to microscopy's transition from popular entertainment to instrument of science.

As the transactions of the Microscopical Society show, the 1840s were important years in microscopy's development and endeavours were made to expand its influence through publications and public meetings. Publicity and representation were important to the growth and development of cell theory. Seeing was believing: witnesses, first- and second-hand, had to be recruited

and the microscope had to be 'made easy' in order that its truths might be widely disseminated. The committee therefore not only encouraged the improvement of microscopes but set up its own magazine, the *Microscopic and Structural Record*, in 1841 (first published in 1842). There were regular public events to promote the 'Wonders of the Microscope' and in 1844, only five years after the society had been established, the cabinet of slides was opened to the public and help was provided one day a week to 'assist gentlemen in microscopic investigations, and to draw either upon stone or paper for the use of the Society' (Turner 1989: 30–33). It was essential to enable people to see for themselves and also to provide the means of verification. This could be achieved in mutually supportive groups aided by instruments such as Nachet's multiple microscope, which allowed several microscopists to view the same object simultaneously (see Figure 49). In addition, visual evidence had to appear in published form. Looking or contemplating was simply not enough. Observation must be made concrete. The microscope had moved rapidly from public projection to private scientific peep-show with serious intent. As the illustration shows, the observer looks down the microscope but does not see what the microscopist is looking at. Looking is clearly

49 Nachet's multiple microscope in use. 'This microscope enables four observers to view the object at a time', from D. Lardner, *The Museum of Science and Art*, 1859, volume IX, p. 33

severed from touching, as is the image of observation from the image observed.

In the early 1840s, microscopy was introduced into the British medical curriculum in Edinburgh. The 'progressiveness' of such a course was picked up by the medical press and the author commented that, 'It will be a matter of surprise if the London Medical Schools do not appoint Professors for the same purpose … Indeed it is somewhat surprising that the Senate of University of London … have not made it requisite for students … to attend at least *one* such course' (Anon. 1842: 172). Cooper was referring to the work of John Hughes Bennett who lectured at Edinburgh University. In his *Introduction to Clinical Medicine*, first published in 1852, Bennett urged the student to 'seize every opportunity of opening dead bodies with your own hands' (Bennett 1862a: 20–21). Similarly, he believed that 'The art of demonstrating under the microscope is only to be acquired by long practice, and … cannot be learned from books or systematic lectures' (Bennett 1862a: 104). This suggests that, at the very least, that anatomy and microscopy were not far apart in the mid-nineteenth century. Bennett's general work included a chapter on 'The use of the Microscope', with advice on the uses of lenses, micrometers, slips of glass, needles, knives and forceps. He advocated light, small microscopes and distinguished them from the unnecessarily heavy 'London' microscopes. There was 'still a general feeling among the public that the larger a microscope is, the more it must magnify; but I need not tell you this is error' (Bennett 1862a: 97). He mocked the earnest technophile who over-invested in complex machinery in order to see more: 'Nothing, indeed, can be more amusing than to see a man twisting his screws, pushing his heavy awkward stage about, and laboriously wasting time to find a minute object which another can do in a moment, and without fatigue, by the use of his fingers' (Bennett 1862a: 97–98). This statement suggests that popular beliefs about the microscope still had currency, and indeed, Bennett claimed that small microscopes were effective magnifiers. His description of what was visible was similar to Hooke's of two hundred years previously: 'the field of vision', Bennett writes, 'is always dazzling, and always presents a glare most detrimental to the eyes of the observer' (Bennett 1862a: 99). The limitations of lenses meant that looking was liable to give the microscopist more than a headache. Bennett warned that he knew 'more than one excellent observer in whom the sight has so much suffered from this cause as to incapacitate them from continuing their researches' (*ibid.*). The description suggests an (Oedipal) punishment meted out to those who looked too hard for too long.

The language of suffering was not attached to the objects of study, although it might have been, for in the miniature scene on the microscopic stage the gallows met the anatomist's slab. Microscopy turned out to be a more refined form of flaying, and what microscopists enacted was little short of butchery carried

out with a complex array of instruments and techniques. Live animals could be publicly dissected and samples subjected to the same treatment. Water could be used on tissue samples to 'render parts more clear'. Teeth and bones had first to be 'cut into thin sections, and afterwards ground down to the necessary thinness'. Liver samples were 'crushed' (Bennett 1862a: 105). Microscopic objects were killed in every conceivable way so that they might yield up more hidden treasures. Animals like the frog were chosen for their relatively flat bodies and translucent skins. Arthur Bolles Lee, in his *Microtomist's Vade-mecum* (1893), did not mince his words, but devoted a comprehensive section to what he called 'special methods of killing' live samples. Favoured methods included drowning, heating, poisoning and asphyxiating (Lee 1893: 9). However, by the 1860s, samples were 'manufactured on a large scale, and may be obtained at a trifling cost' (Bennett 1862a: 105).

Photomicrography required a peculiar abstraction, a particular flattening, and an industrialisation that is characteristic of modernism. If a biopsy was taken, the specimen was made to fit the needs of the instrument and so was fattened up, pared down or battered out, before being carefully observed and copied. Just like an anatomist, Bennett was clear about the need for training the eye: 'the microscopist should early learn to draw … not only because such copies constitute the best notes he can keep, but drawing necessitates a more careful and accurate examination of the objects themselves' (Bennett 1862a: 106). In order to have currency, foreign objects had to be translated into imagery. Bennett also stressed that 'the act of observation is at all times difficult, but is especially so with a microscope, which presents us with forms and structures concerning which we had no previous idea' (*ibid*.). The problem was one not only of recognising what something was, but also of deciding exactly what it might be. This was no simple matter: it was difficult to see anything in those amorphous structures, especially when confronted with new phenomena without having anything with which to compare them. How, in these circumstances, were the observer's drawings to gain credibility as accurate and correct transcriptions? Bennett turned to mechanical standards: 'rigid and exact observations should be methodically cultivated from the start'. Close attention was to be paid to 'Shape, Colour Edge or Border, Size, Transparency, Surface, Contents, Effects of reagents' (Bennett 1862a: 106–107). Thus the formal properties were the most important and content, which was unclear anyway, came low down on the list. The specimen, whether in drawing or photomicrograph, was always an abstract, formal image. This lent it credibility, even if it was like nothing but other examples in the same medium. Moreover, the aniline dyes used were poisons: they not only killed the cell specimen but also altered its structure (see Hacking 1983: 197).

By the end of the nineteenth century, a dark-staining nucleus was found to be at the centre of almost all cells. As Stepney suggests, 'The history of science

is as much one of improved staining techniques as of improved microscopes' (Stepney 1987: 12). Since most cells are transparent, there would otherwise be literally nothing to see. The scientific prestige of photomicrography depended on producing well stained representations. The *Quarterly Journal of Microscopical Science* ran articles promoting the need for photography to be joined with microscopy, providing the reader with practical information in order to provide scientifically verifiable images which would avoid 'the errors and omissions' of woodcuts (Maddox 1865: 9).

In a paper 'On the Molecular Theory of Organization' (presented in 1861), Bennett outlined the beginning of what was to become a shift in emphasis from embryology to developmental biology. He wrote: 'Parodying the celebrated expression of Harvey, viz., *omne animal ex ovo*, it has been attempted to fomularise the law of development by the expression *omnis cellula e cellula*, and to maintain "that we must not transfer the seat of real action to any part beyond the cell" (Virchow).' Bennett argued that the great importance of molecular development had been strangely overlooked. He continued, 'It becomes important, therefore, to show that real action, both physical and vital, may be seated in minute particles, or molecules much smaller than cells, and that we must obtain a knowledge of such action in these molecules if we desire to comprehend the laws of organization' (Bennett 1862b: 43). This suggested an even smaller world within the universe of the cell. The shift from cell to nucleus was dependent not on the microscopic techniques of the observer, but on the preparation of specimens. Without staining, there was no nucleus to be seen.

While Talbot had suggested in his early communications that microscopes and cameras could be combined so as to produce photomicrographs, calotypes were much too coarse for detailed microscopy. It was the invention of the wet-plate process in 1851 that made it possible to distribute microscopy widely. Until this point, the microscope was more easily aligned with the far sharper daguerreotype. This conjoining was instructive: from the start daguerreotypes were highly prized for their reflective qualities and for their ability to show a degree of detail that was imperceptible to the naked eye. Daguerreotypy demonstrated the power of photography to reveal the detail of a universe that had hitherto been unknown, either because it was previously invisible or because, being unrepresentable, it had simply been neglected. Photomicrographs enlarged qualities inherent in the photographic image. A preoccupation with photographing monuments and archaeological ruins had its obverse in the creation of a corporeal universe which monumentalised the body's details. Photography encouraged a public sense of both looking deeply into the nature of things and of looking more widely. It combined an attentiveness to realist detail with a distracted and accelerated gaze.

Looking further afield to the ancient world was one response to the anxiety caused by the quickening pace of industrial, modern life in a world which had been rapidly torn apart and where there was not even the slightest chance of putting the pieces back together. By mid-century, the rapidity of social change and demographic growth had made change irreversible. All that could be done was to move in the opposite direction and take things apart even further, in the hope of finding a deeper, more complex underlying pattern. Microscopy was part of a wider antomisation of the body. For example, chronophotography was a means of breaking down the human body into physical components in order to reassemble it to meet the demands of increased production. Through the amalgamation of a variety of techniques of observation, bodies were made to conform to the machine. The nineteenth century observer began to look for microscopic detail in images. As miniatures, daguerreotypes were designed to be examined, not with the naked eye, but with a magnifying glass; they encouraged an idea of seeing deeply into the nature of the world, but only by withdrawing from it. The viewer could see anew and admire the magnificent detail of what had been overlooked as insignificant. Their portable, cameo and book-like quality emphasised their power to condense information. Daguerreotypy was a succinct art, a response to the demand for increased information and a means of gathering data. Daguerreotype micrographs rapidly assumed the status of books of revelation in an increasingly secular world.

The large quantity of photomicrographic images produced in the first years of photographic production was also an analogy of social change. Photography is quintessentially a system of dissection. As Schor puts it, 'photography is a detailing technique in the etymological sense of the verb, *détailler*: to cut in pieces' (Schor 1987: 48). Photomicrography was a mark of a culture that had been taken apart, a mark of disconnection, if not disintegration, and of re-assemblage. The magnification of detail was inherent in both photography and microscopy.

But enlargements, magnifications, were also problematic. As Barbara Stafford suggests, they belonged to 'sorcerer's mirrors, concealed magic lanterns, and machines for projecting phantoms on smoke in making things appear as they were not' (Stafford 1996: 149). Magnifications had been part of public entertainments in the early nineteenth century. Several shops, like the Microcosm in Regent Street, run by Carpenter and Cooper, housed not only microscopes but spectacles, telescopes, camera lucidas, phantasmagoria lanterns, barometers, thermometers, drawing instruments, sandglasses and globes (Turner 1981: 76). The first edition of the *Microscopic Journal and Structural Record* drew attention to this connection between the popular and the scientific. 'The first and most important attempt to develop to the public gaze the microscope on a large scale was Mr Carpenter of Regent St, who for

many years exhibited a solar microscope for the gratification of the public' (Cooper 1842: 2). One reviewer, writing in the *Foreign Monthly Review*, remarked that 'since the discovery of this wonderful world of microscopic life, it has been represented by fanciful writers as a world of spirits, peopled by forms not to be compared with those of the visible world, sometimes horrible, some-times strangely distorted, neither properly animate, nor yet properly inanimate' (cited in Anon. 1839b: 18). The author continued, 'even in 1820 an otherwise respectable writer described in detail the magic powers with which some of these forms were said to be endowed' (*ibid.*).

The phantasmagoric or magical element of magnification had another effect: breaking an object down to its smallest part and then enlarging it was a defence against encountering the unwieldy whole. Both microscopy and photography allowed a withdrawal from direct human engagement into denatured confines that were also socially sanctioned spaces of anatomisa-tion, whether shop, gallery studio, factory, clinic or laboratory. Photography and micrography shared a capacity to preserve detail at the expense of an overall picture. Daguerreotypes thrived on microscopic detail. Viewed through the magnifying glass or lens, the image could only break down even further.

Photomicrographs satisfy in the sense that they are images which, although picturing what is already dead, seem to teem with life. As *The Mirror of Literature and Amusement* suggested, micrographic projections had pre-sented a world between, one that was neither animate nor inanimate. The photomicrograph produced shimmering, scintillating details that caught the wandering attention by their strangeness, encouraging the viewer to look con-stantly to see something new, something different in the same image, or the same thing in different images, presenting a kaleidoscopic universe that altered at every turn. In this sense, reading photomicrographs was an essen-tially abstract activity. It entailed the identification of formal patterns. The observer withdrew from the messiness of the modern world to the consola-tions offered by less threatening, small image-objects. In the clinic, the histo-logical material 'harvested' from the mute bodies of others was satisfyingly filed and organised. The processes of life and death and disease which linked them were to be understood at the microcosmic level. Thus order, more diffi-cult to maintain in the frenetic macrocosm of the modern world, could be secured, or at least rendered more manageable. Collecting, preserving and filing samples in cabinets was a way of controlling and regulating both bodies and knowledge. Furthermore, that control over the miniature seemed to be more than a refuge against modernity; it seemed to be the only adequate response.

Interest in detail was then, essentially a form of defence. The viewing sub-ject could possess the photographic object without risking a direct encounter

with its dangerous referent. The microscopic observer literally became lost in detail. If the photograph was a section uprooted or cut out of nature, then the photomicrograph was, potentially at any rate, a means of transplantation, of creating one's own universe. A detail, once extracted, could not be put back. Once isolated or 'blown up', the whole thing had already vanished. Photomicrographs were carefully framed to match the round lens of the microscope, discouraging any view outside the image. They offered the very image of the macrocosm shrunk to a microcosm. Here detail began to take on a life of its own, creating a different picture altogether and breaking up any possibility of a coherent viewpoint. The observer no longer looked up and out, but peered down into a flat world with one eye closed to the outside. Microscopy produced a fragmented, kaleidoscopic, abstract pattern of life. As Cartwright suggests, microscopy represents a view that is in itself capillary, 'unfixed from a locale' (Cartwright 1995: 82). Thus the observer is no longer limited to localised points of view. Without history, without spatial depth, the photomicrograph is, for Cartwright, a prime example of a modernist text (see Cartwright 1995: 83).

The link between photography, microscopy and anatomy was fixation on detail. Anatomy was in itself a kind of detailisation which lost sight of the whole. Through the microscope, equally, all notion of grid or axis was lost, revealing a body that was labile, constantly dividing. The extraction of detail and its reorganisation took place at all levels: the social, the human and the microscopic. By the 1870s, the cell, with the organising nucleus at its core, changed the narrative of generation once again and the 'one-sex model' partially returned.

Here at the centre was a master molecule, a master text, that would in the next century lead to the search for genetic code, the information that organises life. The cell, indeed any and every cell, could be penetrated; information could be extracted or inserted. In the nineteenth century human bodies became, for the first time, specimens of something more important: living matter. Hooke's opening image of the point of a needle and his closing image of the moon and stars, suggesting a narrative of observation and penetration, a closing of the distance between looking and touching, is also exemplified in Bennett's observation that microscopy can only be learned by doing, from 'long practice', and not 'from books or systematic lectures' (Bennett 1862a: 104). By the end of the century an epistemic shift in knowledge had taken place. The microscopist had to learn how to move around the microscopic universe. Once he had done so, he was free to begin to move that universe around, to manipulate its structure. Man's pride need no longer show restraint (see Figure 50).

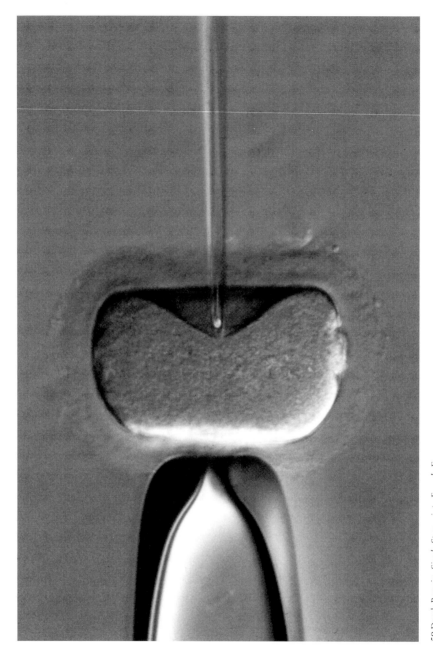

50 Derek Berwin, *Single Sperm into Female Egg*

Notes

1 Alfred Donné was an established microscopist and the discoverer of blood platelets. Between 1830 and 1840 he had published books a number of books on body fluids – saliva, mucus, urine and sperm – as well as a study on sterility in women. He also published advice to mothers on how to raise new-born children.

2 I will leave aside feminist metaphors of entrapment, which seem to me just as unsatisfactory as those of penetration.

Bibliography

Altick, Richard D. (1978), 'The Waxen and the Fleshy', *The Shows of London*, Cambridge, Massachusetts, The Belknap Press and Harvard University Press, 332–349.

An Act to give summary Protection to Persons employed in the Publication of Parliamentary Papers (1840), 3 & 4 Vict. c. 9–10, para. 3, 14 April (Cap. IX).

Anon. (1823), 'A System of Anatomical Plates with Descriptive Letter-press by John Lizars', *Edinburgh Medical and Surgical Journal*, 19: 314–315.

Anon. (1825), 'Dr. Davis's *Elements of Midwifery*', *Edinburgh Medical and Surgical Journal*, 24: 384–397.

Anon. (1839a), 'Photogenic Drawing', *The Mechanic and and Chemist*, 18 May, 182.

Anon. (1839b), *Mirror of Literature and Amusement*, XXXIV, 957, 6 July, 18.

Anon. (1842), 'The Employment of the Microscope in Medical Studies; a lecture introductory to a course of Histology [*sic*] by John Hughes Bennett', *Microscopic Journal and Structural Record*, 1: 172.

Anon. (possibly by J. Allison) (1844), *The Parisian Venus*, Manchester, A. Burgess and Company.

Anon. (1845), *Art Union*, 7, 1 September, 296.

Anon. (1856), 'Advertisement', *London Stereoscopic Company: a catalogue of binocular pictures*.

Anon. (1858a), 'Associate Intelligence', *British Medical Journal*, 6 March, 192.

Anon. (1858b), 'Introductory Address', *Photographic News*, 1: 1.

Anon. (1858c), 'Questionable Subjects for Photography', *Photographic News,* 1: 135–136.

Anon. (1861), *The Wonders of the Microscope Photographically Revealed by Olley's patent Micro-photographic Reflecting process*, London, W. Kent and Company.

Anon. (1866), *The Microscope and its Wonders*, London and Edinburgh, W. and R. Chambers.

Anon. (1873), 'Unqualified Quacks', *British Medical Journal*, 21 June, 718.

Anon. (1886), 'Photography in Pathology', *British Medical Journal*, 23 January, 162–163.

Anon. (1896a), 'Wanted: A Name', *British Medical Journal*, 14 March, 677–678.

Anon. (1896b), *British Journal of Photography*, 34, 20 March, 187.

Anon. (1896c), *Literary Digest*, April, 766.

Anon. (1908a), 'Edinburgh Stereoscopic Atlas of Obstetrics', *British Medical Journal*, 16 May, 1181.

Anon. (1908b), 'Edinburgh Stereoscopic Atlas of Obstetrics', *British Medical Journal*, 29 August, 603.

Anon. (1909a), 'Review of Edinburgh Stereoscopic Atlas of Obstetrics', *Edinburgh Medical Journal*, 2 (new series), 93.

Anon. (1909b), 'Obstetrics', *British Medical Journal*, 12 June, 1419.

Anon. (1958), 'Obituary: George Freeland Barbour Simpson', *British Medical Journal*, 26 April, 1008.

Armstrong, Carol (1998), *Scenes in a Library*, Cambridge, Massachusetts, MIT Press.

Armstrong, David (1983), *Political Anatomy of the Body: Medical Knowledge in Britain in the Twentieth Century*, Cambridge, Cambridge University Press.

Aveling, James H. (1967), *English Midwives: Their History and Prospects*, London, Elliot (first published in 1872).

Baker, Henry (1734), *The Universe, a poem intended to restrain the Pride of Man*, London, J. Worrall.

Baker, Henry (1743), *The Microscope Made Easy*, London, R. Dodsley.

Baker, Henry (1753), *Employment of the Microscope*, London, R. Dodsley.

Ballard, J. G. (1992), 'Project for a Glossary of the 20th Century', in Jonathan Crary and Sanford Kwinter (eds), *Incorporations*, New York, Zone, 1992, pp. 268–279.

Balsamo, Anne (1999), 'Public Pregnancies and Cultural Narratives of Surveillance', in Clarke and Olesen (1999), pp. 231–235.

Barclay, John (1819–20), *A Series of Engravings Representing the Bones of the Human Skeleton with the skeletons of some of the lower animals*, Edinburgh, Oliver and Boyd.

Barclay, John (1824), *A Series of Engravings Representing the Bones of the Human Skeleton with the skeletons of some of the lower animals*, Edinburgh, printed for MacLachlan and Stewart.

Batchen, Geoffrey (1997), *Burning with Desire: The Conception of Photography*, Cambridge, Massachusetts, MIT Press.

Baudelaire, Charles (1863), 'The Painter of Modern Life', in Jonathan Mayne (ed.), *The Painter of Modern Life and Other Essays*, Oxford, Phaidon Press, 1964.

Bell, Thomas (1821), *Kalogynomia, or the Laws of Female Beauty*, London, J. J. Stockdale.

Benjamin, Jessica (1998), *Shadow of the Other: Intersubjectivity and Gender in Psychoanalysis*, London, Routledge.

Benjamin, Walter (1972), 'A Short History of Photography', *Screen*, 13: 1, 5–26.

Benjamin, Walter (1973a), 'The Work of Art in the Age of Mechanical Reproduction', *Illuminations*, London, Fontana, pp. 219–253.

Benjamin, Walter (1973b), *Charles Baudelaire: A Lyric Poet in the Era of High Capitalism*, London, New Left Books.

Benjamin, Walter (1985), *One Way Street and Other Writings*, London, Verso.

Bennett, John Hughes (1862a), *An Introduction to Clinical Medicine*, Edinburgh, Adam and Charles Black.

Bennett, John Hughes (1862b), 'On the Molecular Theory of Organization', *Quarterly Journal of Microscopical Science*, II (new series): 43–53.

Berman, Marshall (1983), *All That is Solid Melts into Air: The Experience of Modernity*, London, Verso.

Bloch, Iwan (1938), *Sexual Life in England, Past and Present*, London, Francis Aldor.

Blunt, John (1793), *Man Midwifery Dissected or the Obstetric family-instructor. For the Use of Married Couples and Single Adults of both Sexes*, London, S. W. Fores.

Bottone, Selimo R. (1898), *Radiography and the 'X'–Rays in Practice and Theory*, London and New York, Whittaker and Company.

Bouchard, Donald (ed.) (1977), *Language, Counter-memory, Practice: Selected Essays and Interviews*, Oxford, Basil Blackwell.

Braidotti, Rosi (1991), *Patterns of Dissonance*, Cambridge, Polity Press.

Braidotti, Rosi (1994), *Nomadic Subjects: Embodiment and Sexual Difference in Contemporary Feminist Theory*, New York, Columbia University Press.

Brewster, David (1819), *A Treatise on the Kaleidoscope*, Edinburgh, Ruthven and Sons.

Brewster, David (1834), *Letters on Natural Magic*, Edinburgh, John Murray and Thomas Tegg.

Brewster, David (1856), *The Stereoscope, its History, Theory and Construction*, London, John Murray.

Briggs, Robert (1879), 'A few practical illustrations of the value of photography in law and medicine', *Photographic News*, 23: 230–231.

Bristow, Edward J. (1977), *Vice and Vigilance, Purity Movements in Britain since 1700*, Dublin, Gill and Macmillan, Rowman and Littlefield.

Bronfen, Elisabeth (1992), *Over her Dead Body: Death, Femininity and the Aesthetic*, Manchester, Manchester University Press.

Bruce, William J. (1907), *A System of Radiography with an Atlas of the Normal*, London, H. K. Lewis.

Bruno, Giuliana (1992), 'Spectatorial Embodiments: Anatomies of the Visible and the Female Bodyscape', *Camera Obscura*, 28: 239–261.

Bruno, Giuliana (1993), *Streetwalking on a Ruined Map*, Princeton, New Jersey, Princeton University Press.

Burnet, Edward and George Freeland Barbour Simpson (eds) (1908–9), *The Edinburgh Stereoscopic Atlas of Obstetrics*, London, Caxton Publishing Company.

Bynum, William and Roy Porter (eds) (1985), *William Hunter and the Eighteenth-century Medical World*, Cambridge, Cambridge University Press.

Cadava, Eduardo (1997), *Words of Light: Theses on the Photography of History*, Princeton, New Jersey, Princeton University Press.

Camper, Pierre (1752), 'Original obstetrical drawings dated 1752 and published with William Smellie's "Anatomical tables" 1761', London (Royal College of Physicians, Edinburgh, AA4.71).

Carlisle, Anthony (n.d., *c*. 1835), *Against the Employment of Men in the Practices of Midwifery*, Manuscript, Royal College of Physicians, Edinburgh.

Carter, Angela (1979), *The Sadeian Woman: An Exercise in Cultural History*, London, Virago.

Cartwright, Lisa (1995), *Screening the Body: Tracing Medicine's Visual Culture*, Minneapolis and London, Minnesota University Press.

Castle, Terry (1988), 'Phantasmagoria: Spectral Technology and the Metaphorics of Modern Reverie', *Critical Inquiry*, 15: 1, 26–61.

Clarke, Adèle and Virginia Olesen (eds) (1999), *Revisioning Women, Health and Healing*, London, Routledge.

Comrie, John D. (1932), *History of Scottish Medicine to 1860*, London, Ballière, Tindall and Cox.

Cooper, Daniel (1842), 'A Brief Sketch of the Rise and Progress of Microscopic Science, and the Principal Means enumerated which have tended to its general Advancement', *Microscopic Journal and Structural Record,* 1: 1–4.

Cooter, Roger (1991), 'Dichotomy and Denial: Mesmerism, Medicine and Harriet Martineau', in Marina Benjamin (ed.), *Science and Sensibility*, Oxford, Basil Blackwell, 1991, pp. 144–173.

Copjec, Joan (ed.) (1994), *Supposing the Subject*, London, Verso.

Court of Common Sense (1840), *Judgement in Error in the Case of Stockdale* v. *Hansard*, London, Longman, Orme, Brown, Green and Longman.

Craig, Alec (1963), *Suppressed Books: A History of the Conception of Literary Obscenity*, Cleveland, World Publishing.

Crary, Jonathan (1990), *Techniques of the Observer*, Cambridge, Massachusetts, MIT Press.

Crary, Jonathan (1995), 'Unbinding Vision: Manet and the Attentive Observer in the Late Nineteenth Century', in Leo Charney and Vanessa Schwartz (eds), *Cinema and the Invention of Modern Life*, Berkeley California, University of California Press, 1995, pp. 46–71.

Croom, John Halliday (1905), *Lectures on Midwifery*, taken by Fergus A. Hewat, manuscript, Royal College of Physicians, Edinburgh.

Croom, John Halliday (1908), 'Preface', in Burnet and Simpson (1908–9), pp. vii–viii.

Crosthwaite, C. H. T. (1896), 'Röntgen's Curse', *Longman's Magazine*, 28: 469–484.

Dally, Ann (1991), *Women under the Knife: A History of Surgery*, London, Hutchinson Radius.

Darrah, William C. (1977), *The World of Stereographs*, Gettysburg Pennsylvania, W. C. Darrah.

Davenport, Alma (1991), *The History of Photography: An Overview*, Albuquerque, University of New Mexico Press.

Davidson, J. Mackenzie (1898), 'Remarks on the Value of Stereoscopic Photography and Skiagraphy', *British Medical Journal,* 3 December, 1669–71.

Donné, Alfred L. (1844), *Cours de Microscopie; complementarie des études médicales, anatomie microscopique et physiologique des fluides de l'économie*, Paris, Ballière.

Donné, Alfred L. and León Foucault (1845), *Cours de Microscopie; complementarie des études médicales, anatomie microscopique et physiologique des fluides de l'économie, Atlas exécuté d'après nature au microscope-dagueurréotype*, Paris, Ballière.

Douglas, William (1748), *A Letter to Dr. Smelle [sic] shewing the impropriety of his New-invented Wooden Forceps*, London, J. Roberts.

Duden, Barbara (1991), *The Woman Beneath the Skin: A Doctor's Patients in Eighteenth-century Germany*, Cambridge, Massachusetts, Harvard University Press.

Duden, Barbara (1993), *Disembodying Women: Perspectives on Pregnancy and the Unborn*, Cambridge, Massachusetts, Harvard University Press.

Durbin, Paul T. (1980), *A Guide to the Culture of Science, Technology and Medicine*, New York, Free Press.

Earle, Edward W. (ed.) (1979), *Points of View: The Stereograph in America; A Cultural History*, Rochester, New York, Visual Studies Workshop Press.

Easlea, Brian (1981), *Science and Sexual Oppression: Patriarchy's Confrontation with Woman and Nature*, London Weidenfeld and Nicolson.

Edwards, Hall (1894), 'Medical Photography', *Birmingham Medical Review*, xxv, 149–155.

Eisenstien, Elizabeth L. (1979), *The Printing Press as an Agent of Change: Communications and Cultural Transformation in Early Modern Europe*, Cambridge, Cambridge University Press.

Ewing, William A. (1996), *Inside Information: Imaging the Human Body*, London, Thames and Hudson.

Farre, John R. (1827), *An apology for British Anatomy and an incitement to the Study of Morbid Anatomy*, London, Longman, Rees, Orme, Brown and Green.

Figlio, Karl (1996), 'Knowing, Loving and Hating Nature: A Psychoanalytic View', in Robertson *et al.* (eds) (1996), pp. 72–85.

Foucault, Michel (1976), *The Birth of the Clinic: An Archaeology of Medical Perception*, London, Tavistock Publications.

Foucault, Michel (1977a), 'Nietzsche, Genealogy, History', in Bouchard (1977), pp. 139–164.

Foucault, Michel (1977b), 'What is an Author', in Bouchard (1977), pp. 114–138.

Fox Talbot, William Henry (1839), 'Photogenic Drawing', *Athenæum*, 589: 114–117.

Fox Talbot, William Henry (1844–46), *The Pencil of Nature*, Longman, London.

Friedberg, Anne (1993), *Window Shopping*, Berkeley, University of California Press.

Friedberg, Anne (1994), 'Cinema and the Postmodern Condition', in Linda Williams (ed.), *Viewing Positions: Ways of Seeing Film*, New Brunswick, New Jersey, Rutgers University Press, 1994, pp. 46–71.

Fyfe, Gordon (1988), 'Art and its Objects: William Ivins and the Reproduction of Art', in Fyfe and Law (1988), pp. 65–98.

Fyfe, Gordon and John Law (eds) (1988), *Picturing Power: Visual Depiction and Social Relations*, London and New York, Routledge.

Fyfe, Gordon and John Law (eds) (1998), 'On the Invisibility of the Visuals', Editors' introduction, in Fyfe and Law (1988), pp. 1–14.

Gallagher, Christine and Thomas Laqueur (eds) (1987), *The Making of the Modern Body: Sexuality and Society in the Nineteenth Century*, Berkeley, Los Angeles and London, University of California Press.

Gallop, Jane (1988), *Thinking Through the Body*, New York, Columbia University Press.

Galton, Douglas (1893), *Healthy Hospitals*, Oxford, Clarendon Press.

Gernsheim, Alison (1961), 'Medical Photography in the Nineteenth Century', *Medical and Biological Illustrated*, 11: 2, 85–92.

Gernsheim, Helmut and Alison Gernsheim (1956), *L. J. M. Daguerre and the History of the Diorama and the Daguerreotype*, London, Secker and Warburg.

Gilman, Sander L. (1989), *Sexuality: An Illustrated History*, London, John Wiley.

Glasser, Otto (1933), *Wilhelm Conrad Röntgen*, London, John Bale.

Goldenberg, Naomi R. (1990), *Returning Words to Flesh*, Boston, Beacon Press.

Gray, Richard (n.d.), 'Notes', University of Westminster Archives, P176.

Grosz, Elizabeth (1992), 'Bodies–Cities', in Beatriz Colomina (ed.), *Sexuality and Space: Princeton Papers on Architecture*, New York, Princeton Architectural Press, 1992.

Grosz, Elizabeth (1994), 'Experimental Desire: Rethinking Queer Subjectivity', in Copjec (1994), pp. 133–157.

Hacking, Ian (1983), *Representing and Intervening*, Cambridge, Cambridge University Press.

Hamilton, David (1981), *The Healers*, Edinburgh, Canongate.

Hanmer, Jalna and Pat Allen (1980), 'Reproductive Engineering: The Final Solution?', in Lydia Birke *et al.* (eds), *Alice Through the Microscope: The Power of Science over Women's Lives*, London, Virago, 1980, pp. 208–227.

Hanson, Norwood R. (1965), *Patterns of Discovery*, Cambridge, Cambridge University Press.

Haraway, Donna (1976), *Crystals, Fabrics and Fields: Metaphors of Organicism in Twentieth Century Development*, New Haven, Connecticut, Yale University Press.

Haraway, Donna (1989), *Primate Visions*, London, Routledge.

Haraway, Donna (1998), 'The Persistence of Vision', in Nicholas Mirzoeff (ed.), *The Visual Culture Reader*, London and New York, Routledge, 1998, pp. 191–198.

Harding, Sandra (1986), *The Science Question in Feminism*, Milton Keynes, Open University Press.

Harding, Sandra and Merrill Hintikka (1983), *Discovering Reality: Feminist Perspectives on Epistemology, Metaphysics, Methodology, and Philosophy of Science*, Boston, D. Reidel.

Hartsoeker, Niklaas (1694), *Essay de Dioptrique*, Paris.

Harvey, David (1989), *The Condition of Postmodernity*, Oxford, Basil Blackwell.

Henderson, Andrea (1991), 'Doll-Machines and Butcher-Shop Meat: Models of Childbirth in the Early Stages of Industrial Capitalism', *Genders*, 12: 100–119.

Hertwig, Oskar (1896), *The Biological Problem of Today*, New York, The MacMillan Company.

Holmes, Oliver Wendell (1859), 'The Stereoscope and the Stereograph', *Atlantic Monthly*, June, 738–748.

Holmes, Oliver Wendell (1861), 'Sun Painting and Sun-sculpture', *Atlantic Monthly*, July, 13–29.

Hooke, Robert (1665), *Micrographia*, London, I. Martyn and J. Allestry.

Hunt, Lynn (ed.) (1993), *The Invention of Pornography: Obscenity and the Origins of Modernity 1500–1800*, New York, Zone.

Hunter, William (1774), *The Anatomy of the Human Gravid Uterus exhibited in figures*, Birmingham, John Baskerville.

Hunter, William (1794), *An Anatomical Description of the Human Gravid Uterus*, Matthew Baillie (ed.), London, J. Johnson.

Imison, John (1803), *Elements of Science and Art; being a familiar introduction to natural philosophy and chemistry*, 2 vols, London, McMillan.

Isenthal, Adolf Wilhelm and Henry Snowden Ward (1898), *Practical Radiography*, London, Dawbarn and Ward.

Jameson, Fredric (1984), 'Postmodernism, or the cultural logic of late capitalism', *New Left Review*, 146: 53–92.

Jay, Martin (1993), *Downcast Eyes: The Denigration of Vision in Twentieth Century French Thought*, Berkeley and Los Angeles, California University Press.

Jenty, Charles Nicholas (1757), *The demonstrations of a pregnant uterus of a woman at her full term. In six tables, as large as nature. Done from pictures painted after dissections, by Mr. Riemsdyk*, London, Fetter Lane.

Jenty, Charles Nicholas (1765), *A Course of anatomico–physiological Lectures on the Human Structure and Animal Oeconomy*, 3 vols, London, printed for J. Lloyd and D. Steel, 3rd edn., first published 1757.

Jordanova, Ludmilla (1985), 'Gender, Generation and Science', in Bynum and Porter (1985), pp. 385–412.

Jordanova, Ludmilla (1989), *Sexual Visions: Images of Gender in Science and Medicine between the Eighteenth and Twentieth Centuries*, London, Harvester Wheatsheaf.

Kaufman, Matthew H. (1993), 'Reflections on Dr. Henderson of Perth's case of an impractible labour', *Scottish Medical Journal*, 38: 85–88.

Kaufman, Matthew H. (1995), 'Caesarean Operations Performed in Edinburgh During the 18th Century', *British Journal of Obstetrics and Gynaecology*, 102: 186–191.

Kaufman, Matthew H. and S. M. Jaffe (1994), 'An Early Caesarean Operation (1800) Performed by John and Charles Bell', *Journal of the Royal College of Surgeons of Edinburgh*, 39: 69–75.

Keller, Evelyn Fox (1985), *Reflections on Gender and Science*, New Haven, Connecticut and London, Yale University Press.

Keller, Evelyn Fox (1992), *Secrets of Life: Essays in Language, Gender and Science*, London and New York, Routledge.

Keller, Evelyn Fox (1996), 'The Biological Gaze', in Robertson *et al.* (1996), pp. 107–121.

Kemp, Martin and Wallace, Marina (2000), *Spectacular Bodies*, London, Hayward Gallery Publishing.

Kendrick, Walter (1996), *The Secret Museum: Pornography and Modern Culture*, Berkeley, University of California Press.

Knox, Robert (ed.) (1829), *The Anatomy of the Bones of the Human Body represented in a series of engravings copied from an elegant tables of Sue and Albinus by Edward Mitchell with explanatory reference by the late John Barclay*, Edinburgh, Mitchell and McLachlan and Stewart.

Laqueur, Thomas (1990), *Making Sex: Body and Gender from the Greeks to Freud*, Cambridge, Massachusetts and London, Harvard University Press.

Latour, Bruno (1986), 'Visualisation and Cognition', *Knowledge and Society: Studies in the Sociology of Culture Past and Present*, 6: 1–40.

Latour, Bruno (1993), *We Have Never Been Modern*, Hemel Hempstead, Harvester Wheatsheaf.

Latour, Bruno (1999), *Pandora's Hope: Essays on the Reality of Science Studies*, Cambridge, Massachusetts and London, Harvard University Press.

Lee, Arthur Bolles (1893), *The Microtomists Vade-Mecum*, London, Churchill.

Lee, Sydney (ed.) (1909), *Dictionary of National Biography*, London, Smith, Elder and Co.

Leisewitz, Thomas and G. Leopold (1908), *Geburtshilflicher Röntgen-Atlas*, Dresden, Zahn u. Jaensch.

Lerebours, Noel P. (1843), *Treatise on Photography*, London, Longman, Brown, Green and Longman.

Little, Thomas (1824a), *The Generative System of John Roberton*, London, J. J. Stockdale.

Little, Thomas (1824b), *The Beauty, Marriage Ceremonies and Intercourse of the Sexes in all nations; to which is added the New Art of Love (Grounded on Kalogynomia)*, London, J. J. Stockdale.

Little, Thomas (ed.) (1825a), *Introduction to a Natural System of Anatomy, Physiology, Pathology and Medicine; to which is added a general view of natural history. By the author of Kalogynomia*, London, J. J. Stockdale.

Little, Thomas (1825b), *Systems of Physiognomy of Camper, Blumenbach, Virey, Gall and Spurzheim, Lavater, Schimmelpennick and A. Walker. By the author of Kalogynomia*, London, J. J. Stockdale.

Little, Thomas (1832), *Houses! Seduction and Treatment il-legal and non-medical of Miss Stabback*, London, J. J. Stockdale.

Lizars, John (1821–25), *Original Drawings*, Royal College of Physicians, Edinburgh, Aa 472.

Lizars, John (1822), *Descriptions of the Plates*, Preface to Part I, Edinburgh, printed for Daniel Lizars.

Lizars, John (1822–26), *A System of Anatomical Plates of the Human Body*, 12 parts, Edinburgh.

Lizars, John (1826), *Description of the Plates*, Preface to Part IX, Edinburgh, printed for Daniel Lizars.

Lowndes, William T. and Henry G. Bohn (1858–65), *Lowndes Bibliographer's Manual of English Literature*, London, W. T. Lowndes.

Lynch, Michael and Samuel Y. Edgerton Sr (1988), 'Aesthetics and digital image processing: representational craft in contemporary astronomy' in Fyfe and Law, *Picturing Power*, pp. 184–220.

Maddox, Richard L. (1865), 'On the Photographic Delineation of Microscopic Objects', *Transactions of the Microscopical Society*, XI: 9.

Mann, Robert (1855), *Philosophy of Reproduction*, London, Longman, Brown, Green and Company.

May, Thomas Erskine (1893), *A Treatise on the Law, Privileges, Proceedings and Usage of Parliament*, Reginald Palgrave and Alfred Bonham-Carter (eds), London, William Clowes and Sons.

McCauley, Elizabeth Anne (1994), *Industrial Madness: Commercial Photography in Paris 1848–1871*, New Haven and London, Yale University Press.

Monro, Alexander (1746), *Anatomy of the Humane Bones*, Edinburgh, Hamilton and Balfour.

Moscucci, Ornella (1990), *The Science of Woman: British Gynaecology 1849–1890*, Cambridge, Cambridge University Press.

Mulvey, Laura (1989), 'Visual Pleasure and Narrative Cinema', in *Visual and Other Pleasures*, London, Macmillan, pp. 14–26.

Needham, Joseph (1959), *A History of Embryology*, Cambridge, Cambridge University Press.

Newman, Karen (1996), *Fetal Positions*, Stanford, Stanford University Press.

Nihell, Elizabeth (1760), *A Treatise on the Art of Midwifery*, London, A. Morley.

O'Dowd, Michael J. and Elliot E. Philipp (1984), *The History of Obstetrics and Gynaecology*, New York, Parthenon.

Ollerenshaw, Robert (1961), 'Medical Illustration in the Past', in E. S. Linssen (ed.), *Medical Photography in Practice*, London, Fountain Press, pp. 1–18.

Ong, Walter J. (1971) *Rhetoric, Romance and Technology: Studies in the Interaction of Expression and Culture*, Ithaca and London, Cornell University Press.

Osborne, Albert E. (1909), *The Stereograph and the Stereoscope*, New York, Underwood and Underwood.

Oute, Mark (1896), 'The Living Pictures – The Skeleton', *The British Journal of Photography (Supplement)*, 43, 4 December, 93.

Parliamentary Reports From Commissioners (1836) 14: 4–5.

Phillips, Adam (1998), *The Beast in the Nursery*, London, Faber & Faber Ltd.

Plissart, Marie-Françoise and Jacques Derrida (1989), 'Rights of Inspection', *Art & Text*, 32: 20–97.

Poovey, Mary (1987), '"Scenes of an Indelicate Character": The Medical "Treatment" of Victorian Women', in Gallagher and Laqueur (1987), pp. 137–168.

Porter, Roy (1987), '"The Secrets of Generation Display'd": Aristotle's Masterpiece in Eighteenth-century England', in Robert P. Maccubbin, *'Tis Nature's Fault, Unauthorised Sexuality During the Enlightenment*, Cambridge, Cambridge University Press, 1987, pp. 1–21.

Ramsbotham, Francis H. (1867), *Principles and Practice of Obstetric Medicine*, London.

Reiser, Stanley J. (1978), *Medicine and the Reign of Technology*, Cambridge, Cambridge University Press.

Ricci, James V. (1949), *The Development of Gynaecological Surgery and Instruments*, Philadelphia and Toronto, The Blakiston Company.

Richardson, Ruth (1987), *Death, Dissection and the Destitute*, London and New York, Routledge and Kegan Paul.

Roberton, John (1806), *A Practical Treatise on the Powers of Cantharides when used internally*, Edinburgh.

Roberton, John (1809), *A Treatise on Medical Police*, 2 vols, Edinburgh, J. Moir.

Roberton, John (1811), *On Diseases of the Generative System*, Edinburgh, J. Moir.

Roberton, John (1813), *A Practical Essay on the more important complaints peculiar to the female*, London.

Roberton, John (1817a), *Roberton's Generative System*, London, Printed for J. J. Stockdale by Cox and Barliss.

Roberton John (1817b), *Letters from Dr. Baillie with remarks by John Roberton*, London, J. J. Stockdale.

Roberts, Kenneth B. and J. D. W. Tomlinson (1992), *The Fabric of the Body: European Traditions in Anatomical illustration*, Oxford, Clarendon Press.

Roberts, M. J. D. (1985), 'Morals, Art and the Law: The Passing of the Obscene Publications Act, 1857', *Victorian Studies*, 28: 4, 609–630.

Robertson, Geoffrey (1989), *Freedom, the Individual and the Law*, Harmondsworth, Penguin.

Robertson, George *et al.* (eds) (1996), *FutureNatural*, London, Routledge.

Root, Marcus A. (1864), *The Camera and the Pencil*, Philadelphia, Lippincott and Company.

Rose, Jacqueline (1986), *Sexuality in the Field of Vision*, London, Verso.

Ross, Andrew (ed.) (1989), *Universal Abandon: The Politics of Postmodernism*, Edinburgh, Edinburgh University Press.

Rymsdyk, Jan van (1774), 'Original chalk drawings for William Hunter. Anatomy of the human gravid uterus', London. MS Hunter 658. (Glasgow University Special Collections, Az1.4)

Rymsdyk, Jan van [fl. 1740–88], 'Set of 25 obstetrical drawings for W. Smellie's obstetrical tables (with drawings by another hand)'. (Glasgow University Special Collections, D1.1.27)

Schaaf, Larry (1989), *The Pencil Of Nature*, New York, Hans P. Krauss.

Schiebinger, Londa (1987), 'Skeletons in the Closet: The First Illustrations of the Female Skeleton in Eighteenth-Century Anatomy', in Gallagher and Laqueur (1987), pp. 42–82.

Schiebinger, Londa (1999), *Has Feminism Changed Science?*, Cambridge, Massachusetts and London, Harvard University Press.

Schor, Naomi (1987), *Reading in Detail: Aesthetics and the Feminine*, New York and London, Methuen.

Scott, George R. (1945), *'Into Whose Hands': An Examination of Obscene Libel*, London, G. Swan.

Senefelder, Alois (1911), *The Invention of Lithography*, New York, The Fuchs and Lang Manufacturing Company.

Shelley, Mary (1992), *Frankenstein*, Paddy Lyons (ed.), Everyman, London, J. M. Dent and Sons Ltd. (first published 1831).

Shildrick, Margrit (1997), *Leaky Bodies and Boundaries: Feminism, Postmodernism and (Bio)ethics*, London, Routledge.

Shohat, Ella and Robert Stam (1988), 'Narratavizing Visual Culture', in Nicholas Mirzoeff (ed.), *The Visual Culture Reader*, London, Routledge, 1988, pp. 27–49.

Showalter, Elaine (1991), *Sexual Anarchy: Gender and Culture at the 'Fin de Siècle'*, London, Bloomsbury.

Silverman, Robert J. (1993), 'The Stereoscope and Photographic Depiction in the 19th Century', *Technology and Culture*, 34: 4, 729–756.

Smellie, William (1754), *A Sett of Anatomical Tables, with Explanations, and an Abridgement of the Practice of Midwifery, With a View to Illustrate a Treatise on that Subject, and Collection of Cases*, London.

Soja, Edward (1993), 'History, Geography, Modernity', in Simon During (ed.), *The Cultural Studies Reader*, London and New York, Routledge, pp. 135–150.

Speert, Harold (1973), *Iconographia Gynatrica*, Philadelphia, F. A. Davis.

Spencer, Herbert R. (1927), *The History of British Midwifery from 1650–1800*, London, John Bale, Sons and Danielsson Ltd.

Spiegel, Gabrielle (1990), 'History, Historicism, and the Social Logic of the Text in the Middle Ages' *Speculum*, 65: 59–86.

Spiegel, Gabrielle (1992), 'History and Postmodernism', *Past and Present,* 135: 189–208.

Stabile, Carol (1992), 'Shooting the Mother: Fetal Photography and the Politics of Disappearance', *Camera Obscura,* 28: 179–205.

Stafford, Barbara Maria (1991), *Body Criticism: Imagining the Unseen in Enlightenment Art and Medicine,* Cambridge, Massachusetts and London, MIT Press.

Stafford, Barbara Maria (1993), 'Voyeur or Observer? Enlightenment Thoughts on the Dilemmas of Display', *Configurations* 1: 1, 95–128.

Stafford, Barbara Maria (1994), *Artful Science: Enlightenment, Entertainment and the Eclipse of Visual Education,* Cambridge, Massachusetts and London, MIT Press.

Stafford, Barbara Maria (1996), *Good Looking, Essays on the Virtue of Images,* Cambridge, Massachusetts, MIT Press.

Stephenson, William (1909), 'Our Four Forefathers in Midwifery: A Historical Study', *Edinburgh Medical Journal,* 2 (new series), 6–17.

Stepney, Rob (1987), 'Human Body', in Jeremy Burgess (ed.), *Microcosmos,* Cambridge, Cambridge University Press.

Stoeckle, John D. and Guillermo C. Sánchez (eds) (1989), 'On Seeing Medicine's Science and Art: Cure and Care, Body and Patient. The Photographic Archives of Harvard Medical School', in Louise T. Ambler and Melissa Banta (eds), *The Invention of Photography and its Impact on Learning: Photographs from the Harvard University and Radcliffe College and from the Collection of Harrison D. Horblit,* Cambridge, Massachusetts, Harvard University Library, 1989, pp. 72–89.

Tagg, John (1988), *The Burden of Representation,* London, Macmillan.

Taussig, Michael (1993), *Mimesis and Alterity: A Particular History of the Senses,* New York and London, Routledge.

Teacher, John H. (1900), *Catalogue of the Anatomical and Pathological Preparations of Dr. William Hunter,* Glasgow, James MacLehose.

Thomas, Donald (1969), *Long Time Burning: The History of Literary Censorship in England,* London, Routledge and Kegan Paul.

Thomson, Ann (ed.) (1996), *Julien Offray de La Mettrie: Machine Man and Other Writings,* Cambridge, Cambridge University Press.

Thomson, D. G. (1884), 'Medical Photography in Recent Times': *British Journal of Photography Almanac,* 157–158.

Thornton, John L. (1982), *Jan Van Rymsdyk, Medical Artist of the Eighteenth Century,* Cambridge, Oleander Press.

Thornton, John L. and Carole Reeves (1983), *Medical Book Illustration, a Short History,* Cambridge, Oleander Press.

Thorwald, Jürgen (1960), *The Triumph of Surgery,* London, Pan Books.

Trall, Russell T. (1891), *Sexual Physiology and Hygiene,* Glasgow, Thos. D. Morrison.

Treichler, Paula A., Lisa Cartwright and Constance Penley (eds) (1988), *Visible Woman: Imaging Technologies, Gender and Science,* New York, New York University Press.

Turner, Gerard L'E. (1981), *Collecting Microscopes,* London, Studio Vista/Christies.

Turner, Gerard L'E. (1989), *God Bless the Microscope,* Oxford, Royal Microscopical Society.

Virchow, Rudolf (1971), *Cellular Pathology*, London, Dover.

Wade, Nicholas J. (ed.) (1983), *Brewster and Wheatstone on Vision*, London, Academic Press.

Ward, Henry Snowden (1896), *Practical Radiography*, London, Dawbarn and Ward.

Weeks, Jeffrey (1981), *Sex, Politics and Society*, London, Longman.

White, Brenda (1983), 'Medical Police. Politics and Police: The Fate of John Roberton', *Medical History*, 27: 407–422.

Wilkes, John (1871) *An Essay on Woman*, London, Private Press, first published 1763.

Willemen, Paul (1995), 'Regimes of Subjectivity and Looking', *UTS Review*, 1: 2, 101–129.

Williams, Linda (1990), *Hardcore*, London, Pandora Press.

Williams, Linda (ed.) (1994), *Viewing Positions: Ways of Seeing Film*, New Brunswick, New Jersey, Rutgers University Press.

Wilson, Adrian (1985), 'William Hunter and the Varieties of Man-midwifery', in Bynum and Porter (1985), pp. 343–369.

Index

Shohat, Ella, 6
Silverman, Robert J., 168
Simpson, Alexander Russell, 132
Simpson, Barbour, 132
Simpson, Sir James Young, 41, 132
skeletons, 100–7, *102*
Smellie, William, 3, 32, 64–8, *69, 70,*
 71–7, 95
Soja, Edward, 6
Speert, Howard, 125
sperm, 157–62, 176
Stabile, Carol, 35
Stafford, Barbara, 173
staining techniques, 171–2
Stam, Robert, 6
Stepney, Rob, 166, 172
Stereoscopic Magazine, 130
stereoscopy, 127–44
Stockdale, John, 56
Stockdale, John Joseph, 3, 38–40, 43,
 47–8, 51–60
Stockdale v. Hansard, 56–8
Strange, Robert, 84
Stubbs, George, 109
Susse, Victor, 147
Syme, James, 41, 92

Tagg, John, 5, 146
Taussig, Michael, 96
telescopy, 162–7
Thomson, D. G., 156
Thornton, John, 65
Tomlinson, J. D. W., 140
Trall, Russell T., 59
Treichler, Paul A., 17
Turner, Gerard L'E., 162

ultrasound images, 35
umbilical cord, the, 88
uterus, the, 106, 123–4, *131*

Vagrancy Acts, 55
Van Rymsdyk, Jan, 64, 67–8, *69, 70,*
 73–84 *passim, 77, 81, 89, 90, 91*
Vesalius, 13
Vice Society, 55, 57, 60
Virchow, Rudolf, 151, 168
virtual reality, 139

Ward, Henry Snowden, *116,* 118, 120,
 123
'watchfulness' (Hooke), 162–3
Waterston, David, 132
wax venus, 16, 30
White, Brenda, 41, 44
Wilkes, John, 57–8
Willemen, Paul, 97
Williams, Linda, 16, 19
Wilmot, John, 36–7

X-rays, 101, 111–22 *passim,* 125–6